The Artist's Daughter

A FICTIONALISED MEMOIR OF ELLEN CHURCHYARD

Sally Kibble

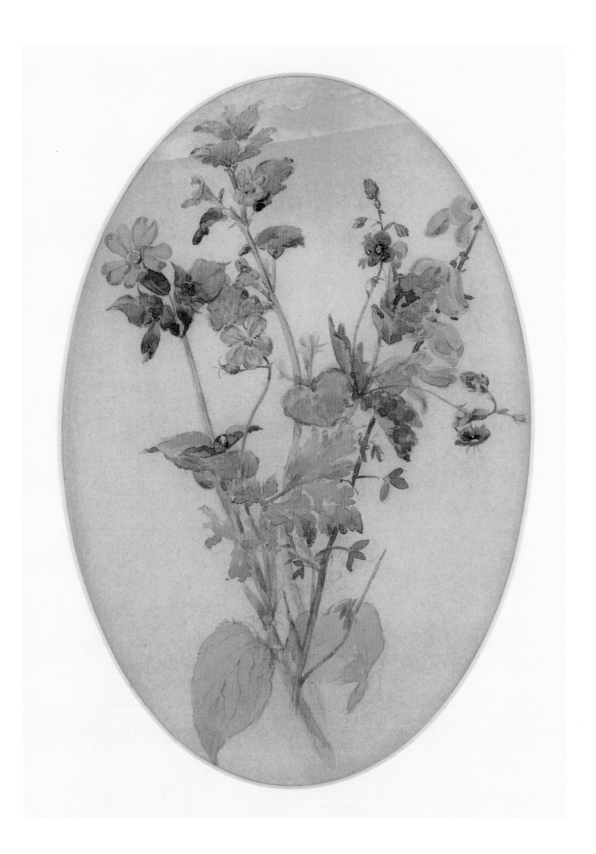

The Artist's Daughter

A FICTIONALISED MEMOIR OF ELLEN CHURCHYARD

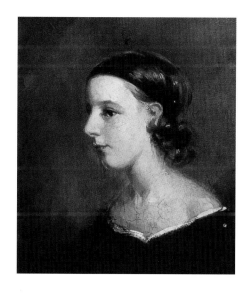

Sally Kibble

ANTIQUE COLLECTORS' CLUB

British Library Cataloguing-in-Publication Data
A catalogue record for this book is available from the British Library

Frontispiece: Wild Flowers. *By Ellen Churchyard. Watercolour. 9¼ x 6½ in. Private Collection.*
Title Page: Portrait of Ellen Churchyard, *circa* 1840. *By Thomas Churchyard. Oil on Panel. Private Collection.*
(Photograph courtesy of Robert Blake.)

Printed in China for the Antique Collectors' Club Ltd.,
Woodbridge, Suffolk IP12 4SD

Antique Collectors' Club

Formed in 1966, the Antique Collectors' Club is now a world-renowned publisher of top quality books for the collector. It also publishes the only independently-run monthly antiques magazine, *Antique Collecting*, which rose quickly from humble beginnings to a network of worldwide subscribers.

The magazine, whose motto is *For Collectors-By Collectors-About Collecting*, is aimed at collectors interested in widening their knowledge of antiques both by increasing their awareness of quality and by discussion of the factors influencing prices.

Subscription to *Antique Collecting* is open to anyone interested in antiques and subscribers receive ten issues a year. Well-illustrated articles deal with practical aspects of collecting and provide numerous tips on prices, features of value, investment potential, fakes and forgeries. Offers of related books at special reduced prices are also available only to subscribers.

In response to the enormous demand for information on 'what to pay', ACC introduced in 1968 the famous price guide series. The first title, *The Price Guide to Antique Furniture* (since renamed *British Antique Furniture: Price Guide and Reasons for Values*), is still in constant demand. Since those pioneering days, ACC has gone from strength to strength, publishing many of today's standard works of reference on all things antique and collectable, from *Tiaras* to *20th Century Ceramic Designers in Britain*.

Not only has ACC continued to cater strongly for its original audience, it has also branched out to produce excellent titles on many subjects including art reference, architecture, garden design, gardens, and textiles. All ACC's publications are available through bookshops worldwide and a catalogue is available free of charge from the addresses below.

For further information please contact:

ANTIQUE COLLECTORS' CLUB
www.antiquecollectorsclub.com

Sandy Lane, Old Martlesham
Woodbridge, Suffolk IP12 4SD, UK
Tel: 01394 389950 Fax: 01394 389999
Email: info@antique-acc.com
or
116 Pleasant Street – Suite #18
Easthampton, MA01027, USA
Tel: (413) 529-0861 Fax: (413) 529-0862
Email: sales@antiquecc.com

CONTENTS

INTRODUCTION
MISS CHURCHYARD 1826-1909

Miss Ellen Churchyard, the eldest daughter of the artist Thomas Churchyard, was a Suffolk girl, a Woodbridge girl at heart, who spent nearly her whole life in the place she loved best. She ran the Churchyard home when years of childbearing had taken their toll on the health of her mother. Ellen was her father's helpmate when financial troubles plunged the family into disarray. She was also an accomplished artist in her own right. In her youth the Quaker poet Bernard Barton admired her talents and her hard work, dedicating a poem to her, which was published in his collection *Household Verses* (1845). She won the love and respect of those who knew her, especially Edward FitzGerald, man of letters and translator of the *Rubáiyát of Omar Khayyám*, who counted her as one of the few women he particularly admired.

Illustrated and inspired by the paintings and drawings of her father, her family and herself, this book is the story of Ellen's life in that provincial town, in that provincial county, spanning the whole long reign of Queen Victoria and more. Looking back over her memories of family and friends, of her neighbours and the townsfolk around her, she paints a word picture of the Churchyards, Woodbridge and a life lived in the nineteenth century. Ellen's viewpoint, gives us the opportunity to see that world in all its complexity but more especially to feel it too.

3. Summer Scene in Suffolk. *By Thomas Churchyard. Oil on Panel. 8 x 9¼ in.* *Private Collection.*

THE PAINTINGS

Thomas Churchyard (1798–1865) was born in Melton, the only child of Jonathan Churchyard, butcher and meat-trader, and Anne White of Peasenhall. The Napoleonic Wars (1799–1815) were the constant backdrop to Thomas's childhood, and the source of his father's success. As soon as his parents realised that he was a talented and intelligent child, they used their new-found wealth and sent him to Dedham Grammar School, where John Constable had studied two decades earlier. After leaving school he became an articled clerk with Crabbe and Cross, Halesworth; he completed his final year in London in 1820, and was admitted to the Roll as an attorney.

In 1825 he married Harriet Hailes and their first child, Tom, was born a few months later. They set up home in Woodbridge, and Thomas began to build his career. Harriet and Thomas had ten children, one dying as a baby, the remaining two sons and seven daughters all outliving their parents.

Thomas sold very few of his paintings during his lifetime. After a brief attempt at becoming a professional artist in London in the early 1830s, he returned home to pick up his legal career. Having to content himself with painting for its own sake, he gave virtually all his free time to his art. He believed in his own work, but rarely sought the opinion of others after his early disappointment.

His daughters also believed in the value of his talent, and after their father's death, were loath to part with more than a few pieces to particular friends. As each daughter died, her share of the works was passed to the remaining daughters. On the death of Harriet in 1927, virtually the whole body of Thomas's artistic output came into the hands of his youngest son Charley. He immediately put the entire collection, in excess of 4,000 items, up for auction.

While his friends Edward FitzGerald and Bernard Barton wrote, leaving us enormously detailed records of every aspect of their lives, Thomas Churchyard painted. His sketches and paintings are his daily diary, the record of his life, the life of rural Suffolk, and his home. He left a trail in minute detail of his daily travels, his mood and his fortunes — if we care to look we can see it all.

4. Cottages at Ufford. *By Thomas Churchyard. Oil on Panel. 9 x 11¾ in.* *Private Collection.*

A Churchyard Chronology

1798 Thomas Churchyard born in Melton.
1808 Attends Dedham Grammar School.
1816 Trains as a solicitor at Crabbe and Cross, Halesworth.
1820 In London to complete his training.
1822 Begins practising as a lawyer, setting up his own office in Woodbridge.
1825 Marries Harriet Hailes. They move to 29 Well Street, Woodbridge.
 Birth of Thomas Churchyard junior.

1826 Ellen Churchyard born in Well Street.
1828 Emma Churchyard born.
1829 Thomas exhibits in Norwich.
1830 Laura Churchyard born.
 Thomas exhibits at Society of British Artists in Suffolk Street, London.
1831 Exhibits at Royal Academy, London and at Society of British Artists.
1832 Anna Churchyard born.
 Thomas goes to London to try to make a living as an artist, accompanied by his friend and fellow artist George Rowe.
 Family moves to Melton with his mother.
 Exhibits at Society of British Artists, London.
 He becomes a founder member of the Ipswich Society of Professional and Amateur Artists.
1833 Returns home. Family moves to The Beeches, Melton. Thomas recommences work as a solicitor in Woodbridge.
 Exhibits at New Society of Watercolourists.
1834 Bessie Churchyard born.
 Thomas illustrates some of Bernard Barton's poems.
1836 Harriet Churchyard born.
1837 Death of John Constable.
 Charles Churchyard born.
1838 Baby Charles dies.
 Thomas becomes friends with Edward FitzGerald around this time.
1839 Kate Churchyard born.
 Bernard Barton writes a poem for Thomas's birthday.
 Young Tom goes as a boarder to Mr Downes Classical Academy in Wickham Market to study farming and science.
1841 Charley Churchyard born.
1843 Family moves to Marsden House, Woodbridge, after Thomas's mother dies.
1844 Ellen begins attending Mrs Jay's Boarding Academy in Bury St Edmunds.
 Bernard Barton writes a poem for Ellen, 'The Housewife'.

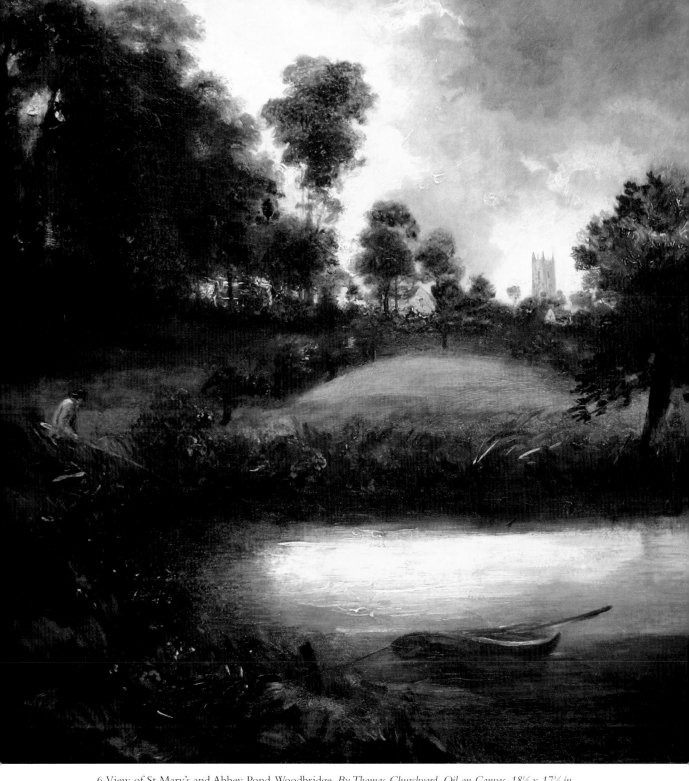

6. View of St Mary's and Abbey Pond, Woodbridge. *By Thomas Churchyard. Oil on Canvas. 18½ x 17¼ in.*
Private Collection.

Opposite: 5. Thomas Churchyard. *Photograph.* *(Courtesy of Ipswich Borough Council Museum and Galleries.)*

1845 Ellen travels to Cheltenham to visit uncles and cousins.

1850 Thomas exhibits at Suffolk Fine Art Association in Ipswich.

1851 Young Tom begins farming at Ufford.

1852 Thomas exhibits in Norwich.
 Young Tom travels to America, where he will stay for six years.

1854 Inventory made of Thomas's household for creditors.

1855 Family moves briefly back to Melton.

1856 Family moves to Hamblin House, Woodbridge.

1858 Young Tom returns home from America. He marries Elizabeth Bardwell and takes over Brook's and Lynn's Farm on lease.

1860 Young Tom and Elizabeth have first child, 'very young Tom'.

1861 Young Tom has a second son, Charles. Charley begins training for the law.

1863 Young Tom and his family emigrate to Canada. The ship sinks; he survives but loses his wife and children in the disaster.

1865 Thomas dies. The family is left with debts and little money.

1866 Auction of Thomas's possessions to raise money. Family move to Penrith House, Woodbridge.
 Thomas's wife, Harriet Churchyard, dies.

1867 Ellen tries to sort out the family affairs.

1868 Ellen leaves to work in a residential post as a housekeeper in Norwich.
 Her sister Harriet begins studying at the School of Art, Ipswich.

1869 Laura and Harriet teach at Brook House, Ladies Academy.

1870 Bessie goes into service in Essex.
 Young Tom travels to New Zealand.

1871 Ellen returns to Woodbridge as Ben Moulton's housekeeper. The other daughters are still living at Penrith House. Harriet begins teaching at Brook House Ladies Academy.

1875 The old Free School is converted into a dispensary and Seckford library.

1878 Emma dies, aged 50.
 Laura becomes Librarian at Seckford Library. Laura, Anna, Harriet and Kate live in the old headmaster's house next door.

1884 Harriet, Anna and Laura join the Ipswich Fine Arts Club.

1885 Ben Moulton dies, leaving Ellen an annuity. Ellen moves to her own home in New Street, Woodbridge.

1888 Bessie leaves service and returns to Woodbridge, joining her sisters at the Library.

1889 Kate dies, aged 50. Her possessions are packed up and placed in the attic of the library.

1891 Laura dies, aged 61. Her possessions are stored with Kate's.
 Harriet becomes the Librarian.
 E.V. Lucas comes to visit Ellen for information about Bernard Barton, whose memoirs he is working on.

1896 Tom dies in New Zealand, aged 71.

1897 Anna dies, aged 65. Her box of possessions is added to the others.

1903 Charley gets a place at the Seckford Almshouses.

1909 Ellen dies, aged 83.

1913 Bessie dies, aged 79.

1927 Harriet dies, aged 91. Charley sells all of the Churchyard paintings in one big sale.

1929 Charley dies, aged 88.

A BERNARD BARTON CHRONOLOGY

1784 Bernard Barton born.

1806 Moves to Woodbridge, apprenticed to Samuel Jessup, a shopkeeper.

1807 Marries Lucy Jessup, and sets up as a coal and coke merchant.

1808 Lucy dies in childbirth; his baby Lucy survives.
Leaves Woodbridge to become a private tutor in Liverpool.

1809 Returns to Woodbridge, to work at the bank of Dykes and Samuel Alexander.

1812 Anonymously publishes his collection of poems *Metrical Effusions*

1818 Publishes *Poems by an Amateur*.

1820 His collection *Poems* published.

1822 *Napoleon and Other Poems* published.

1824 *Poetic Vigils* published.

1826 *Devotional Verses* published.

1827 *A Widow's Tale and Other Poems* published.

1837 Makes himself known to Edward FitzGerald, in order to get an introduction to William Bodham Donne.

1839 Writes a poem for Thomas Churchyard's birthday.

1840 Has a tops'l schooner named after him.

1844 Writes to Ellen Churchyard at school in Bury St Edmunds.
He composes a poem for her: 'The Housewife'.

1845 *Household Verses* published. He dines with Robert Peel at Whitehall.

1846 Granted a pension by Queen Victoria.

1849 Dies aged 69. He is buried in the Quaker burial ground in Turn Lane, Woodbridge.
Edward FitzGerald and Lucy Barton prepare *The Letters and Poems of Bernard Barton* for publication.

1898 Lucy Barton dies, aged 90.

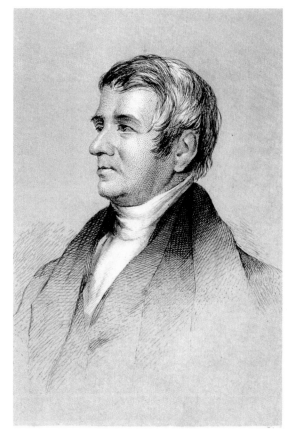

7. Bernard Barton. *Engraving.*
(Courtesy of Suffolk Records Office, Ipswich PR/B/20.)

An Edward FitzGerald Chronology

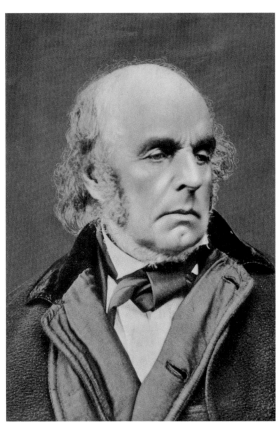

8. Edward FitzGerald. *Photographic Portrait.*
(Courtesy of Suffolk Records Office, Ipswich PR/F/5.*)*

1809 Edward FitzGerald born Edward Purcell, at Bredfield White House.
1816 Moves to Paris with his family.
1818 His grandfather dies and the family changes its name to FitzGerald. He attends King Edward VI Grammar School at Bury St Edmunds.
1826 The family moves to Wherstead Lodge. Edward begins studying at Trinity College, Cambridge.

1829 Meets William Makepeace Thackeray.
1830 Edward graduates. He travels with Thackeray to Paris.
1832 He becomes friends with William Kenworthy Browne. He becomes a founder member of the Ipswich Society of Professional and Amateur Artists.
1835 Visits his friend James Spedding's home with Alfred Lord Tennyson. His family moves from Wherstead Lodge to Boulge Hall. He begins friendship with Revd. George Crabbe, son of the poet George Crabbe.
1837 Begins friendship with Bernard Barton. Sets up home in the cottage at the gates of Boulge Hall.
c.1838 He becomes friends with Thomas Churchyard.
1842 He meets the writer Thomas Carlyle and agrees to help research the Naseby battle site for Carlyle's book on Cromwell.
1843 He coins the phrase 'the chief wits of Woodbridge' for Bernard Barton, Thomas Churchyard, Revd. George Crabbe and himself.
1844 He meets Edward Cowell, a gifted linguist.
1847 Edward Cowell marries Elizabeth Charlesworth, an old friend.
1848 His father becomes bankrupt.
1849 With Lucy Barton he prepares a selection of Bernard Barton's letters and poems for sale after Barton dies. He proposes to Lucy Barton and she accepts. They are engaged for seven years before finally marrying.
1850 *Six Dramas of Pedro Calderón de la Barca* published, freely translated by Edward.
1851 *Euphranor: A Dialogue on Youth* is published.
1852 His father dies.
 Polonius is published.
 He begins to study Persian with Cowell.
1853 He moves from the cottage now his brother is at Boulge Hall.

1854 Living at Farlingay Hall, near Woodbridge, with Job Smith, a childhood friend.

1855 His mother dies.
Carlyle visits him at Farlingay.

1856 He is given a transcript of the *Rubáiyát of Omar Khayyám* to translate by Edward Cowell and his wife, when they leave for a post in Calcutta.
He finally marries Lucy Barton at Chichester.

1857 The Revd. Crabbe dies. Edward separates from Lucy after only a few months.

1859 Publishes *Rubáiyát of Omar Khayyám* anonymously. His friend Browne dies after an accident.

1860 Moves into rooms over Sharman Berry's gunsmith shop on Market Hill, Woodbridge. Buys his first boat.

1861 Buys a new Beccles-built boat called *Waveney*.
Copies of *Rubáiyát of Omar Khayyám* are sold at a reduced price. They are 'discovered' by the Pre-Raphaelites and their friends.

1863 He buys a new boat called *Scandal*.
His favourite sister, Eleanor, dies, followed by his friend Thackeray.

1864 Buys a farmhouse in Woodbridge; he calls it Little Grange.
His sister Isabella dies.

1865 Arranging building work at Little Grange.

1866 Meets a Lowestoft fisherman, 'Posh' Fletcher.

1867 Buys Posh a fishing lugger called *Meum and Teum*.

1868 Second edition of *Rubáiyát of Omar Khayyám* published.

1870 Parts company with Posh.

1871 Sells *Scandal* but keeps *Waveney*, to sail on the rivers.

1872 Agrees to a third edition of *Rubáiyát of Omar Khayyám*.

1873 Has to move out of Berry's rooms, to Little Grange. He is now identified as the author of the *Rubáiyát of Omar Khayyám*.

1876 Tennyson visits; he stays at the Bull Hotel in Woodbridge.

1877 Meets Charles Keene at Dunwich.

1878 Contributes regularly to 'Suffolk Notes and Queries' in the *Ipswich Journal*.

1879 Abridges Crabbe's *Tales of the Hall*. Fourth edition of *Rubáiyát of Omar Khayyám* published.

1883 He dies at the home of George Crabbe, grandson of the poet.

(Chapter headings, which follow, from *Rubáiyát of Omar Khayyám*.
Translated by Edward FitzGerald.)

CHAPTER 1
SOME WE HAVE LOVED

When love first strikes it changes everything.

I do realise just how much that is a cliché; I have read romantic novels enough to know that it is not a new idea. Yet it is true. Scales fall from your eyes and nothing, nothing at all, looks or seems the same ever again. To the smitten this is bliss and agony, paradise and hell; the world is suddenly real in a way previously unimaginable. No doubt it is amusing to those who witness the change. If they can remember that same moment in their own lives, if they ever experienced that moment, maybe they smile to themselves. However, if they have never loved, they may find it less droll, they may even be angry at the changes they find so suddenly, so impossibly altering the one they believed they knew.

I can tell you the very day, the very hour, when I passed from one side of that mysterious veil to the other; for, yes, it is like dying. The Ellen I had been was gone forever and the new Ellen was born: the Ellen who loved.

We had been invited to 'tea on the lawn', a carriage had been sent to collect us but Mamma was not feeling well. I felt sure that I would be asked to remain behind with Mamma, to watch over her and fetch anything she might require. But on that perfect summer's day Papa had said I should not stay behind, he said that I, too, needed a holiday from the house, that I should accompany him and be his helper. So, my heart light with anticipation, I fetched my shawl and slipped out of the door before he could change his mind.

Papa was to paint a picture and he carried his paint box and easel. I carried a basket with two jars of homemade preserve, and I had an idea that I might collect flowers to bring home to Mamma. I longed to be free from the house and yet I knew I would be thinking of Mamma all afternoon until we returned.

Inside the carriage sat dear Mr Barton, dressed in his usual outfit of plain Quaker clothes, chatting incessantly even before we had settled ourselves in our seats. It was for Mr Barton that the grand carriage had been organised; we were included to save Papa the trouble of driving himself. Mr Barton talked and talked but I did not hear his words at all; it was so exciting to be sitting up high, in so smart a carriage, watching the world go by. It was the same road I had often walked, up the hill out of Melton, but it all seemed so new from the vantage of that high, plush seat. The road was very good as the weather had been dry, so the journey was comfortable. The birds sang and the trees were dusty with the summer breezes. We passed the gypsy encampment where I was forbidden to walk; I could see the blue smoke rising from their fires, straight wisps of pure romance. Colourful clothes waved gently from cords strung between the trees; I wondered if it was washing or

9. Lawyer Wood's Lane, Melton. *By Thomas Churchyard. Watercolour. 4¼ x 3¼in. (Photograph courtesy of David Messum Fine Art Ltd)*
Private Collection

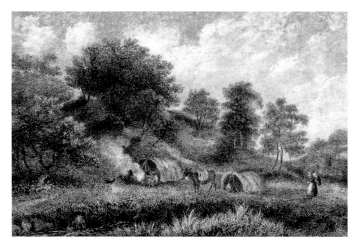

10. Gypsy Encampment. *Print. 2¼ x 3½ in.* *Private Collection.*

if they hung the clothes out in the air to give them more room inside their canvas-covered hooped homes?

We were all going to take tea with Mr Edward FitzGerald on the lawn of his cottage, at the gate of his mother's stately residence, Boulge Hall. He had asked Papa to paint him a picture of the cottage, and it had been decided that on the first mutually convenient fine day of the season he would provide the refreshments and Papa would execute the work of art. Mamma was also invited to see the little home he had proudly created (Papa had often dined there with Mr FitzGerald and his friends, but Mamma had never visited before). Yet she had not seemed disappointed when she could not attend; she did not seem at all concerned. I, however, was desperate to see the cottage I had heard so much about.

Until recently his family had been living at Wherstead Lodge, near Ipswich, during which time Edward FitzGerald had been a student at Trinity College, Cambridge. But he was really a local boy, since he had been born at Bredfield White House, just a couple of miles distant. Now his family lived at Boulge Hall, but Papa said that Fitz could not bear its vast elegance, so he had asked his parents for permission to set up house in the cottage at their gate, to be near and yet away from his family. Preferring to keep some independence, he kept to this little refuge where he could reconstruct the feeling of his student rooms, entertain his friends and study his books. He lived and worked at his writings and studies there whenever he was at liberty to do so, since his mother frequently claimed his attendance on her in London or Brighton. Papa had also told me that Edward was considered rather an eccentric, but I could not see why people said that.

In my imagination it was an idyll, my dream home: a snug, thatched cottage tucked comfortably in a shady nook. I knew that it would be surrounded by beds of English country flowers: anemones, wallflowers, irises, poppies and geraniums, like the designs I embroidered with Nanna onto the edges of the tablecloths and doilies. It would be overhung with the gently stirring branches of mature trees planted in the park many years earlier to hide the family in the Hall from the gaze of the passing world. So ran my imagination and on this

11. The White House, Bredfield. *By Thomas Churchyard. Watercolour. 5 x 7½ in.* *Private Collection.*

great day I felt sure it would be confirmed, improved upon even. It had never occurred to me that the cottage would not be everything I had thought and wished; I was too young to have learned that lesson. As it happened I hardly noticed the surroundings that day because a new image, a new ideal, one never dreamed of, swamped my mind.

The carriage swept majestically through the gates and drew up gently before the cottage door. I began to look for the door handle, but Papa softly restrained me, knowing that the coachman would come around to open the door for me and to lower the step. Watching the uniformed coachman performing this duty I had not noticed that Mr FitzGerald had already appeared at his cottage door. A hand reached out to steady me and I delicately took it in mine, attempting to be ladylike and correct. I stepped down carefully and then looked up to thank the driver for his help, but it was not him holding my hand; it was Mr FitzGerald himself smiling his welcome, eyes so mischievous, blue and dancing.

A thunderbolt may as well have struck my heart. I fell in love. At the age of twelve my heart was lost, and lost for good.

I remember every moment of the visit, but although the images play before my eyes I only felt one thing: his presence. I do not know how often I had met him at Mr Barton's house or at our house where he came to talk to Papa about painting, but I had never before felt about him as I did now. Mr Barton was a great gossip and had told me a great deal about Mr FitzGerald, so I had heard much about how he lived: getting up early and eating only a small breakfast before going to his desk to study all morning, often forgetting to dress

until much later when he decided to go for a walk or visit friends. In company he loved to appear quite indolent, yet he never allowed either his mind or his body to stagnate.

The sun shone for us all afternoon. Papa set up his easel in a carefully chosen spot, and I sat on a stool at his side helping with the paints. Mr Barton found himself a comfortable seat on a garden chair out of the line of Papa's sight, joking all the while that he could soon move if 'Teddy' fancied having some life in his house portrait. Mr Barton insisted on calling Mr FitzGerald 'Teddy', although I could see it caused him to wince each time the word was uttered. But our kind host bustled in and out of the house carrying furniture and supplies. Under the shade of a small pavilion set up on the side lawn, he placed a wicker table and four chairs. The table was then filled with every imaginable delight, enough for ten people: there was salad, cucumber, bread and cheese, cold lamb, butter in a glass dish, oil and vinegar, salt and pepper, plates and cutlery, all awaiting our attention. There was even a promise of strawberries and cream after we had made room on the table. Last of all a jug of lemonade and a jug of ale appeared when Papa had been called away from his work and was settled in the shade.

'How am I to finish the picture if I consume even a fragment of this feast?' he asked, seriously torn between the work in hand and the social occasion. Papa could paint through many a mealtime and never notice his loss, but he was also very conscious of his host and his friend. He ate some lamb and bread, washed down with a little glass of ale, then he announced, 'I am afraid that I will have to ask Ellen to bring me a bowl of strawberries later. I must return to the easel for now or I will not have enough done to work up at home.'

Mr Barton ate and ate as though he had not had a meal for days, and then, after his second glass of ale, he fell soundly asleep in his chair, snoring loudly. At home he lived the simple life of the Quaker, but he always managed to enjoy fully the hospitality offered by his many friends. Gentle, calm and generous with his affections, Mr B returned the love of his friends enthusiastically. He appreciated all the good things the world could offer, without ever expecting any of them. Everyone knew that he had not the means to return in kind the treats he enjoyed, but he always returned more than their value in loyalty and love.

'Well, now we must entertain each other, Miss Churchyard,' said my host, smiling kindly and pushing himself back in his chair.

Blushing to the roots of my hair, I replied, 'I am afraid I shall not be very entertaining.'

'Not true, not true. I have long observed you from afar and I know that you are a truly talented young lady. I have watched you in your home organising the chores and ensuring your father's guests are always made to feel at ease. I am sure you have been an invaluable help to your mother, whose many confinements have kept her from society a long time. And, last but not least, I never cease hearing you praised by dear Bernard here, who would confirm my words if he were to awaken.'

My blushes were now beyond belief but my heart sang. Another cliché, I know it well, but I am sure it did. The fluttering in my breast must have been my heart missing a beat, followed by a great surge of feeling which seemed likely to overwhelm me as my heart raced to catch up. My legs felt weak, my voice lost. Oh, to be noticed; to have been noticed. I was no longer a child; I was a woman, a person.

As though he could read my soul's torment, Mr FitzGerald closed his eyes and turned his face to the sun. He was silent for a while, elegantly allowing me time to regain my

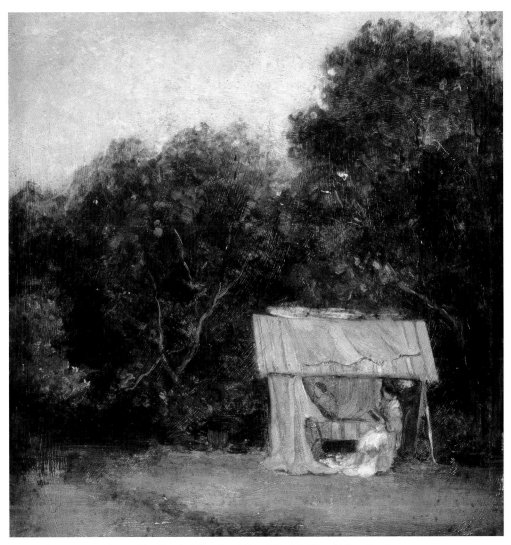

12. Garden Tent. *By Thomas Churchyard. Oil on Panel. 7 x 6½ in. The Tate Gallery, London.*

composure. How kind he was, how generous. After a few moments he spoke again, dreamily saying,

'This is bliss. To sit here in my own garden, before my own cottage on such a perfect summer day; one old friend snoring contentedly nearby and another working diligently at his easel to produce an oil painting for me. Mrs Faiers scuttling about in her kitchen to bring us refreshments, and is that my song thrush calling to us? Then I think that time must be getting on.'

It seemed almost as if, sitting there with his eyes closed, he had forgotten my presence. Clearly he felt at ease in my company, and if that were to be true, I was a part of his perfect world. I

hardly dared to breathe for fear of breaking into his reverie, and yet I wanted him to speak to me again, I wanted to show him that I was worth speaking to.

'Papa showed me the pencil drawing you have made of the cottage. It is very good. He says that you have a very good eye for detail in your sketches.'

Opening an eye he replied, 'Well that is a compliment from your Papa. He is the one with the skill. I flatter myself that I know a little of art and I am sure that his talents are great.'

With that he leaped up from his chair and strode across the lawn to Papa's side. He studied the painting on the easel and then, pointing to an area on the board, he asked Papa a question. They both looked up at the path through the trees and then back to the painting. Papa nodded and returned to his work. I had felt alarmed for a moment, as Papa did not like comments on a work in progress, but all was well. Mr FitzGerald strolled back to my side and asked me to join him for a while, so together we promenaded up and down the pathway, into the shade of the trees and then back to the warmth of the sun on the lawn. Papa painted on and Mr Barton slept comfortably in his cane chair, straw hat tipped forwards over his eyes.

That afternoon, in that place, I was as happy as I can ever remember. Maybe I was as happy, in my innocence and naïvety, as I ever would be in my life. It was a golden moment, which I hardly dare to recall for fear of weakening the memory, of using it up. There are so many things that remind me of that day: the song of the thrush, the dapple of sunlight through the trees, the scent of freshly cut grass, snoring. So very many things.

'Before you leave I have a gift for you, Miss Churchyard,' he said at one turn of our passage along the path.

'Please call me Ellen; it sounds so correct: "Miss Churchyard". I feel rather more like an Ellen.' I changed the subject before the idea of a gift sent me into confusion once more.

'Or Nellie? Mr Barton always calls you Nellie.'

'I don't feel quite so much Nellie as Ellen, I'm afraid,' I admitted, adding, 'and he calls you Teddy!'

'I know, and I don't feel like a Teddy at all. It is strange that some pet names seem to fit and some just do not. I have a feeling that my mother will soon stop the Teddy business. She is very ferocious about such things. He will soon be told not to do it. Then all will be "Edward", "Edward", "Edward" for a while, until suddenly he will lapse and call me "The Truant" or "Edge" — that's one of his favourites — or even of late I've heard tell that I am called "Cottager". It is his poetic way and I don't really mind. It reminds me of Cambridge; it is the way the students go on with each other.

'But you have distracted me — we were talking of a gift. Now come into the cottage and I shall show you. It was the main reason that I insisted your Papa brought you with him this afternoon.'

With that Mr FitzGerald, Edward, waved me into his cottage and through to the scullery and kitchen at the back.

'Now you must meet my family,' he said disappearing from sight.

My heart stopped for a moment, this time with dread. I pictured his grand family in the imposing Queen Anne mansion at the top of the drive. He reappeared, having found Mrs Faiers, and led us back into his study. What a mess of books and papers met us there, a delicious mess. I thought how I would love the freedom to live just as I desired. The walls were covered with the most amazing paintings, quite as beautiful as those Papa collected.

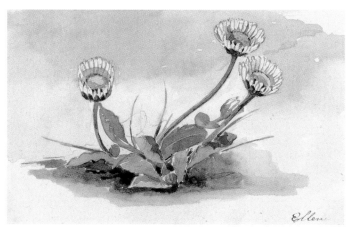

13. Daisies. *By Ellen Churchyard. Watercolour. 3½ x 4¼ in. Private Collection.*

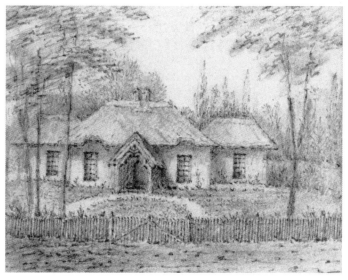

14. Boulge Cottage, Suffolk. *By Edward Fitzgerald. Pencil Sketch. 3¼ x 4¼ in.*
Private Collection.

Mrs Faiers raised her eyebrows and shrugged her shoulders, as if to say, 'It is nothing to do with me'.

'Ha, ha, I see you,' Edward laughed. 'Mrs Faiers doesn't approve of my muddle. Miss Lucy Barton also doesn't approve. She thinks I need a firm hand!'

'Oh I think it is a wonderland, a treasure trove,' I exclaimed, winning a sharp look from Mrs Faiers.

'At last, a fellow free-spirit,' Mr FitzGerald grinned.

Then something moved in the corner near the window, causing me to jump with alarm. I imagined that it could be a mouse, or worse still a rat. But instead a croaking, rasping voice

called out, 'What a mess! What a mess!' Then, 'Silly fellow! Silly fellow!'

'Please meet my great friend Beauty Bob. I am afraid that he, too, is always chiding me for my slovenly ways.'

Edward reached out his hand and a handsome blue parrot stepped on to his arm. It sidled along towards his face and reached across to kiss him with a gentle peck. At that same moment a head appeared from under the table and a tan-coloured, shiny hound dog stretched and yawned his way out. He pushed his way into the folds of Edward's coat and waited for a scratch on his head.

'And my faithful companion Ginger, who has slept the entire afternoon away. But it is Mistress Gatto that we really need to find. She suspects something is afoot and she is hiding somewhere.'

We all cast our eyes around the room in search, eventually finding her behind the curtains. There she sat on the windowsill, the blackest, sleekest cat, her eyes yellow as jewels, burning us with undisguised disdain.

'I am afraid she knows what we are about and she isn't pleased. But I have told her that if she is going to be so wanton then this will be the result. We cannot be overrun.'

Then I saw the basket on the floor, lined with an old knitted shawl, and on the shawl were five little black, fluffy miniatures of their mother, their ears still stubby and their little noses still perfectly soft and warm.

'Now Miss Churchyard, Ellen,' he corrected. 'Your Papa has given permission for you to select a kitten. You are the first to see them, so you may choose any one you like.'

I could not believe my ears; we had never had a pet cat before. Papa had always believed that cats were working farm animals and needed to be half wild to do their job effectively; a well-fed cat would not bother to hunt. I gently picked up each one in turn until a little Betty mewed at me and licked my finger with its rough tongue; that was the one.

'You mustn't decide on a name until you know each other better. It is most important to give a cat the right name. It will never be happy if not and can sulk most dreadfully.'

My happiness gave flight to my shyness; I reached up to his cheek and planted a kiss of thanks. From that moment on Edward became my complete hero; my heart and mind were won and he never knew it. He would have been very uncomfortable if he had realised how my young heart raced; I learned to be glad that he did not know, that he probably never knew.

In the carriage on the journey home, much fuss was made of the little kitten resting in the bottom of the basket, curled in the folds of a piece of old blanket. Mr Barton had only woken from his slumbers when the carriage appeared from the direction of the Hall. He kept insisting that he had not been asleep, just resting his eyes. He was quite amazed at the amount of work Papa had managed to achieve while he 'wasn't' asleep and he was surprised at the new arrival, too.

'I believe that my dear Lucy is going to have one of the kits. But she couldn't be here today or she would have had the first choice I expect.'

My heart now felt its first taste of jealousy. How soon strong emotions follow each other, rushing headlong into our hearts as though there is a vacuum there and once punctured it

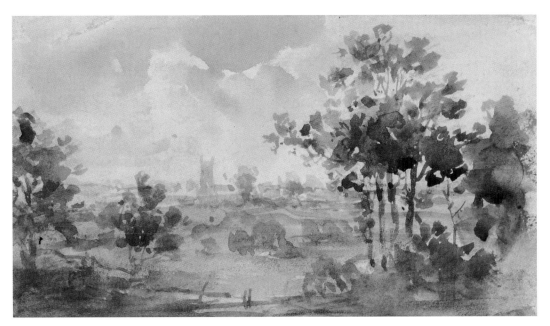

15. Dedham Church 1831. *By Thomas Churchyard. Watercolour. 3¼ x 5¼ in.* *Private Collection.*

must be filled. Lucy Barton was Mr Barton's only daughter, the apple of his eye, of course. She was more or less the same age as Mr FitzGerald, and while she was always kind to me she always treated me as a child. Had she been with us I felt quite sure that Mr FitzGerald would not have noticed me at all. She would have made quite sure of that.

'Oh, was she invited too?' I asked quietly.

'No, my dear, actually she wasn't invited today,' Mr Barton admitted quite unaware of my new feelings.

Then, just as I was feeling irrationally triumphant, he added, 'She is staying in Holbrook with Teddy's sister Jane, Mrs Wilkinson. They are very fond of her. Well, I think that I can say that she is well liked by all of his family.'

I sank into the corner of the seat and, clutching the basket close to my breast, struggled to understand how the most blissful afternoon could change so soon. There was no point in hoping or dreaming; it was quite clear that Lucy Barton was already Mr FitzGerald's friend. Why on earth would he wait for me to grow up?

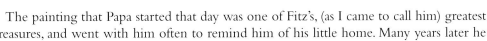

The painting that Papa started that day was one of Fitz's, (as I came to call him) greatest treasures, and went with him often to remind him of his little home. Many years later he gave it to one of his greatest friends, Edward Cowell. Cowell and his wife were moving to India to teach there and Fitz was not sure if he would ever see them again. He gave them the painting to take with them, so that a part of him would always be there with

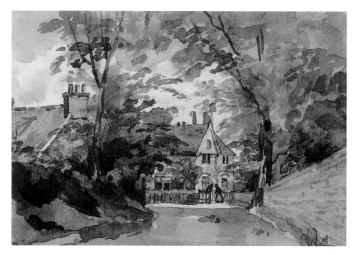

16. Melton Crossroads near The Beeches. *By Laura Churchyard. Watercolour.*
2½ x 3¼ in. *Private Collection.*

them and they could remember him in one of the happiest times of his life. Later, when the Cowells came back to England, the painting came too and remained with them all their lives. That picture, always much loved, created on the day I lost my heart.

Oh, but that was all so very long ago, when I was just twelve years old, and now I am more than seventy. I feel so very old, especially today when my two remaining sisters have put another box of memories into their attic. Now they have a row of boxes lying silently in that dark space; the sparse remains of lives, lying in a row, never to be touched again. Four of my sisters, four of the White Mice, as Edward had called them, all gone now. I feel that I can remember all of their births and it seems so strange that they are gone before me. We were a big family: two boys and seven girls living. When we were young we were so close, Papa held us all together; while we had him we knew who we were. Poor dear Tom, the odd one out in so many ways, died alone last year on the other side of the world, in New Zealand. I often wonder what happened to his things. I suppose that it is the thought of those boxes which has made me wistful, the thought of one's life reduced, concentrated into a mere trunk full of objects. Objects that have been kept as mementoes of people and events, special places and moments in time, crystallising the most intense emotions we ever feel. Then we are dead and they mean nothing. They are wiped of their power.

The worst thing seems to me that my sisters failed to sort out these treasures themselves. I feel that I would like to look at and feel those personal objects. I feel that I would be able to divine some of the memories, to sense the meanings. But their way is to ask a friend to come in and pack away the departed one's earthly possessions. Before Anna's death the same friend, Mrs Redstone, had tidied away the remaining effects of Kate. They asked her to come and open up the box under Kate's bed to sort out the clothes from the personal possessions, then pack them carefully into a trunk to have it carried to the attic. She was then called again when Laura died two years later, and now once more for Anna.

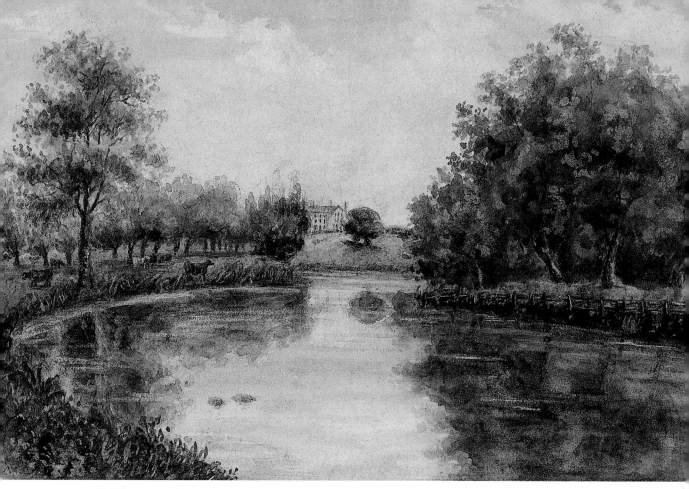

17. Glevering Hall. *By Anna Churchyard. Watercolour. 7¼ x 11½ in.* *Private Collection.*

Emma died so long ago that I do not know what happened to her things. It is an odd thought that a stranger should sift through the flotsam of one's life. I know that I would prefer my things to be arranged by those who had a share in their history. This strange procedure seems almost awful to me, a shirking of one's duty; unfair to the outsider and unfair to the departed. When I die I hope that a loved one will deal with my possessions, and maybe linger a while over bittersweet memories as they do it.

The White Mice had never discussed personal matters, never debated relationships, and so even in death it seems their privacy was sacrosanct. Privacy for them had become a way of life, ferociously clung to for so many years that even at the end they could not waver from it. To do so would be far too personal for them, an intrusion; to change at the last would somehow make a mockery of the way they had lived their lives. I know that I cannot change my sisters and now I never try; we have finally come to an uneasy accommodation and I have no wish to risk it at this stage. Bessie and Harriet now live together at the library, where Harriet took over command from Laura.

I suppose it was thinking of Anna's things that induced me to bring down from my bedroom my own box of treasures. Not a trunk, just an elegant, black, Chinese lacquered box with drawers and cubby holes for storing small delights. Handling them and smelling

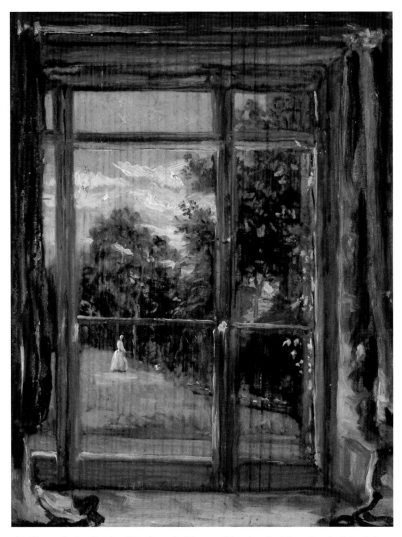

18. Through the Garden Window. *By Thomas Churchyard. Oil on Panel. 6½ x 5 in.*
Private Collection.

19. Edward FitzGerald's Cottage, Boulge. *By Thomas Churchyard. Oil on Panel. 7¼ x 6¼ in.*
Private Collection.

them ignites the beloved memories that cling to this odd collection of bits and bobs. A fragile fern frond, almost too brittle to touch, pressed between the pages of Mr Barton's *Household Verses*; the little golden stone with the hole in it, from the windy shingle of Aldeburgh beach; the crowing note from Lucy Barton, written on her honeymoon, folded together with the pained note from Fitz written on their separation. All the little drawers are crammed with lives and loves. And, of course, I have my paintings and books, treasures indeed, all soaked in association and love.

32

Chapter 2
Then and Then Came Spring

'What the hell are you laughing at?' growled Charley from his chair in the corner. He scowled, clearly vexed with me for being amused.

'I was remembering the day I first got Blackie; do you remember the kitten Fitz gave me?' I knew that I should not mention Fitz's name to my brother Charley, but I did not care.

'We never had a kitten. I can remember a smelly old cat that never caught a mouse in its life.'

'I suppose that it was before you were born and you can only remember when poor Blackie was getting old. She did catch mice when she was young, she was really clever.'

'Everything happened "before I was born", everything good at least,' he complained.

'Actually, I think that I was given Blackie the year that baby Charles died. I expect they thought that it would help our sadness, distract us.'

Charley always hated mention of our lost baby. Maybe he should not have been given the same name; it forged a false connection between them. He seemed to think that we compared him to what we imagined the dead Charles would have been like and then found him wanting. In the end this was indeed to be true; he made it true.

Baby Charles's death had been our great sadness at an otherwise good time in our family's fortunes, when Papa's career was doing well and we were comfortably off. In the middle of winter Mamma had her eighth child, and this time it was another son after six girls in a row. He was doted on by us all. Tom, who was twelve and with the anxieties of youth on his shoulders, was not jealous of his new rival; Papa was really delighted with a new son and all of the women in the house were pleased, Mamma especially. But our baby brother did not ever seem to thrive. At first we thought it was the time of year, and we waited for things to improve as that gloomy winter gave way to spring. He was not well at all and seemed to catch every illness that passed by; a subdued air of sadness settled heavily over our home, a sense of waiting, of foreboding.

Maybe he had come along too soon after Harriet was born and Mamma was not strong enough? Maybe we had not had our share of lost babies? Other people suffered this sadness often, hardly surprised when one of their babies did not survive. We had been blessed and we had taken it for granted. While the Queen was crowned in London and a steam-boat service was started from Ipswich to the capital, our baby Charles sickened. A yacht club was formed in Woodbridge and a regatta planned: sailing, rowing, climbing the

20. Elm Trees beside a Gate. *By Thomas Churchyard. Watercolour. 10 x 6½ in.* *Private Collection.*

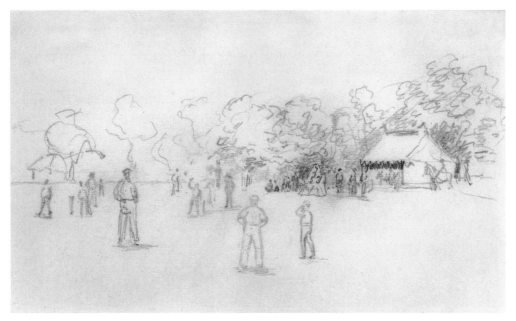

21. A Cricket Match. *By Thomas Churchyard. Pencil Sketch. 5 x 8½ in.* *Private Collection.*

greasy pole, tilting in punts, water-sports, even a duck hunt. All very jolly and amusing, but we could think of little else than poor Charles. I had my twelfth birthday and soon afterwards Charles died. Even though he was so small, we all felt that we had known him, we all had an idea of how he would have grown.

We grieved.

'It would have been better if he had lived and I had never been born,' Charley whined, pulling me back to the present once again.

I always try to ignore Charley's bad manners and respond as though he were polite. Poor Charley's life's box would contain few treasures; his heart is so sour and he insists that he has never been cared for by anyone. But it is not true; he was our golden boy. When he was born we all doted on him and he seemed like a blessing from

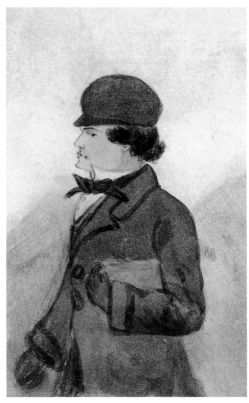

22. Portrait of a young man in a hat. *By Kate Churchyard. Watercolour. 3¼ x 2½ in. Private Collection.*

heaven. He was adored by the whole family, then somewhere along the way he was lost and he has never managed to find any real happiness. He lives with me now because I cannot leave him to the Fates, but he makes it very hard to care about him. There is no doubt that he has been very wicked to his other sisters, tormenting them whenever he had the chance. He has also a special knack of being disagreeable to the townsfolk at every opportunity, and they tend to return the compliment in kind. But here at home I find him to be just a naughty boy, a fifty-six-year-old boy, petulant and moody certainly, but mostly compliant. He swears that he has never had any luck, yet he has had his chances. The thing about luck is that you have to notice it and then you can make the most of it.

Now that April is here at last and the days are lengthening, a renewed energy flows once more through my thin veins and I feel a new optimism about the coming year. Even Charley's complaints can't dampen my spirits. I live very comfortably in my little red-brick, terraced cottage in New Street. I am happy to live here, although it is far in society's terms, if not in distance, from the houses in which I grew up. For so many years I had no money and had to rely on the kindness of others and on hard work to be able to live at all, so although my home is small, it is a haven because it is my independence. And, oddly, it is just because I am my own mistress now that I share my home with Charley, because it is up to me alone. When I had to accept help from others I also had to accept their opinions on how I lived.

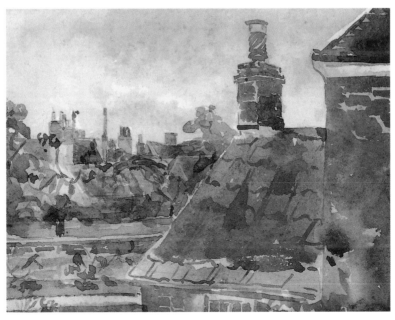

23. View of the Rooftops from Marsden House. *By Thomas Churchyard. Watercolour.*
3¼ x 4¼ in *Private Collection.*

I have two compact bedrooms, either side of my narrow staircase, steep as a ladder. Charley sleeps at the front in the larger room. This is my choice since I prefer the view at the back, looking out over the scullery roof to my little garden and over the roofs beyond. The back of the cottage is quiet, tranquil and beautiful. The road at the front, which is right against my wall, can be horribly noisy with the wagons and the animals passing down from Market Hill, men calling out loudly to each other when they leave the public houses — the old Steelyard, the Cock and Pie, or the Bull Hotel with its bustling livery stables. Loudest of all is the traffic to and from Garnham's livery: hired out for funerals, weddings, excursions and all kinds of jaunts. I think he has every sort of carriage, landau, waggonette, dog-cart and brake to cater for any eventuality, and they all make their own distinct noise, coming and going past my front door throughout the whole day.

I like to be in the heart of the town, although I realise that some folk would not agree. From here I can shop, walk out to the countryside beyond the town when I need solitude, and send messages up to the library for Harriet or Bessie via my errand boy, little Ernie. He is a sweet little lad and always willing to carry things for me. It would be no use asking Charley: even if he consented, he would cause trouble before the chore was done.

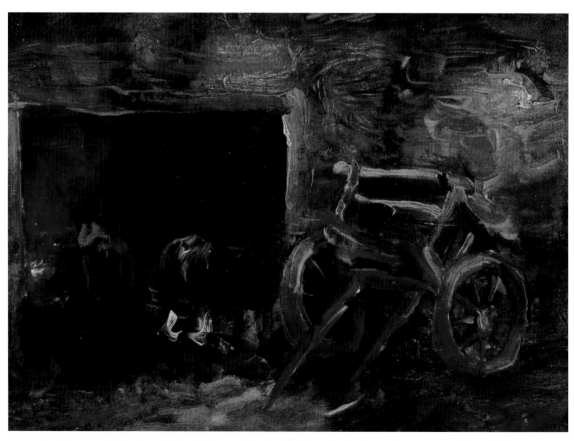

24. Horses and Cart in a Stable. *By Thomas Churchyard. Oil on Panel. 4½ x 6 in.* *Private Collection.*

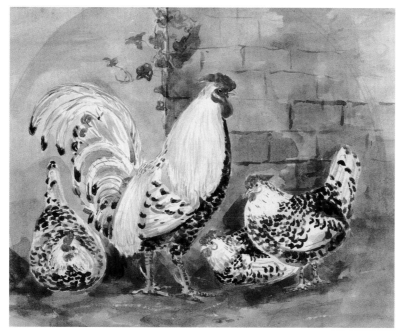

25. Chickens by a Wall. *By A Daughter. Watercolour. 6 x 7½ in.* *Private Collection.*

'What are you planning to do today?' I asked Charley, ever hopeful that he might be doing something productive.

'Why?'

'No reason, I just wondered. It's such a lovely day I thought that I might go for a walk.'

'Well I'm not comin' with you, if that's what you mean.'

'Actually nothing was further from my mind. I should think that nothing could be more unpleasant for either of us. No, I was wondering if you might be going out to do some sketching as it is so fine. I see that your whisky bottle is nearly empty and I think that you fill it with the proceeds from picture sales these days, don't you?'

'What else can I sell? I have nothing, I own nothing.'

'Only because you have already sold all you did own.'

'And I don't suppose that I'll get any of Anna's paintings either, will I? It's not fair, why are the pictures always divided up among you old women and I get left out?'

'Whenever you had any of Papa's pictures you sold them, so no one has trusted you since. They mean so much to us, how could we give them to you only to be swapped for a few shillings or a bottle of whisky.'

'Don't sound so smug; you've sold some of Father's paintings, I know you have.'

'I have, I admit it. But I have only sold them to people who I knew would value them and keep them as safely as I have always done. There are many people who still remember Papa with affection and value his talent.'

'Humph!'

26. Landscape with a Haystack. *By Thomas Churchyard. Pencil Sketch. 2½ x 5 in.* *Private Collection.*

'Charley, please don't be unpleasant about Papa. He wasn't perfect but he was a brilliant artist and a brilliant solicitor, too, and that is twice as brilliant as many people!'

And with that Charley flung back his chair and stormed out, slamming the front door. I should not have fallen into the trap, but it is hard to avoid. What a waste of a life!

Now I think that I really must go for that walk, if only to throw off the bad feelings that will cling to my mind if left to its own devices. It is so easy to step out of the house and seek the beautiful views and vistas that open up all around Woodbridge. The ever-changing weather gives each day a new livery, new sights to see and new images to treasure. When it is warm enough to sit for a while, it is good to take a sketch book and make a new picture, or I might carry home some wild flowers to paint at my scrubbed pine table. Today I just walk up the hill to the market, to listen to the cries of the men and women trying to sell their animals. The sounds are so reassuring: the lowing of the cattle, the shrieks of the chickens in their cages, the vendors calling out the benefits of their produce — butter or pork from the farms, hides for tanning, rabbits on poles, baskets of vegetables. Vivid, too, are the smells that are carried along the streets on fresh salty air, so special to this beloved place. The warm aroma of the horse dung warns me to tread carefully as I cross the hill, lifting my skirts to avoid the pitfalls along the way. It is not a long walk, but a friendly meander, chatting here and there to friends and acquaintances, all with enough time to have a word or a wave. It makes me feel as though I exist. Sometimes spending too long in Charley's company, particularly when he is sulking, can leave me wondering if I am here at all.

Safely home I am pleased to find that Charley is still out. It is quite likely that he will be gone all evening now, so peace reigns. He rarely has tea with me; too genteel a meal for

him to consider, and I will not change how I live for him. I enjoy the luxury of laying out my table, spreading the cloth and arranging my plates with bread and butter, with jams or maybe some salad and whatever cakes I have in the tins. My little larder is never bare; I enjoy the treats I bake up. I learned to cook with my Nanna, but I also like to get ideas from the first cookery book I ever owned. Papa gave it to me after I came home from school when I was eighteen or nineteen; it is called *Modern Cookery for Private Families* by Eliza Acton. It had just been published back then in 1845 and was considered to be a very good work. I studied the book from cover to cover and back again. We had a cook, then, Mrs Watson, during an affluent phase in our life, and she always made me feel that I knew nothing about household management. I do not think that she meant to be like that, but she was so experienced that she could guess and anticipate what was required before I had even thought of it. Everything I knew had come from Nanna, and her ways were country ways. So I studied the book to get ideas and to learn some new techniques, then I took it to the kitchen to show Cook. She flew into a great excitement, clapping her hands in amazement. It transpired that she had been at school with Eliza Acton in Ipswich and had known her well. I later learned from Mr Barton that Miss Acton was also a keen poet and had published a volume of poetry some years earlier; he had been one of the subscribers to the volume.

'It's such a small world, just fancy!' Cook repeated over and over again. 'What a coincidence it is. I never realised that she was interested in cooking.'

Shaking her head, tutting and clucking like a hen, she turned the pages and read the words.

'Well bless me, yes, yes … mmm, well I never did! … Mmmm.'

This continued for a long time before she realised that I was still there watching, then we laughed together before deciding to try some of the receipts as soon as we could. After that Mrs Watson took time to teach me some of her knowledge and that has stood me in good stead over the years, fitting me for the work I had to find after Mamma and Papa died, but also for making my sparse resources stretch.

Just as my kettle began to boil and I moved it from the flames to the side of the range, I heard a gentle tapping on the kitchen door. I knew that it would be young Ernie. He often seemed to arrive at the door at tea time, partly because he knew that there was less chance of encountering Charley, and partly as there was every chance of a piece of cake.

'Hello, Ernie,' I said as I opened the door. 'Don't look so surprised, I knew that it was your knock. What can I do for you today?' I did not want to make it too easy for him, but I enjoyed his company.

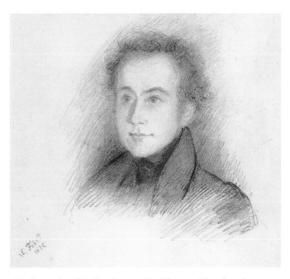

27. Portrait of A. Redgrave. *By Thomas Churchyard. Pencil. 8¼ x 7 in.* *Private Collection.*

28. Thomas Churchyard at Well Street. *By Unknown Artist. Watercolour. 12¾ x 10½ in.*
(Courtesy of Ipswich Borough Council Museum and Galleries.)

29. Harriet Churchyard at Well Street. *By Unknown Artist. Watercolour. 12¼ x 10½ in.*
(Courtesy of Ipswich Borough Council Museum and Galleries.)

'I was wondering if you had any errands for me today, Miss?' he asked whispering into his muffler.

There was quite a tradition here for the younger members of large families to find themselves a tame benefactor. They would read to them — as did Fitz's boys whom he employed when his eyesight began to fail him in later years — carry messages or collect goods from the shops; they would do any small jobs, awkward chores or things that required younger muscles to manage in exchange for small payments or maybe just plum cake or biscuits. It helped everyone. Their mothers were always stretched to the limit trying to feed their many offspring, and approved as long as the benefactor was a proper gentleman or woman. Ernie's older brothers had run errands for me in the past, and I think that I was passed on to him as a right when he became ten.

'No, nothing to do today, I'm afraid,' I answered and nearly laughed at his great look of disappointment. 'Unless you would like to come in and help me to eat some seed cake, which I fear will get stale if it isn't eaten soon.'

His eyes lit up and he was over the threshold before you could say 'Jack Robinson'. As usual he stood patiently until he was invited to sit, and then he sat on his hands to stop

30. The Deben at Methersgate Reach. *By Thomas Churchyard. Watercolour. 3¼ x 4¼ in.* *Private Collection.*

31. Freston Tower on the Orwell. *By Thomas Churchyard. Watercolour. 2¼ x 5 in.* *Private Collection.*

them from grabbing for the food, which was tantalisingly near his nose.

'Would you like a cup of tea?' I asked, sure that he would. He nodded enthusiastically and took the proffered cup very carefully, being sure not to splash the white cloth. He had clearly been warned to mind his manners when he was out, and he was doing very well. I offered him a slice of bread and butter but his eyes could not tear themselves away from the large caraway seed cake, whose aroma filled the room. So I put him out of his misery, cut him a good big slice and told him that he may start. After he had eaten that slice and commenced on another, washing it down all the while with the piping hot tea, he found his voice at last.

'That's a beautiful big box you have there, Miss,' he tried, seeing if that was acceptable conversation.

'It is indeed,' I replied, 'I was looking through it earlier trying to see what memories came back to me from the treasures inside.'

'Treasures?' His eyes grew big, clearly thinking of ducats and doubloons.

'Just little keepsakes which I have collected over the years. I keep them safe in the box, so that I don't use up the memories too much.'

'Can you use up memories?' he asked, in awe of the very idea.

'I think that you can if you are not careful. If you think too often about something, after a while you begin to wonder if it was really true or if you have begun to make up new pieces of memory as the years have passed. Or if you think of something too often it becomes faded and rubbed away with use and less important. That's a shame if it is a special memory.'

'What sort of memories are in the box, Miss?'

'Well, each of the things reminds me of who gave it to me, maybe where we were, sometimes of some special event. Let me see if I can show you what I mean. Wipe your

fingers and then open the lid of the box. Select something from the box and I will tell you about it.'

So Ernie climbed down from the table and very deliberately went to the sink to rinse his hands, wiping them carefully on the roller towel hanging behind the door. Then he stood by the box and lifted the lid very slowly and carefully. Hardly tall enough to see in, he dipped in his hand and carefully lifted the upper-most item.

'Oh! Well, Ernie, just to prove me quite wrong you have found something which holds no memories at all.'

He looked devastated, almost guilty that he had in some way failed a test.

'No, it's not your fault, my dear. It does have a story attached to it, but I cannot remember it personally. As you see it is a pretty little watercolour painting of Well Street, painted in the year that I was born. It was painted by an artist called George Rowe, who was a great friend of my parents. Well Street was the road that we now call Seckford Street, which leads towards the Fen Meadow. We lived there when my parents were young. They already had my brother Tom and then I was born. We only lived there for a few years, and my Mamma gave me this little painting to remember it by. I used to ask to see it when I was a little girl, afraid that I would forget, and in a way I have because I can't remember when we lived there; I was too young. But I remember stories that Mamma used to tell me and I dream that I can remember those gentle days, before poor Papa lost hope that he could make his living as an artist.

'Somewhere else there is a painting of the drawing-room in that house, with Papa's chair and his desk. If I close my eyes I feel that I am there, but of course it must be made up.'

'What can you feel if you close your eyes, Miss?'

'I feel as if I can recall my Papa with all of my senses. He would be sitting comfortably in his enormous wing chair, puffing great clouds of cigar smoke into the sunbeams that would be streaming in through the window, joining him to the very day itself. His right leg bobbed gently as it lay across his left, a brilliant scarlet carpet slipper waving gently as his foot dipped and rose. Then there would be a swish of his silken jacket as he swapped legs and the left foot began its gentle waggling. I would sit in a trance, sharing the calm warmth of his meditation, just happy to wait for him to speak to me. Did this happen once? Was it a daily routine? I really can't tell you.

'Then my patience would be rewarded. The cigar would go dull, to be lain aside for the while, and a smile would be my permission to climb onto his lap and snuggle down by his side. There I would smell the mingling aromas of the smoke, a musky lotion on Papa's hair and the starch on his collar. These scents haunt me still.'

'What happened then, Miss? When you were a little girl?'

'Sometimes Papa would tell me a story, or maybe he would tell me what he had been doing that day.'

'What sort of story? A fairy story?' Ernie was fascinated.

'There was one which he would tell me often. At the time I believed that it was true; now I realise that it was a mixture of truth and make-believe.'

'What was the story? Tell me if you please.'

'Well, if you want to hear it I think that we had better clear the table first and then sit in the comfortable chairs, don't you?'

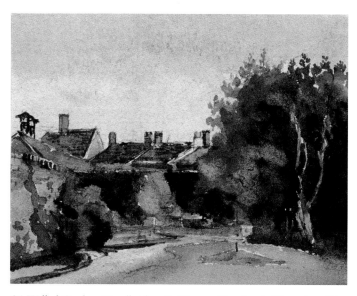

36. Walled Garden, Woodbridge. *By Thomas Churchyard. Watercolour. 3¼ x 4¼ in. (Photograph courtesy of David Messum Fine Art Ltd) Private Collection.*

Ten minutes later, with everything tidied up and looking ship-shape we made ourselves comfortable. Little Ernie had lost his look of fear and was eager for a story: He seemed as hungry for words as he had been for cake.

As a child, I liked to wiggle and snuggle to get myself comfortable next to my father, and then I would ask him to tell me the story of my name; he would tell me a tale of another Ellen and he said that I was named after her.

'I named you for a fair maiden who was imprisoned long ago in a tall tower,' he would laugh. The story which followed was always slightly different but I could not remember how, because I would be absorbed by his voice, the images and my dreams.

> 'Far away, on another river, like our own but wider and straighter and busier with ships of all sizes and nations, there lived a man. He was very wealthy and he owned many of the ships which plied their trade on that river, sailing past his house and out to sea to trade in the goods which added to his fortune. He thought that he had everything in the world that he could ever want. Then one day his wife was brought to bed with a child. The child was a perfect little girl. From that day he had eyes for no one except his beautiful daughter. As she grew taller and even more beautiful he began to be afraid that she might leave him, that some handsome young man might steal her heart away from him.'

'What did he do Papa?' I knew the answer but was impatient for the words.

'He devised a plan to keep her safe and hidden from the world. On his lands, on a green bank which gently sloped down to the wide river, he commanded to be built a strong tower of red bricks. It was very tall: it had a big room on every floor, connected by a tiny, steep, winding staircase. There were six rooms and each was furnished with the most glorious tapestries, furniture and books. But the only people to see these treasures were his daughter and himself. He told everyone that it was just a folly, built to decorate his gardens and to act as a guide to the ships on the river. So in the tower she lived and pursued her studies. She was very clever as well as beautiful: she was talented at painting and music, she stitched the finest tapestries and she knew the contents of many hundreds of books. From the top of the tower, where she was only allowed at night, in her loneliness she made the stars in the heavens her familiar friends.'

'And what was her name?' This was the point of the whole story.
'Ellen de Freston was her name and I named you for her, because you are my greatest treasure.'
'But you will not keep me in a tower? I shouldn't like that.'
'Ha! No, my lovely, I will trust you to want to stay with me freely.'
Then he would hug me until I squeaked with delight.

Ernie was lost in his own imagination and I did not want to break the spell too soon, so I chatted on. 'We once had many sketches and paintings of that tower, some painted by Papa and some by others. I always felt that they belonged to me in some way, because of our story. Papa said that all of the great artists who ever saw Freston Tower would stop to paint a picture of it because it was so romantic. He believed that the great Thomas Gainsborough himself had walked out along the shore there in the days when he lived and worked in Ipswich. George Frost had many times wandered that way and may even have sat with Mr John Constable when he was a young man and sketched my tower. It has been engraved and printed by every draughtsman in the county.'

For a few moments we both fell silent, lost in our own dreams. Ernie watched the sparks fly in the bright embers of the fire and sighed again. Finally I pushed back my chair to end the reverie. It was time to add some wood to the fire and close the curtains; evening was stealing on.

'Now, my dear, I think that you had better run along home. Your poor mother will be worried about where you are.' He looked so crestfallen, as though I had indeed broken the spell, and it made me sorry for him. I felt so grateful that he was interested in my treasures; no one else seemed to be. It was good to show them to someone else before the White Mice put them in their attic or, worse still, before Charley sold them for beer money.

'How about coming back tomorrow for more cake and another story from the box?' His eyes lit up, and with a cheerful goodbye he slipped out of the scullery door and home. I placed the picture back in the box and put it safely away in my chiffonier, out of reach of avaricious fingers. Then I sat in the growing dusk and thought of George Rowe, who had lived nearby in Well Street, with his parents. He was great fun. Papa loved people who

32. The Woods at Nacton. *By George Frost. Pencil. 12½ x 11¼ in.* *Private Collection.*

33. Lane Scene. *By Henry Bright. Pencil. 3½ x 5½ in.* *Private Collection.*

could laugh, and he had the added attraction of being a fellow artist, a skilled one at that. He had had success as a boy, making humorous drawings of local characters. He was, however, a serious artist too and had exhibited paintings in London. He lived in London and made his living there but he never made his fortune. In his old age he was very ill and poor and had to be helped by his friends; I know for sure that Fitz left money for his care, although I expect poor Mr Rowe never knew about that.

We could not leave the house without Papa finding someone to chat to about painting; it seemed that Woodbridge was awash with artists or patrons of the arts. The young man at the chemist's who always spoke with Papa suddenly disappeared off to Norwich to study painting there. His name was Henry Bright and he became a very successful teacher of art, instructing the nobility and daughters of the gentry. Even the Queen bought his work. Papa was very relieved when he was successful since he had advised him to follow his dream. Later John Moore, a young plumber and sign-writer, did the same thing, moving to Ipswich and making a good living painting for the new middle-class patrons there.

Lighting the oil lamp and turning the wick down to a gentle glow, I allowed myself the luxury of thinking about those far-off days. I could not believe that the memories I had were truly mine – much was hearsay and more was imagination – but it seemed real to me. When we had lived in Well Street, Papa had been busy all the time, working hard at his office, trying to establish himself in his law career. He travelled away to the sessions that were held around the county whenever necessary, and he built his reputation. When he was not working he was out hunting with his friend Ben Moulton or walking the countryside sketching and painting. He returned home with a bag full of sketches and often with a friend or acquaintance, deep in conversation, to share a smoke or a glass of wine.

34. Harvest Fields on the banks of the River Orwell. *By John Moore. Oil. 12¼ x 14¼ in. Private Collection.*

Mamma was bound to the house caring for Emma and the baby, Laura, while Tom and I tried to help as much as we could, in our own small way. She was expecting yet another baby and was usually very tired. So it was always as if a great cloud had lifted when Papa came in. Suddenly it was not a house full of babies; it was transformed by his laughter and his bustle. I loved to sit and listen to him talking with his friends; it was talk of the outside world, definitely not about babies.

Ben Moulton was the new boy in the office of Mr Cana the auctioneer. Dear Ben remained Papa's friend always and also became one of my greatest friends, when I needed

35. Procession at the Gates of Seckford Hall. *By Revd Perry Nursey. Oil. 13 x 17 in.* *Private Collection.*

help more than anything. He and Papa worked together sometimes, but mostly they liked to go hunting or to play cards if the weather kept them indoors. Ben was a newcomer to the town, but with Thomas as his friend he was soon accepted. He was almost one of the family and his silly gun dogs were more used to our house than his own. While Papa traded and swapped paintings, Ben Moulton seemed to do the same with his dogs. He was never quite happy with the talents of the one he had, always looking for something better in the next pup. He went to the races at Tannington or Ipswich and also went to half-price performances at the theatre, skating on the Abbey pond, fishing, ten-pin bowling; he was a flirt with the ladies in those long-ago days, attending every ball and soirée. Dear, dear Ben, the main source of my valued independence; he and Fitz helped me more than anyone else in my hour of need. When he left me an income for life it was the key to my freedom.

I shook my head to cast away the thought of need; this daydream was dedicated to the days of my innocence and youth, the days when Papa had hope and ambition. He knew that he needed to work to support his growing family but his love of art was an addiction. His mind was entirely consumed by painting and painters. Old Perry Nursey who lived in a nearby village used to call at the house; he was always very kind to us children, I recall. He was a friend of the great John Constable, one of Papa's heroes. Papa had become excited when Mr Nursey told him that Mr Constable was coming to stay with him and that they would paint together. He begged the honour of being introduced. He had purchased some of Mr Constable's paintings when he could afford them, and had copied them to learn from his technique. The prospect of speaking to the Master himself would have been a dream come true.

Now I feel quite sure that Mr Constable did in fact call at our house himself. However, this could be one of my wishful thinking memories. It could be that it was so anticipated and dreamed of that I made it happen in my mind. Except I am quite sure that I can remember the kerfuffle it caused and the tizzy that it induced in my Mamma. Mr Nursey had praised Papa's work and Mr Constable had been keen to meet a disciple from his own beloved Suffolk. He too had young children, although he was much older than my father. I'm sure that I was told that he made much of me, that I reminded him of his daughter, Emily, who was just a little older than me. He had been in Woodbridge trying to buy back a painting when the owner died; he did not want to risk it being undersold in a small town auction.

In those early years at Well Street we lived a life of happy bustle, buried below the growing heaps of Papa's sketches and paintings, under the loving eyes of our parents. I loved that house, it was perfect and set the standards for my life. I have never desired anything larger or newer. Whenever I see a red-brick terrace of elegant market-town houses with solid, gaily painted front doors and white-painted window frames, I feel at home. Whenever I see a broad stripe wallpaper in a room filled with watercolours and oil paintings it is perfection to me. If I can gaze out across a little garden to the tree-tops wheeling with rooks, or hear the sometimes sombre, sometimes gay sound of church bells as they peal out their messages across the valley, I am content. At Well Street Tom and I were allies and playmates; there Emma grew to join our games; Laura arrived followed by baby Anna, and we were close and comfortable.

CHAPTER 3
IF TODAY BE SWEET

After my walk the next day I began to lay the table for tea, putting out the rest of yesterday's seed cake and the new offerings baked that morning – some Suffolk rusks and some fruit cake, as well as the bread and butter, and jam and lemon curd. I hoped that Ernie would come as promised, because during my walk I had thought of some stories that would interest a young lad. I got out the Chinese box and carefully moved some of the contents, so that those connected to the tales I wanted to tell were on the top. Then I put the kettle on the fire and waited for it to boil.

The quiet little tap sounded on the back door at about the same hour as yesterday, and I called for Ernie to come inside. He came in shyly as before and stood waiting for me to turn; as I did so I could see that he had been scrubbed and he shone with good health.

38. Pathway with Cottage and Trees. *By Thomas Churchyard. Oil on Panel. 8¼ x 13 in.* *Private Collection.*

Opposite: 37. Maida Vale Gardens, Ipswich Road, Woodbridge. *By Thomas Churchyard. Oil on Panel. 4¾ x 6¼ in.*
Private Collection.

Looking him up and down I could also see that he was wearing his Sunday best clothes. Remembering how easily bruised are children's souls I pretended that I had not noticed anything was different. He was clearly not as comfortable as yesterday, but this was the required penance to be paid for an official invitation to tea.

'Please Miss, Mum said to be sure to ask if there is anything I can do for you.'

'Well thank you, Ernie. There is nothing today, but I will be sure to ask you when I have an errand to run.'

'Thank you, Miss.' He sounded relieved; it was an answer that he could relay to his mother to put her mind at rest.

People do not like charity. They have a very noble pride in their family; his mother would be pleased for him to have a genteel friend and for him to have some extra food, but not at the cost of their pride. So it had to be exchanged for something, and clearly errands were the currency in question. I would have to think of something to need.

'Come to the table and have something to eat, and then we will sit by the fire and have a story.'

Today he accepted bread and butter first, then a rusk with butter and a piece of cheese on top, and finally a slice of the seed cake, all washed down with a big cup of tea. He regarded the new fruit cake as though it had appeared by magic and was therefore too risky to try. We cleared away, washed up and settled ourselves without saying too much at all, and then I invited him to look into the box and find a treasure for a new story. As I hoped, he did not dare to rummage too much, and produced a neat little pin cushion embroidered with the motto 'Waste not, Want not'.

'That pin cushion belonged to my Nanna. She made it herself from scraps of material and that was the motto she lived by all her life. Do you have a Nanna?'

'No, all of my grandparents are dead. They all died before I was born.'

'Well, it was nice to have a Nanna. I went to live with her for a while when I was only five or six, and she taught me a lot of things. I think that she knew a lot more about handicrafts and about the countryside than my own dear Mamma. And also my Mamma did not have much time because we had so many babies to look after. Papa had gone to work in London for a while and I missed him a lot.'

'Mum says that I'm her baby. I am the youngest of us all.'

I heard the hesitation in his voice. I recognised the old dilemma of the child: wanting to be petted and loved, yet wanting to be grown-up. I remembered the feeling all too well. Leaning closer as if sharing a secret I whispered in his ear.

'You may be the youngest but you are a strong young man. Soon you will be taller than me!'

He beamed at the compliment, and drew himself up in his chair, confidently and proudly.

'My Nanna taught me to knit.' I glanced at him, not sure if he would be interested in knitting, but he was "all ears", as they say. 'We unravelled an old scarf and washed the skein to straighten it, and then with big wooden knitting needles I learned the art of creation: a scarf for Papa, when he came home from London. I think Nanna understood that I needed to work towards that day. Nanna also taught me to sew. While she sat and turned the sides-to-the-middle on an old bed sheet to ensure a few more years of wear, I sat beside her and stitched a hem on a piece of cotton to make a handkerchief for Papa. Nanna taught me to make a rag rug, but my fingers were too weak to hook the ribbons

of old cloth through the sacking. She had to do that, while I cut up the pieces of old garments from her scrap bag. Together our design grew, together we worked and she whispered in my ear the secrets of her life, of household economy and the way to happiness. I'm reminded of all that by the little pin cushion.'

'My Mum knits in the evenings after tea. She makes us lots of things. We have a rag rug too; I'll ask her if she made it.'

'Nanna wanted to teach me how to be economical with the things around me. She would say things like: "That needs some elbow grease, my girl," or "make-do-and-mend is what I say will make you rich." She did not ever forget the days in her youth when she had less. She and Grandfather had worked hard and done well. She was comfortable and did not need to scrimp but it gave her pleasure. Waste was a sin and idleness the worst thing she could think of anyone. "You keep at it, my little mawther and you'll pass muster."'

39. Portrait of a Boy. "School opens tomorrow". *By Ellen Churchyard. Watercolour. 5¼ x 4½ in.*
Private Collection.

I sensed that she did not always approve of Mamma's way of doing things. Mamma was happy to leave everything to her maid or the nurse while she played with the baby; she was not a housewife.

Now, I was remembering earlier about when we went to the new Suffolk Show. It was the second year that it had ever been held. There was a prize for the biggest family brought up without recourse to charity. It was won by a Hollesley man who had eleven children. 'The way your Mamma and Papa are going they'll enter for that prize in a few years,' Nanna had muttered, but I did not tell Ernie that!

'There was a stall selling confectionery. We all had some frumenty, freshly made by the stall-holder that morning, thick and tasty with cinnamon. But I didn't like the raisins — I thought that they were big old bloated flies — I tried to ignore them, but just the thought made me feel sick. My brother, Tom, laughed and buzzed in my ear, until I could eat no more. Nanna laughed, too, but kindly she bought me a gobstopper to take the taste away. Tom had some barley sugar and Emma, my sister, had sherbet. We carried on around the Show but my gobstopper fell to the ground and was covered in dirt. Of course I began to cry but Nanna rinsed it in a water trough and popped it back in my mouth. "You hev to eat a peck o' dirt afore you die," she said.

'There were produce and flower prizes to be awarded and all the animals you could imagine, handsomely groomed and braided, parading around the ring. There were Punch and Judy puppets violently arguing and fighting, and a fiddler playing to a crowd who

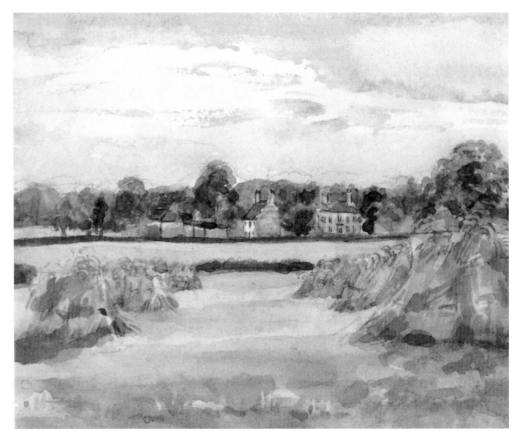

40. Harvest Fields towards Wilford Lodge, Melton. *By Thomas Churchyard. Watercolour. 3¼ x 4¼ in.*
Private Collection.

danced and jigged with glee. Tom tried to win a coconut at the Knock 'em-Downs but never managed to budge the nuts, although he hit them every time. We were asleep on our feet when we returned home, heads buzzing with the sights and sounds of the day.

'Sometimes I got down in the dumps and complained to Nanna that Papa had gone away. She always gave me short shrift then. It made her riled if we felt sorry for ourselves.

"Dew you look at the chil'en in the parish who have t' go out int' the fields pickin' stones t'earn money, they may have sommat to moan about! Or the poor boys who hev't wander alone all day in the fields scarin' the crows!"

"I would like to do that, it would be fun," replied my brother Tom defiantly.

"You might like it for a day or tew, but you wouldn't when it's bitter and th'wind cuts you in half, or th' sun nearly barrns you t' a crisp."

'Then she would soften again and find us jobs to do, so that we did not get too miserable. Off we might set for a hedgerow harvest, Tom and I carrying the baskets and Emma following behind carrying Nanna's walking stick, which we were to use to hook down the branches of the brambles. One day we collected blackberries and crab apples to

make into jam. The next day when the jam had cooled and set, we cooked rusks and ate the first of the jam for our fourses; our own work tasted like nectar. "But remember never eat a blackberry arter Mich'lmus day for th' divil spits on all on 'em," she would say.

'Other days we went out to find mushrooms, sloes, walnuts and chestnuts, the foraging always being followed by a lesson in preparing and preserving. When we had enough left over, we carried jars or bottles to show Mamma. She was very proud of us but didn't think that it was a good idea to feed our offerings to the little ones. Tom taught me to whistle as we walked the lanes but Nanna disliked this. She looked severe and admonished me, "A whistlin' woman and a crowin' hen, are of little use to God nor men!"

'Nanna gave me an iron hoop which had been hanging in the back'us behind a brace of rabbits, and showed me how to bowl it along the street. I wasn't very good; it was nearly as tall as me. She also had a skipping-rope and we took turns in turning or skipping to her songs, one end tied to the door latch. We sang:

> "Down in the valley, where the green grass grows;
> There lives 'Ellen', she grows like a rose;
> She grows, she grows, she grows so sweet;
> Here comes her sweetheart down the street..."

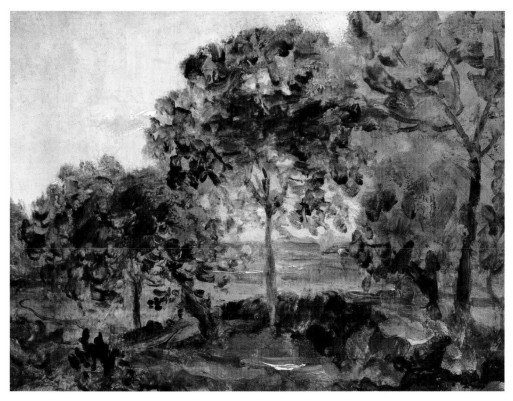

41. Trees, possibly Sutton Hoo. *By Thomas Churchyard. Oil on Panel. 5 x 8 in.* *Private Collection.*

42. Three Men in a Clay Pit. *By Thomas Churchyard.*
Pencil. 5¼ x 6½ in. *Private Collection.*

And little Emma would come into the rope behind me, I would pop out of the other side and the next verse began. Nanna couldn't join in with the turning because she'd got "screws" in her joints that stopped her reaching up too far, but she laughed, "We must look a rum lot, t'gither."

'Is your name Ellen, Miss?' Ernie asked carefully, checking his facts.

'Yes it is, my dear.'

'That's my Mum's name too!' he exclaimed, so pleased to find a connection between us.

'And a jolly good name it is too,' I laughed. 'Once Nanna gave Tom a copy of *The Farmer's Boy* by Robert Bloomfield, which she read aloud to us sitting by the range, on wet days. It had written inside the cover "To my dearest wife Anne, From Jonathan". My brother Tom treasured that book and knew it by heart; he wanted to be that farmer's boy one day, so little quotes would turn up at the strangest times. It was said that our town, Woodbridge, exported the very best butter in England but the worst cheese. When we were having trouble cutting some slices from a hard piece of local cheese one day, Nanna abruptly held up the knife and proclaimed,

"It mocks the weak efforts of the bending blade, Or, in the hog trough rests in perfect spite, Too big to swallow, and too hard to bite!"

'Nanna often sang little lullabies and funny ditties to herself as she went through the day. Slowly they grew in my mind too, and I would hum muddled words to myself and make her laugh. She taught us to say our prayers at night, kneeling in the cold beside the big, creaky bed which we shared.

"Bless my Mamma and my Papa, both so dear to me, and help me through the coming day a loving child to be. Amen," we chanted. Then we hopped into bed as fast as we could, to warm our toes and fingers. Our family were not great church-goers but Nanna believed that children should be taught to be thankful and to think of others.

'By the time this long visit had come to an end, Tom, Emma and I were soaked in enough folklore and sayings, tales and warnings to last us to the end of our lives. In later years they would pop to the surface and surprise us all, sometimes getting mixed up together with hilarious results.'

'I always say my prayers every night,' said Ernie, 'Mum says that I must give thanks for my health and all the good things we have.'

'And she's quite right too, Ernie, health is a great blessing indeed. We had been very

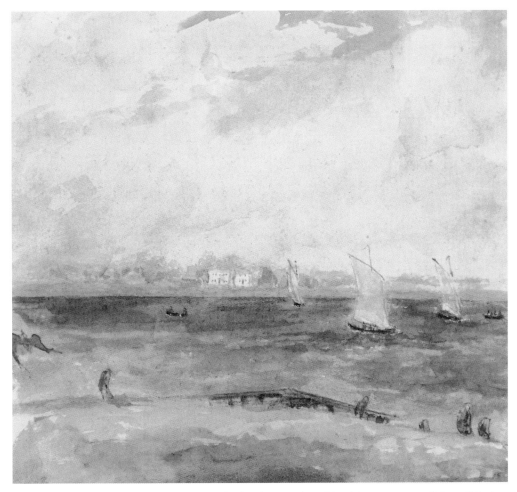

43. Sailing Boats on the Deben. *By Harriet Churchyard. Watercolour. 5½ x 6 in.* *Private Collection.*

lucky in health up until that time. After Papa came home our new sister was born and she was called Elizabeth, or later Bessie. I think that everyone had hoped for a boy, so that Tom wasn't alone, but another girl it was. And poor Bessie wasn't as strong as we had all been, at least not at first. She didn't cry or grizzle but just lay quietly in her crib; we were very worried.'

'She was all right in the end?'

'Yes she was, and tomorrow morning, if you please, I would like you to take her a note from me.'

His eyes grew big and he asked, 'How will I find her?'

'Well, she lives at the library with my other sister, Harriet.'

He clearly could not imagine that we poor old ladies had ever been young children going visiting with our Nanna.

44. Mother and Child. *By Thomas Churchyard. Pencil. 6 x 3¾ in.* *Private Collection.*

45. Crossroads at Melton near The Beeches. *By Thomas Churchyard. Watercolour. 4¼ x 3¼ in.* *Private Collection.*

'Can you call round on your way to school and take the note for me?'

'Certainly Miss.'

Then he got up and thanked me for his tea and began to take his leave.

'You are always welcome to come for a piece of cake and a chat. And you can tell your Mum that I'm happy to see you as you are, you do not need to dress up.'

Looking very relieved he set off home, turning to wave as he disappeared from view.

Now I needed to think of something to write to Bessie so that there would be a note waiting to go first thing. I do not know why I said that I needed one taken; it just seemed that he needed to do something for me in return.

The following morning Charley was up bright and breezy and off almost before I had eaten my breakfast. This was a relief since little Ernie looked quite scared when he knocked at the door. Charley was rather like a large, noisy dog and most people were afraid to set him off barking. I gave Ernie the letter and he trotted off to deliver it and then on to school, promising to call in again later to see if there was anything else needed.

Doing my chores brought Nanna back to mind as always and funnily enough Mamma, too, mainly because she was not as good at housekeeping as she was at looking after babies. I had lived at Nanna's, hating that Papa had gone away and broken up our family home, then out of the blue it seemed Papa was back with us and we were to go to live up the street, all together again. Perversely, I found that I did not want to lose Nanna and cried for her. We packed up our clothes and carefully packed into another little parcel the scarf and handkerchief for Papa, then she walked me to the new house, 'The Beeches'. As we went along she promised that she would always be there when I needed her, and that now I was a big girl I could walk down to her house by myself and help her with her chores. Then quite quickly we were at the new house and together went to see where I was to sleep, sharing a bed with Emma and the room with Laura and Anna.

46. Wilford Bridge, Melton Road. *By Thomas Churchyard. Watercolour. 5 x 7 in.*
(*Courtesy of Ipswich Borough Council Museum and Galleries.*)

Mamma had taken the new home and Papa's return in the same easy manner with which she had accepted his plan to go to London in the first place. She settled happily enough into The Beeches, a red-brick terraced house on the corner of the turnpike road and Lawyer's Lane. Great beech trees grew in front of the houses, adding a great splendour to the row. We could watch every sort of traffic passing by the house. Stagecoaches piled high with luggage and people stopped further up the street to change teams at the Coach and Horses Inn, on their way to or from London. Carriers' carts that met there took people and parcels out to the isolated villages. Sometimes we saw the beautifully shiny carriages of the very wealthy pass, with arms emblazoned on the carriage doors. Many folk trundled past on old donkeys or saggy-backed horses. Elegant folk with thoroughbred horses trotted and cantered down the road; the doctor in his jaunty trap travelled at leisure, never in a hurry to reach his patient. The Coach and Horses hired out animals and vehicles and so was a hubbub of activity. Those who found themselves suddenly in charge of an unfamiliar animal or wagon often had just reached our crossroads by the time they lost control completely. We loved the brouhaha, but best of all we loved it when someone stopped outside to come and visit us.

We settled into this new life, Papa buried in his law books or working away at his paintings, and Mamma finding herself once more with child, smiling contentedly from her sofa. In fact Mamma did not seem to worry about much at all. She accepted her lot in a very stoical way; as long as she had someone to make decisions for her she happily pottered along through life with her babies. She accepted whatever life gave her in a saintly way, but like a true saint it was not hard for her because she had no doubts. She never thought ill of those around her and never expected anything for herself. She did not interfere with Papa's life, happy when he came in and happy when he wandered out again with his gun or his paints. As long as we were all polite and modest she was content to let us grow up as we wished. It was no problem to her if we were constantly out and about, following Papa to the river or across the fields.

'They'll be back when they're hungry,' she often said.

It was at this time I think that I first realised that Mamma was not very good at managing the household duties. It was the contrast with Nanna's many skills that showed up Mamma's lack. Nanna still used every scrap in her house, although she did not really need to. Now I was surprised to find that Mamma did not notice waste or think of planning for the future either. It was not meanness that made Nanna careful, but awareness. She saw those around us who had even less and she could not be wasteful because of them. Every week she would go out with her basket to visit a family who were in some sort of muddle; news of folk's troubles spread quickly enough. She might take a bowl of broth to someone who was poorly, to help them to build up their strength; maybe she would take a little rice pudding to an old widow, often younger than herself, who could not eat very well because of her lack of teeth. Or she might take a real treat of a bottle of porter for an expectant mother, who needed all the strength that she could get before the baby arrived. She and others in the community rallied around one of their own when there was a need. The poor had great pride and they hated to have to accept help from the authorities or from strangers. The shame of succumbing to indoor relief at the House of Industry would be almost worse than anything.

'I'd work the flesh off my bones afore I'd be parted and locked up loike a felon in the work hus,' they would say.

So they often lived in worse conditions in their homes than they might have had

47. Cloud Effect, Hackney, Melton. *By Thomas Churchyard. Watercolour. 2 x 7¾ in.*
(Courtesy of Ipswich Borough Council Museum and Galleries.)

48. Martlesham, Suffolk. *By George Rowe. Oil on Panel. 7 x 9½ in.*
(*Courtesy of Ipswich Borough Council Museum and Galleries.*)

'indoors'. Nanna understood and she helped with as much tact as she could, so that her aid could be accepted.

Nanna Churchyard, she who supported us and taught us when we felt abandoned and alone, a rock in the sands of life. She and Grandfather Churchyard, who had worked hard all their lives to improve their situation and to give their only son a strong start in the world. Grandfather had worked with his own father, and together they had built up an enormous trade herding livestock down the London road to market in the city. They had farmed first and then had been butchers in Melton; the droving seemed to grow out of their own trade and be a sensible new venture. Then 'Old Boney' had come to power in France and for the first fifteen years of my Papa's life there had been war or the threat of war with France. This menace, however, gave them another advantage, with the many troops stationed along our coast needing food, including good rich meat. Prices doubled and at last there was hope after many poor years in farming.

It must have been a great sadness to Nanna that she only had one child, yet that child was strong, clever and loving, a great blessing. She and her husband Jonathan had such plans for him and he did not disappoint them. They longed to see him with a secure profession so that his fortune was not tied to the weather and the Fates. In due course he went off to school in Dedham, the best school they could afford, then he was articled to solicitors in Halesworth, completing his training with a year in London. Shortly before Papa was due to begin practice in Woodbridge, his own grandfather died and left him a

small legacy, which he put to good use, setting himself up in his new office.

Just as Nanna saw him beginning to build up his legal reputation, her son suddenly informed her that he was expecting to be a father. He had been friends with Harriet Hailes for some time, but it was a surprise to Nanna that their friendship was so close. She had hoped that he would progress in his career for a few years at least before he settled down. However that was no longer possible, so arrangements were hastily made and Thomas married Harriet at St John the Evangelist in Westminster, from the home of her sister. Young Tom was born a few months later, but by now the newlyweds were set up in their own home in Well Street, Woodbridge. The two families had sorted out furniture and linen to get them set up and they seemed very happy.

Nanna knew better than to worry too much when things did not go as planned. She soon made the best of having a daughter-in-law and a grandson. She cautioned Harriet to be careful not to have another child until she was ready, but it was only just over a year later when I came on the scene. And I suppose the rest is history: ten babies, nine surviving, in sixteen years. Still, I know that Nanna was always pleased to help her son when she could and she certainly did that. Her husband, Grandfather Jonathan, died the same year that Young Tom was born, and she was left reasonably well off, certainly in a position to help out. Nanna was also one of my Godparents and she took her added role very seriously.

When Papa dropped his next surprise in her lap — that he had decided to go to London with George Rowe to try his hand at making a living as an artist — she quickly agreed to take his family under her wing. No question she doubted the wisdom of his move, but she loved him so she was happy to support him even when the tongues of the town wagged about his 'vanity', his 'irresponsibility', his 'recklessness'. Suddenly her house was fuller than it had ever been and there was hardly any room to move. Mamma settled into the parlour with her three youngest, the babies. Nanna took Young Tom and I under her wing. To avoid going totally mad she took us out and about as much as she could. My feeling was that she had little patience with Mamma's fertility and could not come to terms with Mamma's ability to let her children do as they pleased. The few months we lived with her were the most important of my life, and yet at the time I had felt they were the very worst. With hindsight I can appreciate that at her side I gained a vast amount of knowledge and many of the attitudes to life that would stay with me always.

Then, just as we were getting used to the life we were living, Papa returned and we had to move once more. But this time, since Nanna was on her own, we lived at 'The Beeches' in Melton, just a short walk up the street from her house. For the next ten years Tom and I lived as much in her home as our own; she was the mainstay of our life. Later, when she died, Papa was at last on his own to care for his family, but we were lost without our dearest friend and teacher. She had become very frail and had not been able to get out of the house for a long while. She had looked grimly on as neighbours brought her gifts of rice pudding. I had tried to help as much as I could, but it was so sad to see her decline. Papa called to see her every day, to talk and stroke the wafer-thin skin on her hand. Sometimes we walked home together from her cottage, no words adequate to express our grief. Then she was gone and we were relieved that her suffering was over, and guilty at our relief. We had no words for that either.

CHAPTER 4
STILL A GARDEN BY THE WATER

49. Hay Barges and Fishing Boats on the Deben. *By Thomas Churchyard. Watercolour. 2¼ x 3¾ in.* *Private Collection.*

Today I feel energetic enough for a long circuit. So I wrap up well and set off up the hill, past my sisters' home at the library, knowing that I am not likely to see them unless I go into the great wood-panelled room itself. It is not far to the Fen Meadow, always green and lush because of the stream that divides it. Then it is easy to follow the Pilot's Way, a beaten path taken by the pilot who kept watch from his attic window in Seckford Street. He could see the masts of the ships that needed to be guided through the mud-banks to the harbour; fewer ships now than there were when I was a girl, because the river is slowly silting up. The path crosses pastures after the new town cemetery, although this, too, has changed over the years. Great villas are being built on these slopes to house the town's grandees, rather different in scale to my little home. The path leads me down to the main road, which I cross carefully; it is always busy with traffic from Ipswich. Under the trees of Maiden's Grove a sandy track is a shortcut through the woods and on towards Broom Heath. I like to stop here for breath and because I so love this wide tract of broom and furze. The yellow flowers of the furze scent the whole world like a coconut confection: sweetly spiced. It is here that I can smell the water again and see the brilliant shine of the creek leading away inland to Martlesham, or if it is low tide I can smell the pungent tang of the drying mud, the ebbing river leaving tiny rivulets and streams meandering across the mud-flats.

The path crosses the railway line on a high romantic bridge, spanning the deepest cutting for miles. I remember when the railway first reached out to our town, passing

50. River Deben near Kyson, Suffolk. *By Thomas Churchyard. Oil on Panel. 10 x 12 in.* *Private Collection.*

along the quays and the ancient salt-flats, seeming to cut the town off from the water's edge. The trains were so large and long, so noisy and smelly, but oh, how they took our breath away as they arrived from the great wide world to our little town. They seemed to bring the whole country with them to our riverside, just as the ships had done for centuries before. As the number of ships dwindled, the trains arrived and brought the visitors and goods to us once again. Businessmen turned away from the troublesome schooners; although the river tried to fight back for a time with flat-bottomed barges, they never really competed with the train. The barges had much smaller crews, usually just a skipper and a boy, so many of the families who had lived by the river had to look for new

occupations. Often the barges did not even come to the town quays; they loaded up their holds with mangolds and topped them off with hay or straw on the deck directly from the farm-side wharves. Then they sailed these down the coast and along the Thames to London to supply the many horses there, before sailing home again with cargoes of 'London mixture', a strong potent load of horse manure and old bedding straw, which was spread on our fields; a neat circle closed. The children loved this new harvest because the 'London mixture' contained treasures to be found during harvest or after ploughing. The city folk dropped their coins, shoe buckles and buttons into the muck that littered the streets. They could not or would not retrieve it, so the treasures washed up in our fields, real treats for a young lad's sharp eyes.

At the beginning, when this railway line was first opened — it must have been about 1859 — I think Papa and Laura caught the locomotive train home from Ipswich to see how it was. They were very late home that evening, later than they would have been if they had used the coach. We were just beginning to worry that there had been an accident when Papa burst in through the front door in a state of high indignation. Laura followed him close behind, looking as though she did not know whether to laugh or cry, then he guffawed and laughter won the day. We were all amazed and waited patiently to hear what the cause of this kerfuffle was.

'What a dunce I am sometimes!' he declared.

51. The Deben from Martlesham. *By Thomas Churchyard. Watercolour. 3¾ x 4¼ in. Private Collection.*

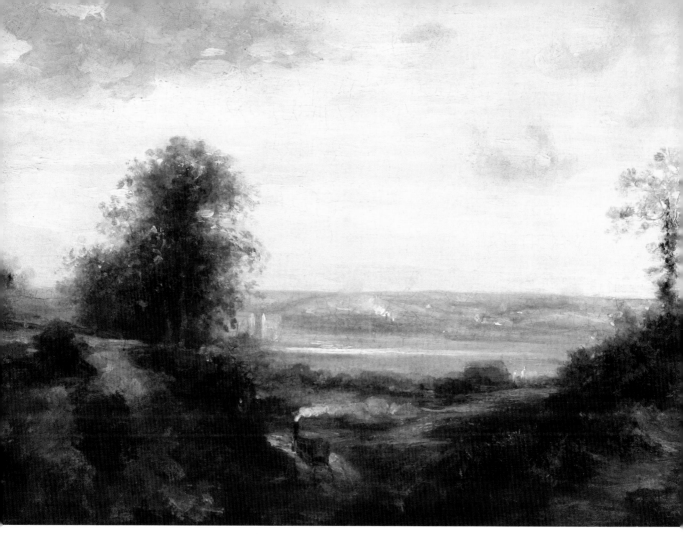

52. River Deben with Tide Mill and Train. *By Thomas Churchyard. Oil. 8½ x 12¼ in.* *Private Collection.*

'Tell what has happened,' we begged.

'All of Woodbridge knows by now so I must tell you. We boarded the train at Ipswich station as planned. We settled in the carriage and waited to be amazed by our journey home. And we were amazed; it was delightful to see a new view of our familiar countryside. The valley of the Finn through Playford and Bealings was so beautiful, passing over The Street in Martlesham, then along by the Creek before plunging into the new cutting at Kyson and emerging to the glorious sight of the Deben and Kingston meadows.' He sighed, 'It was wonderful.' He stopped and we waited.

'Then,' now he was serious, 'then the train dutifully drew in to the new station. As we were in the last but one carriage, we waited for the train to move up to the platform, so that we could alight.'

'Yes, yes, then what happened?' we clamoured.

'The train began to move but it wasn't moving up the platform for us, as I had imagined. It went faster and faster and set off to the next station.'

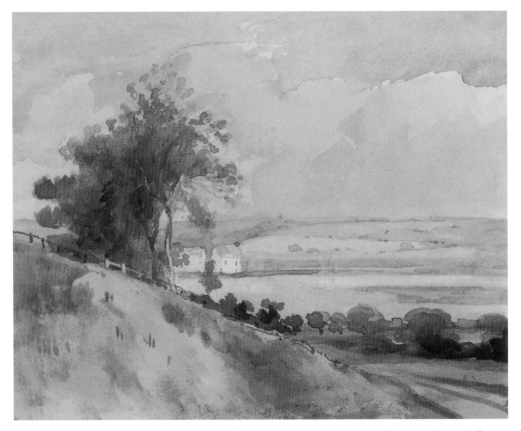

53. Tide Mill seen from Kyson Bridge. *By Thomas Churchyard. Watercolour. 3¼ x 4¼ in.* *Private Collection.*

None of us were sure whether to laugh or not; we waited with bated breath.

'At the next stop we hopped down as fast as we could. We had been kidnapped!'

'So you had an extra long journey for the price?' I suggested.

'No! That's what I was cross about! The guard wanted to charge us for the extra station and then we had to walk back to town from Melton in the rain!'

The next morning it was indeed the talk of the town. The great lawyer, Churchyard, had missed his station and then had to pay for the error. How they loved it, how they teased.

So this bridge always reminds me of poor Papa's misadventure, but I like to linger here watching the river, a silver ribbon in the distance and the tracks shining as they wind gently away to the town. Here on the cutting the banks are lined now by the rich gold of the furze and broom flowers, which have colonised the raw earth over the years. Beyond the turn in the track are the flood meadows and the river-walls, the Tide Mill always centre of attention on the dockside beyond.

My route takes me along the finger of land that divides the river from the creek and as I walk, every turn of my head shows me another painting, another work of art. I mean, of course, that it is so beautiful that any of it would be suitable for a subject. But I also mean that I have seen all of these views painted in watercolour and in oil. Papa made so many sketches and finished works that there is hardly a corner to be turned without a sense of recognition. We have all painted along these walks and some of these pictures are very good, too, but we never capture the essence of the scene as well as Papa.

The path dips steeply downwards towards Kyson Point and I have to choose whether to bend under the hanging trees at the river's edge to the actual Point, to linger awhile there or to go straight on back to town. I always imagine the Angles appearing in their ships around the bend in the river and deciding to come ashore here, to trade and then to settle. It is a place of power and mystery, as well as beauty, where the townsfolk love to be free to stroll. But the decision is made for me, as the tide is high and lapping well over the path. Gone are the days when I could lift my skirts and paddle through; at my age, sadly, I have to be more sensible.

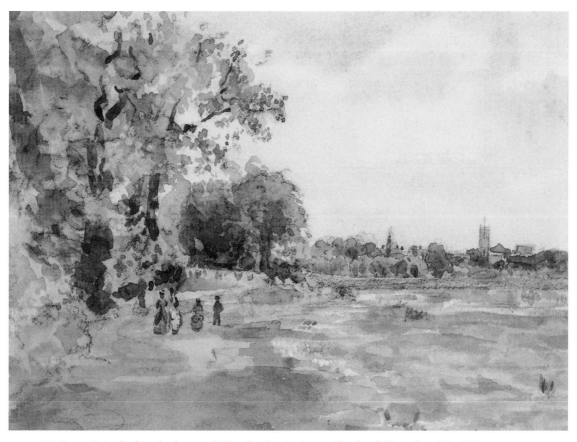

54. Kyson Point looking back towards Woodbridge. *By Laura Churchyard. Watercolour. 5½ x 7½ in.*
Private Collection.

55. Boats in the Dock at Woodbridge. *By Thomas Churchyard. Pencil. 3¼ x 6¼ in. Private Collection.*

56. Ship at Anchor. *By Thomas Churchyard. Pencil. 2¼ x 3½ in. Private Collection.*

So the next decision is which way to head homewards: along the high, exposed path on the ragged river-wall, through the briny sea grasses and reeds; or if it is not too muddy the track through the flood meadows to Kingston Farm? The wall is always my preference if there is not too much bite in the wind's edge. I remember just after Papa's death Ben Moulton told me a story about Papa painting along by the river, a favourite place in any weather. A shopkeeper had sadly told Ben that just a few days before he had seen Papa sketching along the river wall, a watercolour of a three-masted schooner at anchor on the river. He had stopped beside him saying crossly, 'Why don't you go to your office to earn some money? You owe enough.'

I remember wincing as Ben said this. True as it was, it was still hard to bear. Papa owed him money for hardware that he had bought for Tom when he had emigrated to Canada two years before. But apparently Papa in his usual easy manner did not take offence; he simply handed the watercolour to him and replied, 'Here, take it; it is worth all I owe.'

At the time the shopkeeper had crossly folded the painting up, stuffed it into his pocket book as though it was indeed money, and stomped off. When he heard so soon afterwards of Papa's death he had been truly sorry that his last words had been so harsh. I believe a lot of the townsfolk had felt like that in the end.

Eventually I find myself beside the yards and jetties and the town quay. Here there is always hustle and bustle, but best of all there are shelters where I can sit to catch my breath before the final walk back up Quay Lane or White Hart Lane towards home. Some days when I walk I see no one; at other times I think that the whole town must be out strolling or hurrying about some urgent business. I am glad that I can still walk; when that is no longer possible I shall not like to live much longer. I could not be one of those dowagers pushed about in a Bath chair. Although come to think of it who would push me? I certainly should not trust Charley. I sometimes feel that I only survive him because he has nothing to gain from my death. The money I have is only mine for my life, reverting away when I am gone, a very sensible plan made by friends who knew that Charley could perhaps become even less human than he is. It is not a very pleasant thought but if I am honest with myself he is quite capable of any nastiness, more than likely to round on the

only friend he has left. I shall never be able to understand just how the golden boy became this dark and moody man.

Another day and another walk as the weather remains mild, and today I thought I should follow my heart and take out my sketch pad. It is rather a palaver to take painting things at my age; I need my easel, stool, paint box and so on. Maybe I shall ask Ernie to accompany me one fine day, to help carry the things. So today it will be pencils and paper only and a stroll to the town quay to sketch the boats I think. I never know what I will see there, the sort of trade has changed so, over the years. Now some ships wait at Kyson and only come up on the top of a spring tide. Others unload some of their cargo onto lighters and, when they float higher in the water, are able to come up to the quay to complete their work. Schooners were built less often as they had the great disadvantage of needing to carry ballast in their hold when they had no cargo. Many foundered in heavy seas because of their instability. Funnily enough the last schooner to be built in Woodbridge was called the *Ellen*. Like Mr B I felt a kind of fascination for the ship that carried my name as I watched her slowly grow and then splash into the world.

Although, of course, his ship, the *Bernard Barton*, was truly named after him, he was so proud when he told Fitz and Papa over their pipes one evening. He thought only to divert them with his latest piece of news: he was to have a newly built tops'l schooner named after him here on the Deben, but when Fitz heard this he solemnly moved his chair to the corner of the room saying, 'I will not presume to sit at the same table as one who is about to have a ship named after him!'

Poor Mr B for a moment did not realise that it was a jest and looked very unhappy. Then laughter broke out all around and we all clamoured for more details. It was to be captained by William Passiful and was to trade up and down the coast to Liverpool.

Mr Barton was very modest; he joked, 'If my bardship never gets me to the Muster Roll of Parnassus, it will get me into the shipping list… I shall at any rate be registered at Lloyds.'

57. Vessels at Sea. *By Thomas Churchyard. Watercolour. 1½ x 4¼ in.* *Private Collection.*

58 *Peewits. By Thomas Churchyard. Pencil and Watercolour. 5¼ x 9 in.* *Private Collection.*

So the *Bernard Barton* had been launched and we all began to gravitate to the dockside when she was expected to arrive or depart. At first it was to humour Mr B who never tired of thinking of 'his' ship, but we soon all became addicted to the salt air, the smell of the tangy mud, the cries of the curlew and the plover that wheeled across the farmland and the river-walls together.

I especially loved to walk there beside Fitz: six feet tall, his bright blue eyes hidden under bushy eyebrows, his rugged features, with his mellow resonant voice and interesting conversation holding me captive.

'Oh,' he said, 'for to sit upon the banks of the dear old Deben with the worthy collier's sloop going forth into the wide world.'

But I had thought, 'Oh, to sit here with you and hear you speak of the world beyond and the people beyond in that wide world.'

I truly think that our town's favourite topic of conversation was the river, the sea and the boats. First and foremost it was a sailing town. Ships had been built here for centuries, and men of Woodbridge had sailed the high seas with the best of the country's sailors. The river brought visitors from other countries to our shore; it had carried the smugglers under the cover of darkness to their hiding places on shore; it brought loved ones home after dangerous sea passages; sometimes the river and the sea kept loved ones, too. A new ship launched would have brought some gain to half the town. The Master Mariners who controlled the craft, the mates, the seamen, the boys and their families all had an interest

in the life of the river. Sail-makers, rope-makers, carpenters and riggers; so many folk stood to gain from a successful voyage. Fitz became quite fascinated by the men and the water, and for a while he hid himself away on his yachts, avoiding what he came to see as the horrors of society and of marriage.

Later on another reason had drawn me to the water's edge. Tom had gone. He had decided that he was not succeeding as quickly as he had hoped at Ufford. The talk, many years earlier, of the land he stood to inherit had sounded good, but inheriting is a strange business as it depends on the deaths of members of the family. To a young man, each year of Great Uncle Isaac's life seemed to be an eternity. So he decided to see the world for a while. At the age of twenty-six he sailed away from the town quay, first to Liverpool and then across the Atlantic to America. News travelled slowly in those days. I longed to hear how he fared. He had been my best friend and constant companion at an important time in our young days. We had shared so many secrets and dreams. So I watched the waves that lapped on the river-wall and felt they connected me with him, somewhere in the world. I read magazine articles and books about travellers, trying to store the knowledge ready for Tom's return, hoping that we would be prepared. Mamma had been upset when Young Tom set off for America; it was quite beyond her imagination to picture his life in such a distant country. She had hated his departure to the Classical Academy in Wickham Market, but had seen him quite often; then he farmed for some time in Ufford and she saw him even less, but she could imagine where he was and what he was doing; it was all familiar. America, though, was quite beyond her imagination, and she almost seemed to grieve for him as if he were dead to her. He was away for more than five years and when he returned she was not sure who he was any more; he had grown older and was now quite a man. To Mamma her children were just that, children; she was not able to find a place for this strong and rugged man. I remember Charley had been delighted that Tom had gone and insisted that now he was the 'only' son.

Back in those days we filled our time with sketching too. Papa's tribe of

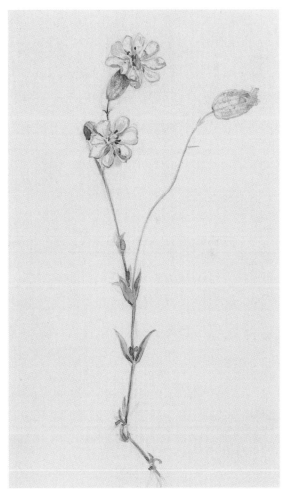

59. Study of a Flower (Campion). *By Ellen Churchyard. Watercolour. 6¼ x 4¼ in.*

Private Collection.

60. Oscar. *By Thomas Churchyard. Pencil. 3 x 2¼ in.* *Private Collection.*

61. Mouse in Red Collar. *By Thomas Churchyard. Watercolour. 2 x 1½ in.* *Private Collection.*

62. Puck. *By Thomas Churchyard. Watercolour. 2 x 1½ in.* *Private Collection.*

daughters were seen by the town, out and about whenever the weather permitted. I enjoyed searching out flowers and grasses, birds and bird's-nests to draw and paint. Sometimes I carried them home to study indoors when the weather was not so good. But we all preferred to be out in the garden or walking in the fields. We made our way to Ufford along the river bank or took the little ferry boat over the river to the Sutton shore, to paint the town from a new perspective. We huffed and puffed along carrying our paint boxes, stools and boards under our arms, our voluminous crinolines hindering us at every turn. We had over the years a number of little dogs — Puck, Mouse, Pickle and Oscar — who loved to follow us to the river, where they could snuffle around in the long grasses, annoying nesting birds and little creatures. There they would snap at a bee innocently lowering itself onto the clover, or duck when a seagull flew over their heads. They liked to hide under our skirts and it was no rare thing for one of us to trip headlong over them, laughing unless it was a muddy day. I remember the weather being mostly one extreme or the other. The sun could be so hot that we had to take great care not to burn: straw hats trimmed with tulle sheltered our noses and warded off the freckles, gaily coloured neckerchiefs loosely knotted protected our bosoms. Or it rained and a torrent poured down the street outside our window, trying to find its way down to the river.

After sketching and daydreaming by the water's edge, I hurried home hungry for my tea and wondering if I would have a visitor. But he had beaten me to it, looking worried and hovering around by the little alleyway that leads to the back door.

'Oh good, will you bring me in some coal and some small logs so that I can stoke up the fire?'

At once his eyes lit up and he was off like a rocket, knowing well where to find everything. He sorted out the fire and I began the spreading of the treats. In due course we were settled at the table and I began to chatter about the old days, pleased for an audience for my reminiscing and flattered by the interest shown in Ernie's eager face.

'My Papa was a solicitor here in the town.'

'But I thought he was an artist?' Ernie was clearly paying great attention.

'Oh yes, he was a fabulous artist, and if things had been different I believe that he could have been as famous as John Constable. But it was not to be, and he had to make his painting wait until after his day's work was done. Although he could not resist making sketches in the court room too. Little scraps of paper covered with caricatures would appear from his pockets after a long day at law.

'A lot of his day work was on the Market Hill at the Shire Hall, where the petty sessions are held on market days. There was always a wonderful hustle and bustle of stall-holders and animals in the background against the noise of the courtroom itself. Whenever I was allowed I loved to sit and hear Papa in full flood, in defence of some poor soul. I had to ask first because there were some cases that Papa did not think I should really attend, but some were so funny they were almost an entertainment. Squabbles over stolen firewood or 'borrowed' land could be laughed over. But some cases were not comical at all and not suitable for a young lady. Gradually Papa objected to fewer and fewer and I was considered sensible enough to understand the rights and wrongs of the cases.

63. Surveyor Stones. *By Thomas Churchyard. Pen and Ink. 8½ x 6½ in. (Photograph courtesy of David Messum Fine Art Ltd)* Private Collection.

'A good example was when the *Rosabelle*, a ship owned by Mr William Bird, an innkeeper of Ipswich, was taken by the revenue cutter *Scout*, and found loaded with smuggled tobacco, snuff and spices. I had sighed and said, "It's so romantic". Feeling that since Papa smoked, our great friend Mr Barton took snuff and we all appreciated the uses of spice, there could be little harm in the trade.

'Balmy, moonlight beaches and handsome smugglers risking all so that we could have those luxuries, I had imagined.

'Ooh, that sounds like a book my brother has.' Ernie was caught in the dream.

'But my father put the alternative view, the one I hadn't thought of. "Or is it just greed and treachery?" he had

64. Wooded Bank. *By Thomas Churchyard. Oil. 9 x 12 in.* *Private Collection.*

suggested, "The revenue men risk their lives for law and order. And in the days gone by, when smuggling was at its height, they were often attacked viciously to line the pockets of some smuggler who lived abroad in safety and luxury, happy to let others risk their lives on the cold, grey troublesome waters of our coast just to get luxuries to the already rich."

'I admitted that I hadn't thought of it in that way, and I asked him why the ordinary people helped them. He explained how badly they needed the money and often they could not afford to be choosy about the work they did. A boy earning 18d. a day for hours of hard work on a farm would be very happy to be paid 2/6 to wait on a beach to collect goods as they were landed.

'Did everyone know what was happening?' Ernie wondered.

'I think that in its heyday few people were untouched by smuggling. They say old Revd. Meadows at Great Bealings used to leave his coach house open and his stable unlocked, so that the smugglers could borrow his horse and carriage to collect goods from the Creek at Martlesham. Then the carriage and horse would be returned to their home along with a keg of Holland's as a "thank you."

'Blimey, even the clergy helped them?'

'And judges and lawyers too, according to my Papa! I remember the stories sounded exciting but I'm rather glad that it doesn't happen so much nowadays. The violence was not good. They cut off the nose of an Excise Officer called Gardiner with his own sword! In Beccles I remember hearing of a man being dragged from his bed, whipped, tied on a horse and carried away, never to be seen again, all because he had informed on his friends.'

'What did they bring in that was worth risking their lives for?'

'Nutmegs, cloves, tea, lute-strings, spirits, silks and laces, all the luxuries, playing cards, tobacco and snuff. The duty was so high that people couldn't face paying it when they could buy from the smugglers so cheaply. When the duty was lowered then it was not really worth it. It did make people inventive; the hiding places were astounding. Goods were found hidden in the shingle on the beach or maybe in a dung heap, in cellars, attics, beds, coffins, even in secret rooms in houses that had been constructed for the purpose. In the High Street in Hadleigh they said that the attics of the houses were connected with hidden doors, so that the smugglers could enter one house and emerge at the other end of the street, unseen.'

'It sounds quite exciting,' Ernie insisted, just as I had with my father, novel reading having rather led my mind astray in these things.

'Well, transportation to Australia for seven years isn't very romantic. Neither is hanging from a gibbet. But no doubt the admiration of the common folk was a big attraction.' I used Papa's argument now, but with only a little success. 'So gradually I learned something of the ways of the world, from the Sessions and having a lawyer for a father, maybe more

65. Near Seckford Hall. *By Thomas Churchyard. Watercolour. 6½ x 11 in. (Photograph courtesy of David Messum Fine Art Ltd)*
Private Collection.

66. Fishing Shed and Boats on Beach. *By Ellen Churchyard. Watercolour. 4¼ x 5¼ in.*
Private Collection.

than some of the other young ladies of my age.'

Then to amuse Ernie I produced a piece of Bruges lace from my Chinese box, an exhibit from a trial, which had appeared on my pillow one night. He held his breath as he reached out for the genuine piece of contraband, wondering what had become of the smuggler who had risked his life to bring it to Suffolk. We chatted on as the light faded, and I felt so grateful to this lad who was interested in my silly stories. I realised that I needed to be able to talk and yet I had fewer and fewer friends to talk to. Charley, usually sulking or sullen, had no need for the past, unless it was an excuse for a whine about how hard done by he was. Fitz had loved to chat about books and paintings and old friends, but it was many years since he had left me alone.

Eventually Ernie had to leave, and he politely thanked me for his tea and I thanked him for getting in my coal and logs. Then, promising to call again in case there was a chore needing his attention, he slipped out of the scullery door. I sat on, in my chair near the kitchen fire, and thought about a book called *The History of Margaret Catchpole, A Suffolk Girl*, published in 1847. It was a novel written by Revd Richard Cobbold, although he always professed that it was a true account. I had read the book and thought that it was wonderful — a tale of smuggling, horse theft, riding through the night; of imprisonments, escapes, battles on beaches and, of course, love. Margaret inspired me with her bravery and her simple honesty. Oh, to be remembered like that. But Papa once again questioned the romance in smuggling, and in fact questioned the accuracy of the story. His lawyer's eye

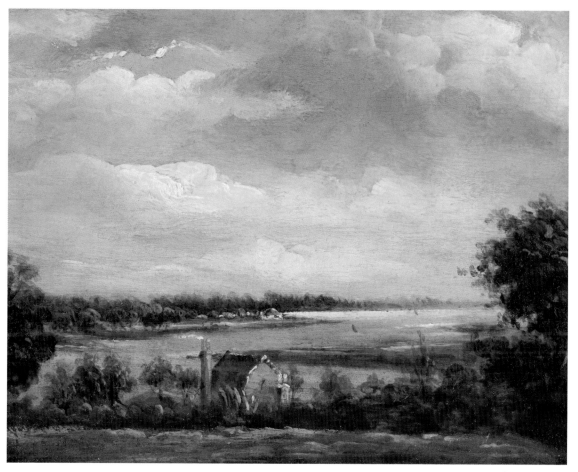

67. River Scene, possibly the Deben at Kyson. *By Thomas Churchyard. Oil on Panel. 5¾ x 7½ in.*
Private Collection.

soon spotted inconsistencies and his powerful memory could recall much of the real story of poor Margaret. She was a local girl, who was sentenced to death for stealing a horse and then reprieved, to be transported to Australia for life. She had worked for the Revd Cobbold's mother, Elizabeth, at one time, and that good lady had written to her, visited her in prison and sent goods to Australia to help her start a new life. But she had not been a heroine, and her punishment caused her great sadness to the end of her days. The good Revd had cobbled together some facts and a lot of hearsay to create his Suffolk girl. But I still thought it a wonderful book and re-read it a number of times. Both Papa and Fitz knew the Revd Cobbold; he was said to be very pleased with the reception that *Margaret Catchpole* had received. Fitz told me that Cobbold's mother, was the original for Mrs Leo Hunter in Mr Dickens's *Pickwick Papers*, she who was renowned for her 'Ode to an Expiring Frog'. Maybe I will find my copy of *Margaret Catchpole* and read it with Ernie when the evenings become lighter.

CHAPTER 5
THE BIRD IS ON THE WING

Charley was being obnoxious again at breakfast time and I ignored him as far as I could. He was still angry that he had gained nothing by the death of Anna, but I am not sure exactly what he had been expecting. None of us has anything of value except Papa's paintings. Papa rarely sold his own work and only gave pieces away when he truly trusted the recipient to value it. His paintings and drawings were like pieces of his soul, and so not to be treated lightly. We learned this at an early age and we treasured them, too, as a part of him that we never really lost. Although we all painted, and sold our own pictures whenever we had the opportunity, we rarely sold any of Papa's.

Even during the worst years when the family was bankrupt and had to sell up and move briefly back to Melton, we always kept the paintings. Papa and I wrote his daughters' names on the backs of the oils; wearing his legal hat he said that they belonged to us and not to him, therefore they could not be sold to pay his debts. Papa and I sorted together the sketches and watercolours which were bound into great albums. These were shared out between us all, and in this same way they were saved from the auctioneer's hammer. At the end, after Papa died, we sorted and shared the crates full of his life's work: the albums, the heaps of oil paintings on canvas, on board, on paper, on cigar-box lids — he had painted on anything he could lay his hands on. We even shared out his paints and pencils, his brushes and paper, so that we could continue with our own work. I was rather afraid that it was charity at first whenever we managed to sell a sketch or someone commissioned one from us, but we did not make too bad a job of it, and so earned a little to help with our dwindling resources.

When dear Emma died, twenty long years ago now, those of Papa's works in her name were divided between us and our names written on the back below hers. We did not need to think about it; it seemed the only way to deal with what was our only but our most precious inheritance. In the beginning Papa had not exactly included Charley in this scheme, since he hoped and imagined that his son would have a career and an income of his own. However, by the time Emma died we had already learned that Charley was not going to support himself and also, most importantly, that he was not safe to entrust with any paintings. I have not completely shunned Charley as the others have, but I do agree with them that he is not to be trusted with Papa's work. Heaven help us if he outlives us all, which is very likely since he is the youngest by far.

Mind you, I readily confess that I have had to sell some paintings over the years and even some of the books that Fitz gave me. I excuse myself because, like Papa, I ensured

68. The Cherry Tree Inn, Bromeswell, Suffolk. *By Thomas Churchyard. Oil on Panel. 5¼ x 4¼ in.*
Private Collection.

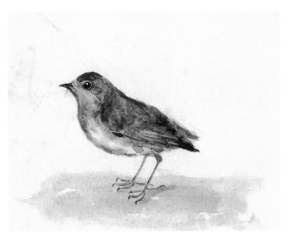

69. Chaffinch. *By Emma Churchyard. Watercolour. 3¾ x 4¼ in.* *Private Collection.*

70. Robin. *By Emma Churchyard. Watercolour. 3¼ x 3¼ in.* *Private Collection.*

that the purchaser genuinely wanted the item for themselves and that they would value it as I did; also I only sold when I really needed the money, not for a bottle of whisky or a game of cards.

A few years ago a Mr Lucas came to my door to ask me about dear Mr Barton, our Quaker poet. He was writing a memoir of his life, and had heard that there were still a few folk in the town who remembered him well. He had been sent to the library to see my sisters and Harriet had directed him back down the hill to see me. I told him all I could with great pleasure and showed him the many volumes of Mr B's poems that I owned, dedicated inside to our friendship. I did not tell him anything about Lucy Barton and Fitz; the less said about that the better, I always feel. I told him about the poem that Mr B had written for me and published in his *Household Verses*. I showed him the manuscript, and Mr Lucas was very surprised and excited by my news since he had thought it was written to another lady. I showed him the letters that Mr Barton had written to me when I was away at Mrs Jay's Boarding Academy. He wanted to buy some of my books, but I did not wish to part with them. I have never owned very much but what I do own is precious to me. I promised to write to him if I changed my mind; I knew that he was a genuine person and that he could be trusted. He left a standing order for tea with the grocer Davy Crowe in Church Street, to be delivered to me each week while I lived. It was a kind thought, but I suspect it was to ensure that I should always keep him in mind.

I have had to sell one or two of the books dear Fitz had given me, but never the volumes that he had inscribed personally. If I had visitors asking about my books I never admitted to them just what I owned. They could easily become a nuisance,

71. At Kingston Farm. *By Thomas Churchyard. Oil on Panel.* *7 x 4¼ in.* *Private Collection.*

hanging around to beg for a glimpse of my letters or the notes inscribed in the volumes. Fitz had published quite a number of small works but he was so modest about them, he only intended them to be for his friends. He usually had to be persuaded to give them up, even his most famous work itself.

'What are you going to do today?' I asked Charley. I try to speak to him as I would to anyone, try to maintain the pleasantries, but I rarely get a civil reply.

'What can I do? I've no money.'

'Well we have discussed this before; you need to do something to earn some money. You are so good at painting, why don't you get together a selection of sketches and watercolours and show your abilities. I think there will be an exhibition in a couple of months and you could enter some pieces there. If you could get your name in the public's mind and show that you can be reliable, then I think you would get commissions. It might not pay much but it would keep you going.'

'My name you say! The only trouble is that "Churchyard" is not just my name, is it? Everyone who hears it expects my father's talent or one of my clever sisters.'

'I don't think that's really true. Your style is very different from Papa's, and your subjects are usually different from the sort of paintings the rest of us do. For example, you never paint flowers and that is what I have concentrated on of late. You are the only one to make these comparisons.'

'I suppose that now the weather is getting better I could do something. Have you any paints that I could borrow? I think I have used mine up.'

'Now why didn't I expect that? I should have guessed. If you promise to paint something I will sort you out some colours, but you can't have my brushes. They wouldn't suit your painting anyway.'

'I've got brushes, I think.'

I was so pleased by this turn-up for the books that I hurried to my room to find him some paints. I had intended to treat myself to some new ones for the New Year, and this would spur me on.

'What shall I paint? I feel as if I've done everything around here. I wish I could go somewhere for a change of scene.' He was a man of fifty-six and he sounded like a petulant child.

72. *Thistle. By A Daughter. Watercolour. 7½ x 5¼ in.*
Private Collection.

73. Shire Hall. *By Charley Churchyard.Water-colour/Pencil. 5¾ x 5 in.* *Private Collection.*

'Well, one thing at a time. Do some pictures here, exhibit the best. There are many subjects here that are very saleable to visitors: the Shire Hall, the Tide Mill, anything along the river, Melton Bridge maybe?'

'The Shire Hall drives me mad; I've painted it so many times.'

'But you've sold all of those paintings, haven't you? Actually it would be better not to do it. Knowing you you'll set up your easel on the pavement outside the library to annoy our sisters, I know you've done that before. I heard that they were trapped indoors all day trying to avoid you.'

74. Changing Huts on the Beach. *By Thomas Churchyard. Watercolour. 5¼ x 8½ in.* *Private Collection.*

Charley chuckled at that memory. It had not been very funny at the time, though. I think that Laura had cut him in a shop, so he had got very drunk and then sat outside their door trying to paint and failing badly. He loved to scandalise the townsfolk whenever he had the opportunity.

'Why don't you get started around here and then take a trip to Aldeburgh or Southwold later in the year. You could get some new subjects and have a change of scene too. Papa loved to paint by the sea. He said that it was such a refreshing change from the fields and trees of our countryside; new colours, new shapes.'

I had a sudden image of Charley as a toddler trotting proudly along the promenade in Aldeburgh behind us, laughing and chattering happily. When did it change? I think it was around the time that Papa tried to give up smoking; he had come to believe that it was not good for his health, and thought that he suffered headaches because of his pipe and cigars. Dear Mr Barton had never smoked and he complained frequently of the smell and the fug that his friends produced in a room. He was delighted that Papa was planning to give up and had written to Fitz with the news, maybe hoping that the idea might appeal to him too. Fitz had written back instantly in horror, '…let him leave off cigars: that is good: but pipes!'

Fitz did admit however, that he, too, suffered headaches because of too much tobacco. Still, he need not have worried; it did not take long before Papa was back with his pipe again. Old habits die hard.

75. Figures and Boats at Aldeburgh. *By Thomas Churchyard. Watercolour. 4¼ x 8 in.* *Private Collection.*

It was that same summer we planned a trip to Aldeburgh for a holiday. We had never before travelled away together. Mamma was always either with child or nursing. Now at last even Charley was toddling around and manageable, so Papa planned a few days at the White Lion. We were so excited and full of plans for walks and bathing, salty sea and salty breezes. Then when Fitz heard that we were going to Aldeburgh, he wrote to say that he was jealous and might just have to come to visit us if he could get to Suffolk on time. He told me that he had holidayed there thirty years before, when he was a tiny lad. There he had first seen the sea and first felt its draw. It was one of his most treasured memories. I wanted to feel the same, and felt sure that I would. I longed to share his feelings and I studied to remember everything he told me.

He did arrive, the day before we were due to journey home. He had a friend's cottage available to him and planned to stay there for a week after his recent travels. I think that was when he had been to Naseby; his father's land there included the site of the battlefield. Fitz was advising Thomas Carlyle on the actual position of the battle for his book about Oliver Cromwell. We walked together up and down the shingle and talked of everything and anything, while the rest of the family sat and watched the sea for the last time that holiday. Papa painted a watercolour of the Moot Hall, the third one that week. Each was from a different viewpoint and it was the three of them now hiding in my box which reminded me of that first holiday.

Fitz had confided to me that his mother was annoyed by the silly things he wrote in

76. Moot Hall, Aldeburgh. *By Thomas Churchyard. Watercolour. 5¼ x 7½ in.* *Private Collection.*

his correspondence with Mr B. 'I hope that your Mamma wasn't really cross with you for writing to Mr Barton,' I had said, genuinely concerned that he had been upset.

'Ah! I see my old friend has really been keeping you up to date. No, well yes, actually, but it doesn't matter. Mamma is always cross about things I do and then about things I don't do as well. She is impervious, beautiful but impervious to reason. She dominates us all, we are only free when we are away from her, but then she calls us and we have to go. We are all mad. I love her totally when I'm away but as soon as I'm with her she frightens me.' Sadly he shook his head.

'I can't imagine being frightened by one's own mother.'

'Well your Mamma is a different sort of woman. She is a mother first and foremost. My mother is a tyrant, a majestic tyrant, and she has made my poor father a cipher. He can do nothing but amuse himself with sport or the theatre. He is not permitted an opinion.'

I was so happy to be the one person to whom he could pour out these thoughts. I must be a friend or he would not speak of such things to me. I must be valued by him. It was what I wanted. Then he had stopped and bent to the stones on the beach,

'Here, I thought I was right!' he picked up a pebble and inspected it carefully.

'Yes, it is a stone with a hole through. It's good luck! Here, Ellen, keep this piece of luck to remind you of your holiday by the sea.'

Smiling I took it from his hand, but I knew that it would remind me of Fitz rather than the sea.

My heart aches still. I sighed sadly at the memory; just yesterday I had seen the stone in the box. I also remembered something else he had written to Mr B, another letter that Mr B indiscreetly showed me:

> 'Does not your little Nellie laugh at two elderly gentlemen (for am I
> not thirty three — which is certainly elderly in a damsel's eyes)
> corresponding in this way? She hasn't those eyes for nothing —
> rather mischievous eyes, if I remember.'

I remember his words so clearly. I had treasured every hope I could find — that he noticed me, that he admired me — every word.

Then I came back to reality with a bump as Charley moaned,

'You're off again. God knows where you go, I think you must be losing your mind, you just go into a daze.'

'Actually it's the opposite; I seem to be remembering things all the while. I was thinking about that first holiday we had in Aldeburgh when you were a toddler.'

77. Beach with Boats. *By Anna Churchyard. Watercolour. 3¾ x 4¾ in.* *Private Collection.*

78. Coastal Scene, probably near Felixstowe. *By Thomas Churchyard. Watercolour. 5¾ x 7¼ in.*

Private Collection.

'Well, I don't remember it.'

'No, well, you wouldn't, would you? You were too young and anyway you refuse to believe in a time when you were happy.'

'Oh, don't start on with your great theories. I've said that I'll paint today. Isn't that enough for you?' And off he went, hopefully for a day of doing something constructive for once.

We holidayed along the coast whenever we had the chance, whenever work allowed Papa the chance of a trip or a few days' freedom. Rarely were we all together, there always being some claim to our time, some at school, some staying with friends. It was the greatest treat to be able to accompany Papa when he decided that he needed to head for the sea. Felixstowe was more easily reached, being the nearer to Woodbridge, and the tall sandy cliffs, covered with flowers and grasses, were a favourite subject for Papa's sketches. Sometimes after a storm there would be a slip of sand from the cliff and the scene would change, then another expedition was arranged to see the effects of the

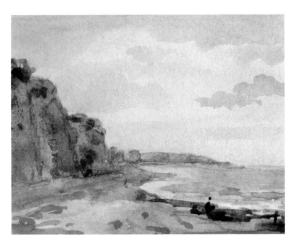

79. Felixstowe Cliffs. *By Thomas Churchyard. Watercolour. 2½ x 3¾ in.* *Private Collection.*

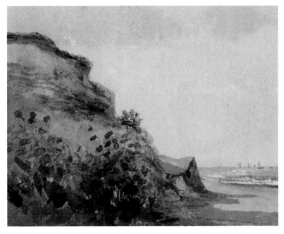

80. Felixstowe Cliffs looking North. *By Thomas Churchyard. Watercolour. 3¼ x 4¼ in. Private Collection. (Photograph courtesy of David Messum Fine Art Ltd.)*

weather on the land. It was also possible to take the ferry at Bawdsey across to Old Felixstowe and walk along the beach from that direction.

Aldeburgh was another favourite destination for us all, the rustic fishermen's cottages jostling cheek by jowl; it always had a special place in our hearts. Mr B and Fitz loved it for its poetry; the lines of the poet George Crabbe were often recalled whenever they were with us. Papa loved the Moot Hall and the boats drawn up on the shingle. The work of the fishermen was fascinating to watch while sitting on the beach and enjoying the fresh air. Sometimes work would demand Papa's attendance, and we were quick to take advantage of the journey. We could enjoy a short stay while Papa attended to his business, then together we could sketch and paint to our heart's delight. Some visits were not so jolly, like the time when Mamma was poorly and Papa took her to Aldeburgh for some rest and a change of scene, later sending for us to join them. Mamma did not know how to relax without her family around her. Once, when Papa was confined to his room with a bad leg, he had managed to paint the most finished, delicate paintings, because he was forced to sit still and work from the viewpoint of his window.

In later years we even managed a number of visits to elegant Southwold, with rather grand Georgian villas framing the broad greens. The greens were an oddity, opening up wide spaces in the heart of the town, allowing the eye such amazing views and vistas to the sea, across the flood meadows to the river and across the common. Every view an artist's delight. There Papa painted and painted, only moving his stool a few yards along and then starting again, catching the light and the sky and the day itself. Sometimes he would not move at all but would work one picture through slowly, then dash off another in a few minutes, lighter and fresher than ever. Looking at the delicate

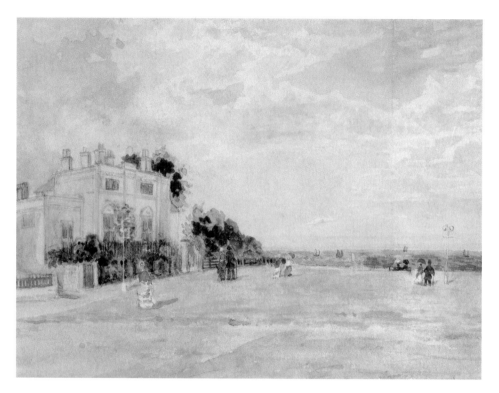

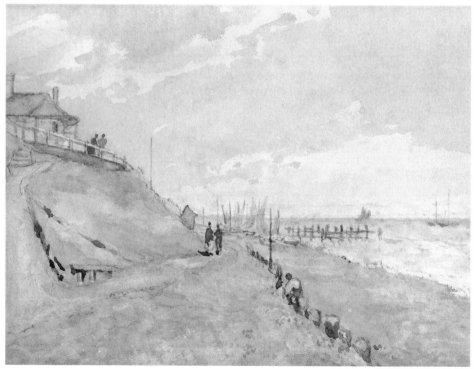

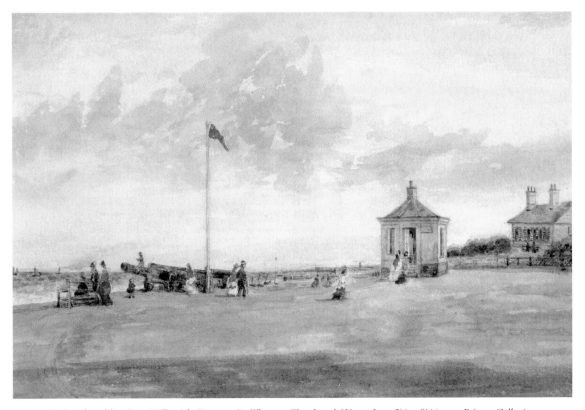

83. Southwold – Gun Hill with Figures. *By Thomas Churchyard. Watercolour. 5¼ x 8½ in. Private Collection.*

watercolours in our albums, still fresh and colourful, they are better than a picture postcard of the holidays we enjoyed. The villas, the ladies promenading in their finery, the cannons on the cliff and the flags flying gaily from the flagpoles, paths sloping steeply down the cliff face to the beaches, the fishing boats and fishermen at their work, all brought to life once more in my mind.

Other years we went to Dunwich, Lowestoft, Orford or even once a long trip to Weston-super-Mare. Mamma was happy wherever she was as long as her family was nearby, and Papa was happy as long as there was a view to paint. And, of course, my memories are always of beloved Papa working away at his easel, absorbed by the world around him, oblivious for the while to anything else.

Opposite top: 81. Southwold – South Green with Figures. *Thomas Churchyard. Watercolour. 5½ x 7¼ in.*
Private Collection.

Opposite bottom: 82. Southwold – Path from Gun Hill to the Beach. *By Thomas Churchyard. Watercolour. 5½ x 7¼ in.*
Private Collection.

CHAPTER 6
CHEQUERBOARD OF NIGHTS AND DAYS

After a brisk walk I felt better as always, and returned home inspired to do some more baking. It is all very well telling Charley to do something, I must do something too. If little Ernie was coming for tea then I needed to have supplies of food and stories ready for his arrival. There were some stories I did not want to tell him, as he would not understand, so I needed to be ready with a tale he would like. I could think about that while I prepared my ingredients. So I found my apron and set about arranging the kitchen for the work. The routine of the tasks is steadying and reassuring, linking me to the girl who learned to cook and learned to manage.

After dear Nanna died and Papa inherited the rest of Grandfather Churchyard's estate, life

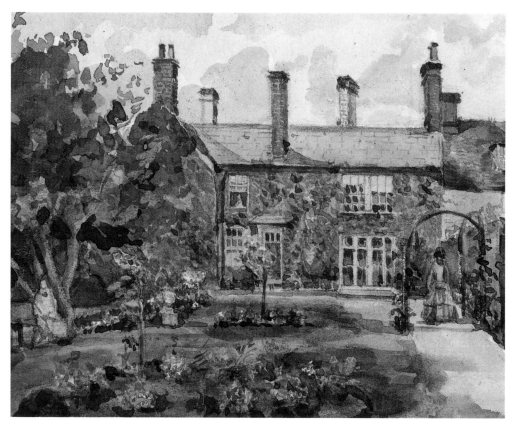

84. Young Ladies in a Walled Garden. *By Emma Churchyard. Watercolour. 3¼ x 4¼ in.* *Private Collection.*

was easier for us financially. Nothing kept us in Melton now that Nanna was not there, so we moved to Woodbridge to live at 'Marsden House'. This was also Papa's office and rather a large undertaking. He had two clerks in the office, and the house had a cook, a maid and Miss Bird, our governess.

Having money troubles lifted from his shoulders for a while Papa decided that he should send his daughters to school, to learn some of the many things that Miss Bird was not able to teach. I protested I did not wish to go and felt sure that I was needed too much at home to be spared; besides at eighteen I was too old for such things. Papa chose Mrs Maria Jay's Boarding Academy in Bury St Edmunds, an establishment of twenty-six young ladies. The subjects to be studied included grammar, Latin, French, German, music, geography, handwriting and drawing, history and arithmetic. Bury was said to be the cultural capital of Suffolk, our county

85. Market Square with Houses and Figures. *By Thomas Churchyard. Pen and Ink. 5¼ x 5½ in.*
Private Collection.

being unusual in having two main towns, one east and one west. Ipswich was the trading centre, the administrative heart of the county, but Bury was the religious and artistic heart. To begin with Emma, Laura and I were the first to attend the Academy. The others would follow in due course. Emma and Laura were excited at the prospect and did not understand my objections. In the end we reached a compromise and I agreed to go for at least a term so that I would have the experience and would know what the others were doing. Papa thought it would not be fair to exclude me.

When I complained about my fate Mr Barton gently put me in my place writing:

'My little Nellie there are always lessons to be learned and we are never too old to learn them. So my dear Nell make the best of these six months, as a dutiful and sensible good temper'd and true hearted girl should, and come back to us as much like thy old self, improved, as may be.'

As I had predicted I worried too much about home to be able to enjoy my stay there. Mamma was not good at dealing with the staff, so I knew that having two new servants, who needed constant attention, as well as there being workmen in the house making alterations, would all be bound to fret her. Then Mr B wrote to me and let slip that she was not well and certainly not coping.

'Mamma very poorly with a bad headache; muddled about her servants and

they have workmen about the house and yards ever so long, which had already kept her in didles [worries] as the Suffolk folk say.'

This was the final straw, so I wrote to Papa insisting that I should be at home. Thankfully he agreed that Emma and Laura were now well settled in and maybe at last he was convinced that I did not mind. In my absence he had come to realise how much I had been doing in the household. He came to collect me and we were both relieved. After only a couple of months I was horrified at the deterioration I saw in Mamma. She was ever more vague, and less interested in day-to-day things. She sat for some hours at a time hardly moving, then she would carry on with some small task unaware that time had passed. She had headaches and her legs and feet were badly swollen. Any small problem that was

86. Interior with Naughty Girl. *By A Daughter. Pen and Ink. 4½ x 4¼ in.* *Private Collection.*

brought to her vexed her badly and she would have to go and lie down.

Iris, the new housemaid, was very slovenly and never completed a task. I had often thought poor old Winnie, our maid, slow but now I missed her thoroughness. So, taking a deep breath, I warned Iris that she must change or she would be sent home without references. She cried buckets of tears, until she was good for nothing at all, so I told her to take her half-day holiday and think about what I had said.

Then Mrs Pryke, the new cook, was in a tizz because she had no help and had a meal to prepare for Papa and his friends. So I spent the rest of the afternoon helping in the kitchen, which was rather enlightening. Cook had, it seemed, rather a taste for cooking with alcohol. However the alcohol was not in the cooking, it was in the cook! Every time I came in to see how she was managing she was putting a bottle under the table.

I did not think that I could confront two staff on one day. I needed to see what conclusion Iris had come to, before I could speak to Mrs Pryke. I did not mention it to Papa either, I wanted to try to handle the problem myself, if I could. When Iris returned, I asked to see her and she very sheepishly stood before me.

'Have you had a think about what I have said?' I asked her, trying to keep a stern look in my eyes.

'Yes, M'm.'

'And what is your conclusion? Are you willing to try to improve?'

'Yes, M'm. Me mum said that I'd gotta, across we need the munney.'

She had obviously been home to discuss her warning with her mother. I knew that they were hard up and that three of the daughters were in service, sending home their meagre wages.

'Good, I'm glad, but I shall be watching you and you must try harder. Don't leave a job until it is complete.'

To be fair to her she had not been supervised properly before and I hoped that with a little help she would learn.

Then I wondered what I should do about Mrs Pryke. She had come to us from an agency. They had recommended her as having 'wide experience from a number of previous positions'. I began to wonder if there had been a number of positions because of a particular problem. I watched her carefully for some days and thought that things were settling down. Then I discovered her quite tipsy at one o'clock in the afternoon, kneading the strangest looking lump of pastry which had become sickly grey with over-handling. She had no idea what she was doing and it would have been rather funny if she was not a problem that I had to deal with, once and for all.

'You are intoxicated!' I said firmly. 'You are drunk! I think that you should leave this house immediately.'

'I don't take my orders from a chit of a girl,' she shouted back. 'I take my orders from the Missus!'

With that she broke off a piece of the grey pastry and hurled it at my head. Very regally I drew myself up and said, in what I hoped sounded like a commanding voice, 'I am in charge here at present and you are dismissed.'

She hesitated for a second before throwing the remainder of the pastry, hitting me this

87. Ferocious Mistress. *By Harriet Churchyard. Pen and Wash. 5½ x 8 in.*　　　　*Private Collection.*

time. She tried to flounce out of the door but she did not quite manage it; she seemed to trip over her own feet, sprawling headlong on the ground. At that moment Papa arrived, drawn by the commotion, just in time to see me collecting up the pastry, which had lodged itself in my dress and my hair. I explained that I had had my suspicions for a while but today Mrs Pryke had only managed to cook her own goose and nothing else. Papa thought that it was extremely funny, except that he was disappointed she was so totally incapable. She left us as soon as she had sobered up enough to pack her things. We heard later that she had left the country for Australia; some poor colonial family was going to have a surprise.

So again we advertised for a new cook and in the meantime I produced what I could to keep us going. From the new shortlist we first selected a Mrs White; her references were good, but she could not cook. Then we found Mrs Watson. Papa and I went to see her previous employer, hoping that if we looked them in the eye we would be able to tell if the reference was accurate. They told us that they had been genuinely sorry that she had to leave but because their children had all left home they did not have as much need for a cook anymore. They were now reduced to one maid-of-all-work. We decided to take a chance on Mrs Watson and she proved very good.

We could at last settle down to normal life, but I learned to keep a close watch on the household and I also began to manage the accounts. It was hard work and I had a lot to do, for Mamma was no help at all. I thought that no one noticed how busy I was, but on my next birthday I had a surprise. Papa organised a little party for me and both Mr B and

88. Servantgalism. *By Harriet Churchyard. Pen and Wash. 5½ x 8 in.* *Private Collection.*

89. Fishing on the River Deben. *By Thomas Churchyard. Watercolour. 5¼ x 7¼ in.* *Private Collection.*

Fitz were there, as well as all of our family. Tom had come home for the weekend from his Classical Academy at Wickham Market, where he was studying farming, and he had brought me a young apple tree, which he planted for me in the garden. It grew very well and the following year gave us eight beautiful golden apples. Dear Fitz had brought from London a bolt of silk that had come in from China, at his sister Lusia's suggestion. It was so luxurious that I spent many hours worrying about what to do with it, hardly daring to lay scissors to it. Papa bought a necklace of creamy pearls, which was so elegant it won me many compliments. But the most special present was from Mr Barton. He had written a poem for 'his Nellie', as he called me, and he had copied it out beautifully for me to keep, tied as a scroll with a piece of red ribbon. Mr B told a friend, 'I copied out fairly this morning a Piece to Tom Churchyard's pretty little daughter Nelly commemorative of her skill in making pies, puddings, tarts and bread.'

These words were passed to me by Fitz, causing me to blush and stammer like a fool. And my poem was later to be included in the new collection published as *Household Verses*, dedicated to Her Majesty the Queen. This is my poem:

To A Very Young Housewife.

To write a book of Household Song,
Without a verse to thee,
Whom I have known and loved so long,
Were all unworthy me.

Have I not seen thy needle plied
With as much ready glee
As if it were thy greatest pride
A sempstress famed to be?

Have I not ate pies, puddings, tarts,
And bread – thy hand had kneaded,
All excellent – as if those arts
Here all that thou hadst heeded.

Have I not seen thy cheerful smile,
And heard thy voice – as gay,
As if such household cares, the while,
To thee were sport and play?

Yet can thy pencil copy well
Landscape. Or flower or face;
And thou canst waken music's spell
With simple, natural grace.

Thus variously to play thy part,
Before thy teens are spent,
Honours far more thy head, and heart,
Than mere accomplishment!

So wear the wreath thou well hast won;
And be it understood
I frame it not in idle fun
For Girlish womanhood.

But in it may a lesson lurk,
Worth teaching now-a-days;
That girls may do all household work,
Nor lose a poet's praise!

Oh dear, how I cried, in front of everyone! I was so pleased that I was loved by those that mattered so much to me. Papa told them that he did not know how they would manage without my help, that he dreaded the day that some young man would take me away. I wanted to tell him that I had never met a young man that I was interested in. I seemed to be doomed to unrequited love. But I could say nothing; I did not trust my mouth to frame the right words. Mamma beamed and looked happy, surrounded by her brood. I gave Mr B such a hug that he feared he would break in half. Lucy Barton gave me a kiss and confessed that the poem had been in composition for weeks and a great secret. Then Fitz whispered in my ear that now I knew how much they all admired me and loved me. My heart pounded against my ribs. His words meant so much to me but I only longed for him to see me as I saw him. How often his kind words still ring in my ears.

With rather a deep sigh I tried to change the direction of my thoughts. I must guard against getting too maudlin. I did not want to wallow in sad thoughts. Those early days of learning to run the household set me in good stead to go into service after Mamma and Papa died. They qualified me for becoming Ben Moulton's housekeeper, and even now they help me to manage on my small resources.

It is a funny thing but I have found that furniture seems to flow from house to house

in a very fluid sort of way for such a tangible class of thing. Sitting in the late afternoon quiet, while my cooking cools on the racks, I let my mind slip back to the time when, at the grand old age of fifty-seven, I first had the pleasurable task of finding a cottage to rent, to make my own home. I had small pieces of furniture that I had kept since Mamma's death, like a delicate work box in rose-wood that stood on a little table with a drawer below, and the rag rug I had made with Nanna, very old but not so worn, since it had mostly lived in my bedroom. I had many books, from the Book Club or precious gifts from Mr Barton and Fitz. I had beautiful paintings, which had been Papa's, the richest of treasures to me. But just at that time I found that what I needed was more in the line of kettles and saucepans, tables and teacups.

When Fitz's family had sorted out Little Grange after his death they kindly asked if I would like to have something as a memento from there. I did not mention that I had carefully hoarded mementoes of Fitz stretching back fifty years. I politely said that I should really appreciate it and chose his eccentric, iron umbrella-stand and the umbrella that he had bought in 1839, then the latest thing in London. It was moth-eaten and stiff with age but I wanted it to stand in my hall and for it to rub shoulders affectionately with my own umbrella. I'm sure that they thought I was quite mad and in fact they took it upon themselves to add some extra gifts: a sturdy hall chair, a mahogany board of hat pegs and the little table where Fitz had often played cards or chess, and even the chessmen themselves. In my mind's eye I saw dear Fitz and I heard him reciting:

'Tis all a Chequer-board of Nights and Days,
Where Destiny with Men for Pieces plays:
Hither and thither moves, and Mates, and slays.
And one by one back in the Closet lays.

My cottage was small, so my few items seemed to suit it somehow. In a way it was Ben Moulton's legacy, a thank you for my years as his housekeeper and, I suspect, for love of his oldest friend, my father, which had finally freed me to set up my own household. Therefore, it was pleasing to be summoned by the Moulton heirs to select something for my new home when they came to dispose of Ben's furniture. Being more practical a second time I chose a pine table for my little kitchen and four beechwood chairs. Not to be outdone by the FitzGerald executors they added some coco-mat for the kitchen floor and a carpet from my old bedroom for the sitting-room floor. Now I began to look civilised.

There had been two iron bedsteads in the cottage already, one in each of the bedrooms, and I had a mattress and feather bed of my own, so I could at least sleep in comfort. I went to an auction, a sale of the contents of a poor bankrupt's house. Having lived through that pain myself I felt for the family as all their possessions were sold. But I knew that the money was needed and so I bid fairly for a single mahogany table and four walnut chairs with damask seats, a chest of drawers, a wash-stand and a dressing-glass that matched and were not too large.

Then I had an unforeseen surprise. I opened my door one morning to the excited rapping of a young lad. He had a wooden-trolley behind him and in it rested a pine box.

'It's fer you! I've bin ever so careful, Missus. That wer wholly hard t' get 'em home in one bit.'

90. Redbrick House by a tree. *By Thomas Churchyard. Watercolour. 3½ x 4½ in.*
Private Collection.

I lifted the lid of the box and inside was Mamma's blue and white china. The Mice had sent me a present. My young friend carefully but excitedly brought in the box, helped me to unload it on to the table and then clutching to his breast a brace of pennies he shot away home to tell his mother of his day's work. I unpacked the china from the straw that protected it and set it out on my table. I hoped it was an olive branch, although Laura was always meticulously fair, so it might have been just to ease her conscience.

I had put on my shawl and hurried up New Street, across Market Hill, to the bells of St Mary's tolling out the hour. In my head I heard Fitz's voice telling how the bells could drive a man crazy. Before I could allow myself to think about what I was going to say I knocked at the door of my sisters' house. Who would it be that answered? Stern Laura, ram-rod backed and scowling-browed; Anna, her constant companion and trusty assistant; Harriet, exotic in her artist's smock and her business-like way; or baby Kate, forever worried that she was not what people expected her to be. I should have guessed that at that time of day Laura would have been in the library and it was Anna who greeted me, drying her hands from the sink.

'I had to come immediately to thank you all for the china. It means a lot to me to have it, much more than having something new.'

'We have still got the other sets so it was no loss,' Anna said, rather too sharply. But I realised that she was taken by surprise and not sure what Laura would have wanted her to say. Then I wished that I had sent a note, which I could have considered carefully and they could have considered before replying.

But in for a penny, in for a pound.

'Well it means a lot to me and I will enjoy using it and thinking of the old days, when we were together.'

I hoped that she would remember my words to repeat to the others later. I hoped that they would kindle something in their hearts.

'Please thank everyone for me.'

I finished and began to back away; she was not going to invite me in. So I had gone back to my home-making. It was like playing; there is so little to do for one person, especially one person who does not make a mess. Gradually my rooms filled up with purchases and presents, I pottered around in the scullery during the mornings, preparing my food and washing my clothes to hang in the little back yard. After lunch I would close the little curtain and strip to the waist for a refreshing wash in the big stone sink. Then, cool and refreshed, I would put on a clean blouse and hang up my apron on the back of the kitchen door.

In the afternoons if the weather was good I would set out for a long walk, my favourite exercise, sometimes with a destination, sometimes just wandering where the feeling took

91. A Pleasant Prospect. *Attributed to Harriet Churchyard. Pen on Cotton Doily. 7 in. Dia.*
Private Collection.

92. Framlingham Castle. *By Thomas Churchyard. Watercolour. 5 x 7 in.* *Private Collection.*

me. If the weather was not so good I would sit in the front room on the little sofa and read or write a letter. I never felt lonely. It was pure heaven to have no one else to think about or to feel responsible for, no one to seek out.

When I returned from my position in Norfolk, home-sick after only three years, I found myself a mere stone's throw from The Mice, as Ben Moulton's housekeeper. I had gone to Norfolk hoping to be far enough from my sensitive sisters and their disapproval, but when Ben's offer gave me the chance to come home I could not resist. Actually it did not involve an awful amount of work; the Moulton house ran like clockwork and I had only to wind the clock each day for it to tick happily away. I was allowed a lot of time for myself, so I was truthful when I had written to poor Tom with my new address and told him that I was back sketching on the river bank as he desired.

Fitz had been happy, too, that I was under the protection of Ben Moulton, safe and happy, but also occupied. The next years passed quite quietly, with something of an order that I had never been used to before. The Moultons were very calm and steady souls who had become a steady feature of Woodbridge. Ben had arrived when I was just one year old, moving to Woodbridge from Worlingworth, to work for Mr Cana the auctioneer. Papa had taken to him immediately and they had remained friends for life. Ben it was who had sold our things from Well Street when Papa went to London. Ben had valued our

possessions when the creditors were on Papa's tail in later years. Since Papa's death he had helped us all in numerous ways, and finally he was my benefactor. The help that Fitz had given me was enough to allow me to be free. But Ben's help was more practical and easier to accept, a position in the bosom of his family. Certainly I worked for my keep, but it was not a hard task at all and I was well rewarded in money and in love for my efforts. I enjoyed their company and they mine, so we were really more of a happy family. My time was my own as long as the household affairs were ordered and I had time therefore for friends and painting, for reading and walking. When the weather allowed I walked for miles, following the old paths and roads that I had loved as a child. I walked to Martlesham, to Kyson and to Melton. I took the ferry across to Sutton and walked the far shore of the river to get a different view. This kept me fit and healthy but also somehow sane. I had longed for independence after Mamma had died, so I saved my salary and, together with the money I had saved in Norwich, I slowly built a real nest egg. When Ben died he left me an annuity of £30 a year for the rest of my life, but it was the gift of freedom in reality. I suspected that Ben and Fitz had colluded over my future security, to ensure that I had enough. Bless them! Ben would have known that I would stay with him until his death and so it was arranged. They could rest easy knowing that I was safe, and also that none of their money would end up falling into the hands of my sisters and the disreputable Charley. I smiled at the thought of them planning their strategy.

93. Red Lion, Martlesham. *By Emma Churchyard. Watercolour. 3¼ x 4¾ in.* *Private Collection.*

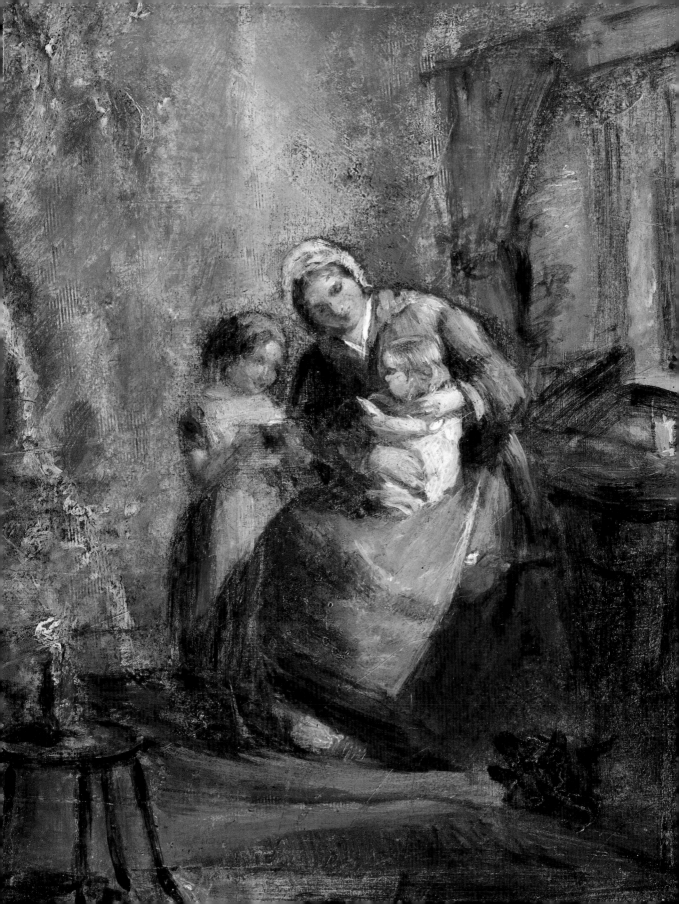

CHAPTER 7
ONE BY ONE CREPT SILENTLY TO REST

Dear sister Bessie decided for herself to go into service after Papa and Mamma had died. We did not have enough money to keep ourselves and, while our other sisters railed against the situation they found themselves in, she decided to lessen their load by taking herself off into employment. They were horrified that a Churchyard should be in service, but she stuck to her guns. She went to live in Essex with an old widower called William Cornwell at Wendens Ambo. She settled in there very comfortably and did a good steady job managing the farmhouse, with a cook and a housemaid to help her.

When the old farmer died she came back to Woodbridge to retire. Only later did I hear that she had come to ask if she could live with me. My misfortune was that I was out and Charley spoke to her. She explained her thoughts and asked him to tell me when I returned. He did not mention it at all and so I of course never replied to her. He did not want to share me with anyone. Eventually I heard that Bessie had gone to live with my sisters at the library. I was pleased of course that she was well and had a home to go to, but I was sorry that she had not asked me. She in turn thought that I had ignored her, so she had sadly reconciled herself to not knowing me. When I learned the truth from a slip of Charley's tongue, I was furious with him, angrier than I could have imagined. So he went for a visit to our cousins in Cheltenham and did not return for a month. He finally reappeared with his tail between his legs, cowering as though I might well beat him.

Eventually I managed to catch Bessie walking on the Fen Meadow one day.

'Bessie, Bessie,' I called out and saw her hesitate. 'Bessie, please wait.'

'Good afternoon, Ellen.' She smiled nervously, not sure what I was going to say.

'Oh Bessie, Charley never told me that you had come to the cottage,' I blurted out. 'I am so sorry that I wasn't there when you called, you would have been very welcome to stay with me. You can, indeed, any time that you may wish.'

I rushed along saying too much, desperate to tell her that I had not ignored her. A look of great relief flooded her face and I realised just how much it must have hurt her, just how much pain Charley's selfishness could cause.

'I am glad that it wasn't true that you wouldn't even speak to me. I couldn't understand what I might have done to be so spurned.'

How I winced at her words, how I cursed Charley.

'Please forgive me; I never knew until weeks later when he let it out by accident. But when I heard the whole story it was too late. Are you all right at the library?'

'Oh yes, it is fine. There is plenty of room for us all. I find that I fit in very well. I can help with the housekeeping and the others are free to work in the library or to paint, they

94. Interior with Family Group. *By Thomas Churchyard. Oil on Board. 6¼ x 5¼ in.* *Private Collection.*

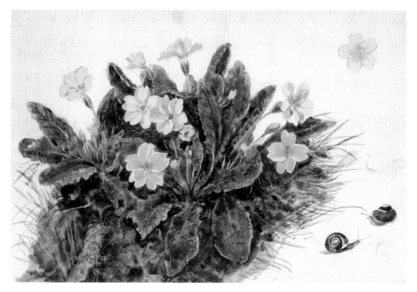

95. Primroses on a Bank. *By Emma Churchyard. Watercolour. 9 x 13 in. Private Collection.*

are much better at both than I.'

'Can you ever forgive me?'

'Oh my dear there is nothing to forgive. It wasn't your fault that you were out. If anything I am at fault for trusting a message to Charley. Why is he so difficult? The thought that you wouldn't speak to me weighed heavily on my mind. Now I know that isn't true I am happy with everything.'

'My dear sister, we must never let such a thing come between us again. Believe me that I will always love you.'

With that I reached for her hand and she pulled me to her for a kiss.

It was soon after Bessie had settled into the library that death came once again to shock us. It was the following November; the weather had been very sharp again although not as bad as the previous winter. I was alarmed to find William Jarrold, Ernie's older brother, at my door, looking very white and anxious.

'Please M'm, I've bin axed t' get yer. Yer sister's poorly an they reckun' yer shud come now.'

I put on my cape and followed him up the hill to the library. Bessie let me in and it was the first time I had crossed that threshold. I still had no idea who was ill. Clearly it was not Bessie, who for some reason I had been imagining it was. It was Kate, Kate the wag, Kate the funny little thing of our youth; only fifty years old like poor Emma before her. I could not believe it, it did not seem right, so young.

It was Kate herself who had summoned me, and Laura stood stiffly at her side, listening for any betrayal to fall from those white lips.

'Kiss me, Ellie, like you used to do, kiss me goodbye,' her voice was just a breath.

I kissed her forehead and shushed her.

'Everything is all right, my dear, sleep tight,' I said and she closed her eyes with a sigh.

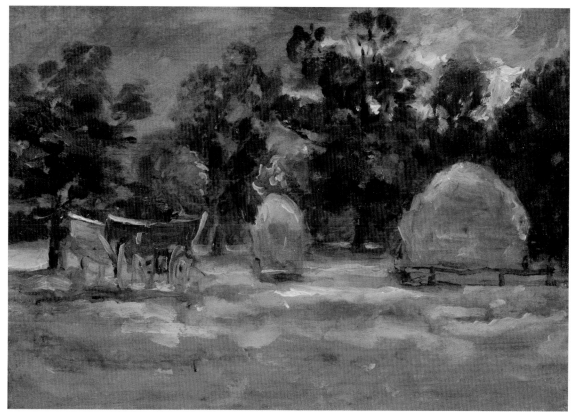

96. Haystacks and a Farm Cart beneath trees. *By Thomas Churchyard. Oil on Panel. 5 x 7 in. Private Collection.*

She did not die until the next morning, but she was peaceful. We had all sat wordlessly by her bedside, wrapped in our own worlds of thought. When it was over I walked slowly back home, thinking of the regrets I had felt when Emma had died and how I had so wished I had been able to speak to her. Maybe Kate had felt the same; she had had the strength to get her way at the last.

Kate was laid to rest near to Emma and in due course a bundle of Papa's pictures had come down the hill to me, my share of Kate's inheritance.

Now since Anna's death it is just Bessie and Harriet at the library. Over the years I had been sister, mother, tyrant and traitor in their eyes; now I was just sister again. I actually get along quite well with them. Has death softened them or were they simply not the root of the problem? Laura died two years after Kate. Laura had long been my greatest critic and she was stronger than the others. Laura and I clashed. She had hated the trust Papa placed in me, she had hated that I was the eldest, the 'Miss Churchyard'. She had taken control of The Mice, very proud of her position as librarian, which conferred on her the role of head of their household. Now Harriet is the librarian, she is the guardian of the books and of the boxes in the attic. Harriet, another one of the strong and able; she has

always had great ability and a special style of her own. I do not really know why she was prepared to submit to Laura's rule.

And Bessie, bless her, at once the most vulnerable and yet the only other who had a life of her own, at least for a while. She managed to get away; she managed to be free because she never thought that she was special. And that is exactly what did set her apart, she was the most special. Suddenly I felt that I wanted to send Bessie something that would remind her of our childhood. It must be the reminiscing I have been doing that has given me the idea, but it must not be anything with sad connotations. It has been a sad enough time since Anna's death. Something to cheer her up, or better still something to cheer them both. Maybe something from the lacquered box? It was hard to think what would be right; Bessie is much younger than I and would have been too young to share many of my memories. Maybe the poem that our cousin, Mary Hailes, sent from Cheltenham? She had written that she was envious of our painting abilities; that was a good time in our lives, we made an album for her of paintings by all of us to show our budding skills.

I think that it was when I was nineteen that I first went to visit Mamma's brother, Uncle John, and his new wife, Aunt Mary, in Cheltenham. I had heard all about the big wide world from Fitz, whenever he came home after his travels around the country, and I wondered if I would ever travel. I had not left Suffolk in my life, and for a while I yearned for a taste of the world. The only hope seemed to lie with Uncle John, who had returned from India with his family. There he had been a soldier for thirty-two years, only returning to England when he retired at fifty. He was a widower and had three daughters, cousins we heard of maybe once a year. At first they visited Grandma Hailes in Ipswich, then they moved to the Lake District to settle. Just when I thought that I might by allowed to visit them there, we had news that he had remarried, to Miss Mary Green, and they had moved to Cheltenham. I wrote to send our best wishes to our new aunt, an elderly daughter of a parson, and I added that I hoped I might see Cheltenham one day.

97. A Portrait of a Gentleman. *By Ellen Churchyard. Watercolour. 4½ x 3½ in.* *Private Collection.*

I remember Mr B saying that if I went travelling to such a fashionable city I would be surrounded by beaux and would never want to come home again to our dear old town. Fitz had said the opposite, that I would soon realise that I wanted to be nowhere else other than our dear old town for the rest of my days. Papa said I should not worry about the problem until I received an invitation. Times were

98. A Glade near Woodbridge. *By Thomas Churchyard. Oil on Panel. 4½ x 6½ in.* *Private Collection.*

changing, I was changing, and the world around me was changing too. I thought that I was so grown-up; everyone said that I was, I had no reason to doubt it. Looking back now I see that I hardly understood a thing.

When Emma and Laura had returned to school for their second term and I was sure that Mrs Watson was to be trusted, I finally accepted an offer to go to Cheltenham to visit Uncle John and Aunt Mary. He had written inviting us all to go, but I did not think that we should all arrive at once. Papa insisted that the younger ones could not go until I had, so I found that I came under a lot of gentle pressure to have a break. Papa knew that I had worked very hard to organise our move to Marsden House and to get everything running smoothly. I sometimes think Papa also had some inkling of the pointless affection that I held for Fitz. He had a vague hope that by sending me to school at Bury or to visit Cheltenham I would be distracted by young men of a more suitable age.

Uncle Augustus, also a widower and retired Lieutenant of Marines, had visited his brother, John, and shortly afterwards married Aunt Mary's older sister. They had moved into a nearby road and settled down to a new life. Then drawn by this new Hailes enclave, Uncle Henry Hailes retired and moved his family to Boddington, only five miles from

99. Landscape with Trees. *By Thomas Churchyard. Watercolour. 3½ x 4½ in.*　　　*Private Collection.*

100. Trafalgar Square, London. *By Thomas Churchyard. Pencil. 3¼ x 5¼ in.　Private Collection. (Photograph courtesy of David Messum Fine Art Ltd.)*

Cheltenham. A visit was therefore agreed to be an easy thing to arrange as there were three uncles to entertain and amuse me. Needless to say by the time the invitation came I had no great desire to go there; I wasn't inclined to fashionable places and my dreams of seeing the world had dwindled. But it seemed that, until I did, no one else was to be allowed; a sort of gentle blackmail.

The visit was arranged and Papa was to escort me to London by coach and train. There I was to be met by Aunt Mary, who would accompany me to their house. Of course I enjoyed Papa's company and the half-day we spent together in London. He

showed me the wonderful column and statue in Trafalgar Square, which had been newly erected to commemorate that great battle and Admiral Nelson. Papa said that he had seen Nelson when he made his victory progress from Yarmouth to Ipswich, although he confessed that he could not remember it; Nanna had told him. Nelson had lived for a time in a house called 'Round Wood', on the Woodbridge road from Ipswich, but his nerve-ridden wife did not like Ipswich and Ipswich by all accounts did not much like her. Nelson's father was reputed to have said that it was because she would not talk 'scandal with the County Tabby Cats!'

I actually enjoyed my stay with Mamma's family; they were all very kind. Cheltenham was elegant and buzzing with life and society. We drove out to the surrounding countryside in Uncle John's phaeton; we visited friends and also dined with them. Every day was full and pleasurable, but as soon as the time came for me to return I was ready to go. I had to promise to return and to recommend them to my sisters. I felt that young lady visitors were a sort of currency in a fashionable resort like Cheltenham. I had dreamed of travel when I was younger but now I longed to be left in peace at home. Mr Barton wrote to me to tell the news and each word seemed to pull me back. Mamma was fine, in the capable hands of Mrs Watson; Papa was busy with a case about stolen firewood; Lucy Barton had been away too, visiting Fitz's sister Jane in Holbrook. Mr B said that he had been very quiet without her and without me to chat with; he was afraid that he had been rather pestering Papa for company.

After I had been to see the cousins, the others were allowed to follow and did so in their

101. Nelson's Column, Yarmouth. *By Thomas Churchyard. Watercolour. 4½ x 7 in.*　　　*Private Collection.*
(Photograph courtesy of David Messum Fine Art Ltd.)

102. The Cherry Tree Inn, Woodbridge. *By Thomas Churchyard. Black Chalk. 3 x 4¼ in.*
Private Collection.

turn. I am quite sure that Bessie must have gone too. The poem from our cousin was ideal: it was complimentary and funny and from a happy time. So I sat and wrote a little note to go with it, saying that I had found the poem and wondered if they remembered it too, and then I tied them together ready for Ernie in the morning, hoping that he would come before Charley surfaced to avoid the sarcastic comments that would surely follow.

Then, as if I had spoken of the devil, Charley appeared in the doorway, either home late from his painting or early from the pub, I was not sure which.

'So how did it go?' I asked, hardly daring to hope.

'It was good,' he admitted, almost sounding happy.

'Tell me about it. Come in and sit down. I'll put the kettle on if you would like.' I knew that I was risking a great snort of contempt but was amazed when he accepted my offer.

'I went down by Wood's nursery,' he began, but all I could see in my mind's eye was the Cherry Tree Inn, indeed a picturesque but also a tempting subject. 'I thought that I would try to get some studies of trees and shrubs done, to get my hand in again. Anyway after half an hour someone came over and looked at what I had done. It seems that Wood's has been taken over by Notcutt's and they would be interested in a series of paintings of the nursery as it stands, then maybe some more later on when they have made some changes.'

He was clearly flattered and this would go a long way with Charley. I tried to sound impressed but without putting him off by being too keen, which I have done before. This was a tightrope that I often had to walk. It seems that he had a commission and that he was inclined to accept. I could only keep my fingers crossed and hope that all would go well.

In the morning Ernie dutifully arrived and carried my letter to the library, and then after

103. Valley of Fern. *By Thomas Churchyard. Print. 2¼ x 3½ in.* *Private Collection.*

breakfast the following morning I was surprised by a knock at the door. Opening it I found my little messenger, Ernie, grinning nervously at me, holding out a letter and small parcel.

'Miss Elizabeth Churchyard asked me to call this morning to bring this to you.'

'Well thank you, my dear. Do you have time to stay or are you busy this morning?'

'I'm sorry but I have to go. There is no school today but I have errands to do for my mum.

'Good, I am very glad that you are a help to your mother. Well, be sure to pop in again as soon as you have the time. I'm always happy to see you.'

'Thank you, Miss,' he said as he sidled backwards towards the gate.

I could not decide whether to open the letter or the parcel first. After sitting and staring at both for a few minutes I thought that opening the parcel would tell all, so laying aside the letter I carefully untied the string on the little bundle, and peeled back the paper with bated breath, to find before me Mr Fulcher's Pocket Book from sixty years ago. I knew immediately that it was the one that contained Papa's picture of the Valley of Fern and I felt my heart sing. I knew straightaway that Bessie, too, remembered the old days and treasured those memories as I do.

We were introduced to a little vale close to our home in Melton, which Mr Barton dubbed the 'Valley of Fern' in a poem; from then on it was always known as this. It was along a path that we had seldom used before. It sounded so romantic that we promised to arrange a picnic together there as soon as could be. When a suitable Saturday afternoon arrived both families set out from our house, with hampers and easels, through the long grasses and wild flowers, to the site of the 'Valley of Fern'. In the poem Mr B had contrasted the valley then, with how it had been when he had first seen it years before. He wrote, 'the hand of the spoiler has fallen upon thee.' But to our eyes it was glorious still. 'That just shows you how perfect it was before!' he insisted. Papa smiled sadly. 'One

104. Valley of Fern. *By Thomas Churchyard. Print. 3¼ x 5¼ in. (Selections from the Letters and Poems of Bernard Barton)*

day it will all be houses I suspect, as the town grows and eats up the villages around.'

There we carried our picnic and carefully selected our position, setting out our rugs in a little clearing. Papa immediately began to sketch the view down through the trees below, looking towards the gleaming river from whence came a cool and fragrant breeze. From our rugs we could see the dusty heads of bluebells beginning to fade, and drooping cowslips tired after their proud display, but up through the grasses pushed the delicate heads of orchids and marsh marigolds about to take over the stage. In a nearby copse a woodpecker drilled and then flew home in a flash of red and green with his booty. A little owl dozed in the sunshine on the dry stump of a lightning-blasted oak. Later, as the shadows lengthened, we were all lulled into our own deep reveries — even Papa had stopped sketching and was lying on the grass — when the sound of a nightingale began to fill the valley. It was as in a dream and no one wanted to be the first to wake.

And here was the *Fulcher's Sudbury Pocket Book* published the following year, 1834, with Mr Barton's poem and Papa's drawing, etched and printed in black and white; inside it a pressed fern frond from that day, a cousin of the frond that I have in my box, the very one I had wistfully regarded just a couple of days earlier. In my mind I can still feel the warmth of that sun and remember the sounds, the scents and tastes; a time when we were all together, all happily playing and dreaming. Lucy Barton happily helping Mamma with the little ones and Laura playing with Emma and me.

Then I hesitate: surely I cannot remember Bessie there on that day? I feel that she was not born; certainly she is not there in my mind's eye. Quickly I open the letter to see what she has written to me. There I find that I am only partly correct; she was there but she was not yet born. She tells me that she thought I would like this memento that had been

Laura's. She says that she has always felt that she could remember the picnic because we had so often mentioned it when were young. She says that she feels she was there in spirit.

It is so good to read the note and see the book again, but deep inside I am more pleased that my sisters did in fact share their memories and treasures after all. Maybe I have misjudged them all this time. Before Charley can spoil my mood I carefully place these new treasures in my Chinese box and then slide off in my mind where he cannot follow.

Papa had other sketches engraved by John Hawkesworth, a London illustrator, such as *Melton Spring,* which was a spot to be found near to the old rectory where the village had once been. The improved roads to London and Yarmouth had drawn the village away from its old base, and the old church now sat alone with its shady churchyard. People still made the effort to walk up to the old spring to get their water because it was reputed to be good for rheumatism and many everyday ailments. When the gypsies camped at Gallows Hill, Papa sketched their canvas houses for *Gypsy Encampment* and told us tales of the old village wise women and the Witches Pool, where they were dunked to prove their guilt. He, like Nanna, loved the old stories but he did not take them very seriously. He did not like people to scare us with wild tales. He was cross with Tom when he came home from Uncle Isaac's farm with tales of Black Shuck, the Devil's dog, who ran the roads or frightened folk along the river-walls. It was not so much the stories, which the farmhands had enjoyed passing on to Tom, but the pantomime afterwards. I remember when we played in the evenings out in the harvest fields, then Tom would come up behind us at twilight panting loudly like the yellow-eyed black hound from hell. The shrieks were enough to call up Black Shuck himself. Then Papa was not amused, as he did not want us to have nightmares.

105. Suffolk Pollards. *By Thomas Churchyard. Print. 3¼ x 5¼ in.* (*Selections from the Letters and Poems of Bernard Barton*)

But making the mistake of smiling to myself seems to be a red rag to a bull when Charley finally appears in the kitchen. He is clearly not a morning person, especially when he has enjoyed an evening in one of our many pubs with his fair-weather friends.

'I didn't see you last night, how did your painting go?' I ask, hoping to sound suitably uninterested for fear that he will snap back.

The snap does come back, 'What's it got to do with you?' I obviously did not get the balance quite right.

'I was only enquiring. You said that you had a commission and were going out to paint.'

'Oh, I have done some sketches and laid out some pages, but what's the point of it, I'm sure no one will want them in the end.'

'If you don't do them you will never know. There's always a chance that they will take them, and anyway, your work is so good that if they don't you're bound to be able to sell them to visitors in the summer.'

He softened a little at my words of praise. Needing constant reassurance and no criticism whatsoever makes talking to him a delicate line to tread sometimes. As always I wonder how he came to be like this: selfish and mean. But when all is said and done he is my brother, and in some ways I was almost a mother to him when he was born. For a while our poor mother, so worn down by childbirth, could hardly look after herself. So Charley was the last child and spoiled by all until he became a young man, when out of the blue people expected him to do something for himself. This was naturally a great shock to him; he had not seen it coming and reacted very badly to the idea. He is still reacting badly and still does not see what is wrong with his doing nothing. I wonder sometimes what will happen to him when I am gone for good. Maybe the trustees of Thomas Seckford would be so kind as to consider a charity for Charley; they've been so kind to The Mice.

I can recall my surprise when this sullen visitor first arrived at my door. Charley had soon heard that I was well settled and had some money, multiplied no doubt in his mind to wild proportions. He said that he was worried about me being alone and thought that I needed someone to look after me. I could see where this was leading. He said no more but promised to visit again soon. Oh joy! Just when I thought I should have some peace.

In a few days he was back and this time telling me how much he hated his job, his life, he had no prospects and no home to call his own. I discovered that I felt rather detached from his problems and realised that I did not much care, but I also did not much worry if he wished to come and live with me either. I realised that I would never be his slave, I had the upper hand and the money, so if he came it would be on my terms. Not much caring helped a lot. I felt quite unemotional about him; he could stay but he had to behave or he could leave.

So rather too soon after my freedom arrived, I found that I was sharing it with Charley. He moved into my spare room but I did not give up anything else. He had to eat what I put on the table or go without; if he missed a meal without telling me, the next meal I only prepared for myself. He was not welcome in the front room, which I felt was my own domain. He soon realised that I was not going to dote on him at all. But it still suited him well not to have to work, and to be able to hang around with his cronies on the corners and gossip. If he wanted anything more than his room or meals he had to paint a picture and sell it.

106. Woodbridge. *By Thomas Churchyard. Print. 3¼ x 5½ in. (Selections from the Letters and Poems of Bernard Barton)*

The gossips said that he lived off me, which I suppose was true in a financial sense, but he did not live off my independence and freedom. Those I guarded jealously. He was a pathetic creature, this boy that my parents had wanted so. I never had to worry about him in any other way though; he would not have touched my things or taken my money. He was rather like a sullen dog; he knew that he needed me and so was very wary about upsetting me. We had few problems, as he soon learned what I expected and made sure that he did not cross the line.

Neighbours joked that Charley had only moved to town again because the Ipswich racetrack had closed. It was true that he seemed rather easily to lose the little money he ever earned on gambling or on drink. I think that he was an easy dupe for more cunning men. They managed to persuade him that he was a man of the world and in the process he lost all. He was able to dash off sketches and paintings or plans at a moment's notice, but they were not as good as Papa's work by any means. I think that is because of his lack of love for his subjects. He could have been much better if he had cared about what he looked at. He complained that there was no future in art now that Eastman Kodak had brought out their film and processing system, which made it so easy for anyone to have images of their favourite places. He liked new inventions because he thought that they were all designed to reduce his own efforts. He complained about my oil-lamps when he heard that gas-mantles were the thing. Then just as quickly he coveted electricity, which was becoming more and more common in the larger households that could afford generators. Electric light was the only way to go, he said. But I liked my oil-lamps, which were soft and cosy. I thought of Fitz and his poor eyes; he would have liked electric lights to save having to sit up close to a lamp and squint at the books. He, too, had always rather liked new things, while affecting to not care for them.

CHAPTER 8
THE WINTER GARMENT OF REPENTANCE

After a busy morning preparing a tasty little suet pudding for my dinner, I had a sit-down for an hour as is my habit, then decided to set out for another walk. Not so far this time, since my muscles were aching a little from recent excursions and the weather was not so promising. Thus I indulged my heart and went in a new direction, wandering past Fitz's old house, 'Little Grange'. I had walked this way most afternoons until his death, popping in to chat for half an hour about the latest gossip or the old days we both so treasured. He was sometimes away but I still called, as I also liked to chat to Mrs Howe who kept house for him. John and Mary Ann Howe were real characters: John always in his blue pea jacket and Mary Ann in a bright red skirt with matching cloak. Fitz had called them his Fairy Godmother and the King of Clubs; they liked him very much and appreciated the way he went to great lengths to make their lives as easy as he could. However, in some ways he was a typical man and did not notice what was in front of his eyes. For example, in later years poor Mrs Howe suffered very badly from rheumatism. Although she was kept awake at night by the pain and could barely move some days, yet without complaint she did the housework at Little Grange as usual. Finally I told Fitz what he had not seen for himself and he was horrified. Then I was soundly chided by Mrs Howe for telling him what she had literally taken great pains to not tell. He immediately sought help for her in the house and asked the doctor to call regularly to try any remedies he could find.

'I don't know what I would do without you, Ellen,' Fitz had said, his words striking deeply into my heart. How many times he had said such things over the years and yet he had never seen the pain that crossed my face. My love for him was as invisible to him as Mrs Howe's rheumatism. So it is always bittersweet to walk that way; everywhere there are ghosts to haunt me, beloved ghosts. Every twist and turn of the road recalls moments of happiness and of pain, stretching right back to those early days when we had left our first home and gone to live with Nanna Churchyard in Melton, when Papa had left us for London. Looking back now it did not last for long, but those few months were an eternity to us then, at least to Tom and I, who were the only ones who seemed to really care.

My brother Tom and I were as twins when we were very young. We did everything together, we shared everything and we understood each other without any effort. His thoughts were my thoughts, his disappointments mine and his joys, my joys. There was just a year and a half between us at birth and we were so well loved; the two first born, the son and the daughter, we completed the newly built nest our mother dreamed of creating. We were the first children of this new generation in our family, bringing hope and a sense of the future to the great-aunts and uncles and also to our grandparents.

When we were born Mamma and Papa lived at 29 Well Street, in Woodbridge. Mamma, married just a few months before Tom's birth, had been Harriet Hailes, daughter of Captain George Hailes RN. Grandpa Hailes had been a naval officer, but had spent much

107. *Little Grange. By Laura Churchyard. Watercolour. 6½ x 11¼ in. (Courtesy of Ipswich Borough Council Museum and Galleries)*

of his career based on land in charge of the defences that guarded the coastline. Not for the Hailes the long months away from a father while he was at sea, the fate of most naval families. He retired on half pay after the war with France was over, but they were not a settled family even then. Mamma's three brothers went off to seek their fortunes in the wide world and then her own mother left home and went to live with her elder daughter in Ipswich. Grandpa Hailes died when I was just a baby; Mamma had to depend on letters to keep in touch with her own family and had only the constant company of her mother-in-law for any practical help. She must have missed the whirl of family life, the chatter of her sisters and the boisterousness of her brothers. Papa was altogether more self-contained, both used to and happy being alone.

Thomas Churchyard was a newly qualified solicitor setting up in business in Woodbridge. His parents had worked hard to send him to school to qualify for a profession, to raise him up from the hard work of his forebears, who were farmers and drovers. He was their golden boy, their pride and joy. So in 1825 and 1826 when Tom and then I were born into that little household it seemed that everything was quite perfect.

Papa had a little money to help him get started in life: his father Jonathan had died at a

108. Study of a Cow. *By Thomas Churchyard.*
Pencil. 2¼ x 4¼ in. Private Collection.

109. Cattle Grazing near an Estuary. *By Thomas*
Churchyard. Watercolour/Chalk. 3¼ x 4½ in.
Private Collection.

relatively young age and left his only son half of his estate. Jonathan had been rather successful during his life, working with his own father droving cattle and sheep to market in London and supplying the many troops that had been stationed near the coast, ready to defend against Napoleon's invasion. The expected invasion seemed to affect the lives of all around, bringing prosperity to the farmers for a while as well as jobs for other professions too. But as soon as the alarm was over and the troops were dispersed or pensioned off, the good times seemed to fade away.

110. Picnic in Gainsboroughs Lane, River Orwell. *By Robert Burrows. Oil on canvas. 24 x 36 in.*

Private Collection.

Mamma's father had also died just after I was born, and so Mamma's share of his estate was added to their means and her little nest was furnished. While Tom and I grew happily together Mamma had set about producing more babies. Every two years another daughter was born and space on Mamma's lap became more and more scarce. Was this why Tom took it into his head to look after me? Is that why I learned to look to Papa for attention and comfort? Maybe it was just the way of things in those far-off days. Emma was born and so at two I was no longer the baby. Laura followed and at four I was able to roam around with Tom as my guardian. Then, just as Anna appeared, when I was six and Tom was seven, everything changed; our life was literally tipped on its head.

Tom and I remembered this time very clearly and we never forgot the terrible lesson that it taught us: nothing is forever. The babies did not seem to notice at all and in later years could never understand why we recalled it with such horror. Papa's collection of paintings was sold in an auction at the Crown Inn. The walls were suddenly bare and this in itself was shocking: our walls had always been covered with the most beautiful paintings and now only a very few remained, which had not been considered worthy of sale. The following year worse was to come: the furniture from our home was auctioned by Papa's

friend Ben Moulton – the books, beds, tables and chairs. Everything was gone and so were we. Mamma and her brood of children were despatched to Melton to live with Nanna Churchyard and then Papa left for London.

Papa had a dream that was even bigger than Grandfather Jonathan's dream of him being a successful solicitor. Papa wanted to be an artist. All he wanted to do was to paint, but he knew that if he were ever to be successful enough to support his family then he needed to be in London. He was to go to seek his fortune and when he had made his name he would send for us. Then we would follow on the Blue Coach to join him. Papa had been riding high on happiness and confidence; he had been asked to be a founder member of the Ipswich Society of Professional and Amateur Artists. The other founders were respected men of talent and authority. He was flattered to have been included with Robert Clamp, the Ipswich schoolmaster; Robert Burrows, another local rising star; Samuel Read; the Revd Richard Cobbold, author, poet, artist and son of the lovely Elizabeth Cobbold; Jabez Hare; Stephen Piper, a publisher; and even a young gentleman called Edward FitzGerald of Wherstead Hall, recently down from Cambridge. Papa was proud to be associated with these men, but he dreamed of following the paths of Constable and Gainsborough out of Suffolk to fame.

Papa's friend George Rowe went with him, also a young and promising artist, but he was luckily without the ties of a wife and five children. Mr Rowe had lived near to us; both he and Papa had convinced each other that it was worth the try, worth the risk. After all, how would they ever know if they did not try? They both admired John Constable and his work. They knew that he had left his beloved East Bergholt and the Dedham Vale to follow his dream. They knew that he exhibited great works of art at the Royal Academy and that he was forging new thought and new ideas in art. They needed to go there and try to be part of that movement.

This is what we learned later when we asked Mamma why everything that was so perfect had had to change. At the time we were simply in shock at the sudden rending of our lives. Mamma was never worried; she had thoughts only for her new baby and did not notice the effect it had on her older children. Luckily we had one ally, one saviour: Nanna Churchyard, who saw how it was and took it upon herself to keep us busy until her son reappeared. She took Tom and me out and about with her when she went visiting the family and the poor of the parish. She spent time with us talking of the days when Papa was a boy, keeping him alive in our minds, and she reassured us that we would find everything back to normal again soon enough. She loved her son enough to help him make his attempt to change career, but she had not lived her long, hard life without learning something of the nature of these things. She was quite sure that it took more than skill and talent to make a living in art.

This was our first drama. Tom and I had clung to each other and together had survived until the day, in fact only a few months later, when Papa came home again and began to rebuild his previous life. He had found that it was no easy matter trying to work, trying to get paintings accepted and hung. The sorrow that he felt when he decided to return can only be imagined, as he never spoke of it again after he came home. It was in the past and the future involved rebuilding his own household and restarting his career as a solicitor.

111. Landscape with Trees and Sheep Grazing. *By Thomas Churchyard. Watercolour. 10 x 15 in. Private Collection.*

We moved out of Nanna's house and into 'The Beeches', on the corner of the crossroads in Melton, still near enough for Tom and me to walk back down the street to Nanna's whenever we needed her love and help. Papa began to work from an old building in Quay Street, Woodbridge, then quite soon he went into partnership with Edwin Church Everitt and worked from 'Marsden House', Cumberland Street. Life began to follow the old pattern once again: a new baby arrived the next year, another girl, Elizabeth or Bessie; then Harriet two years later. Papa worked hard to support his growing family of one sturdy young boy and six daughters aged from ten to newborn. He took in a new partner, Daniel Charles Meadows, brother-in-law to the successful barrister Rolla Rous. Papa also continued his painting and drawing at every moment he could spare.

Tom and I had weathered the storm that had shaken our world and we were happy that all was well once more, although something remained with us that I believe made us remain more self-sufficient, more independent than our sisters. We needed to know that we could look after ourselves. That sounds strange for a young girl but I knew then that I needed to have more control, an easy thing perhaps for a girl with a mother perpetually distracted by her babies. Girls were expected to help and so I learned how the house ticked and how life was organised. The time spent with Nanna came later to be one of my most treasured

112. Landscape with Cattle Grazing Under Trees. *By Thomas Churchyard. Watercolour. 3½ x 4½ in.*
Private Collection.

memories; born out of fear and confusion I found a soulmate and a guide. I came to love Nanna very much and I knew that she loved me. Nanna walked with us and talked with us and together we had learned a new rhythm to life. Nanna talked of Papa when he was a boy, and Tom loved these tales, which seemed to unite them together more than before. Nanna walked with us all around the lanes showing us where Papa had played in the Splash, where he had climbed the blasted oak or had hidden under the old gorse bushes with his puppy. In his absence he came alive to us in a new way. We went to visit relatives we had never seen before, in crumbling farmhouses set like ships afloat the green sea of young corn, which rippled and swelled around them. Tom loved the farmyards and the animals. He wandered off to cut himself a spear from the hedge and to go hunting imaginary game. I loved the warm hearths, the singing kettles, sitting on an old rag rug and listening to the murmured stories of days gone by.

Thinking about that move to Melton, it has just occurred to me that it was the beginning of the difference between Papa and Tom. Not the fact that Papa had gone away, but that the time spent at Nanna's was when Tom learned to love the countryside, when the dream of being a farmer had taken hold of him. When Papa was a lad his parents had pushed him to do well at school and had encouraged him to learn a profession. They wanted to lift him from the hard work of farming and trade that the family had always followed. Although he had wanted to paint he had dutifully studied and taken articles to

113. A Ploughman in Open Landscape. *By Thomas Churchyard. Chalk. 3¼ x 5¼ in.* *Private Collection.*

please his father. It was always hard to change station in life, and he still had a fight on his hands even when he was fully qualified. The four solicitors in Woodbridge were all related to other established solicitors; that was the way the system worked.

In due course he had wanted Tom to learn a profession, but Tom wanted to farm and they argued about it for a long while. Tom could not understand why his ambition was disapproved of. He came to believe that it was in his blood and was his destiny. But it seemed that some of the adults thought he was going backwards, back to the hard work and risks of the old days. A profession would have guaranteed him a standard of living and a position in the world. Tom did not want a position; he wanted satisfaction and the sensual pleasures that would reward his labours. We talked of it often and I knew his feelings on the subject well. This made it hard when I heard him criticised. He was accused of being awkward and ungrateful, he was chided for not obeying his betters. But no amount of discussion or nagging would change his mind.

In the end Papa decided that if he was so sure he should be allowed to try his hand, but he had to do it Papa's way. Tom agreed; he did not mind as long as he could see his goal in the end. It was much discussed within the family and eventually it was agreed that Tom could expect to inherit Block's Barn, which was Nanna's; as well as marshes at Ramsholt and farms at Clopton and Burgh, which were owned by his great-uncles who had no sons of their own. There was also the tenancy of Byng Hall, which he could take over in due course. This all

seemed at least to give the plan a chance of success. I felt sure that the great-uncles were pleased to have the only boy child of the younger generation wishing to follow them.

It was however a very bleak time in farming, particularly in Suffolk. None of the farms were doing as well as they had done twenty years before. Tom argued that there were many new methods and techniques which could halt the downslide and turn the land back to profit again. The big advantage of being well educated and intelligent was that he could defend his corner in the fight. So later, when he was fourteen, he was enrolled in Mr Downes' Classical Academy at Wickham Market, which prided itself on its scientific approach to farming. It had a farm, a laboratory, a collection of philosophical apparatus, a geological collection and a library. There Tom was to become a gentleman farmer, to try to please everyone.

It was a great loss to me when he was away. I had not realised just how much I depended on him, quite how much we were friends. Everything that happened, everything that was said seemed to lose some of its excitement because I did not have Tom here to share it. At first we wrote to each other often and I could save up my tales and my observations to send to him. But after a while his letters became less frequent and then if they did come they were full of his studies or tales of the farmhands. I tried to be pleased that he shared it with me but I feared he had lost interest in our family. At least he was communicating with me, and I tried to ask him sensible questions when I wrote back, to encourage him to reply. So gradually we spoke less of home and more of his new world. A world I tried hard to understand or feel for as he did, with little success, I fear.

When he came home for holidays his conversation, too, was all about farming and his plans for the future. I was happy for him but I felt a loss inside myself. He was becoming a man and I supposed that I was now no longer a child, but I was not ready to lose the childhood that seemed to be fading away from me, and all of my efforts could not retain it.

When he talked of the farm, he came alive with the stories. The men were full of magic and spells for getting the best from the animals, and it was not just the men that Tom admired; he loved the horses too, the Suffolk Punches, beautiful 'chesnut' beasts with their deep chests and solid shoulders. They did not have the feathered feet of the Clydesdale or the Percheron, as on the heavy mud of Suffolk the feet of these horses would have always needed cleaning. The Suffolk horse was the pride of the county and the new love of Tom's life. I felt jealousy, silly and irrational, but very real all the same, when he spoke of the horses with such passion and I could hear that he no longer needed me, I no longer shared his world. So in this way I slowly lost Tom; he came home less and less. When he was not at the Academy he was with Uncle Isaac at Byng Hall. He was our own 'Farmer's Boy'.

Tom did not like the gentility of our life; he was not entertained by evenings of witty conversation. Like my dear Edward he rejected the life his family led and longed to be his own person. Fitz loved his family but hated their way of life, the society and the fashions. We were not so high and mighty, but Tom shunned the drawing-room for the farmhouse kitchen.

114. Burgh Church and Windmill. *By Thomas Churchyard. Watercolour. 3 x 4 in.* *Private Collection.*

115. Logging in the Snow. *By Thomas Churchyard. Watercolour/Chalk. 3 x 4½ in.* *Private Collection.*

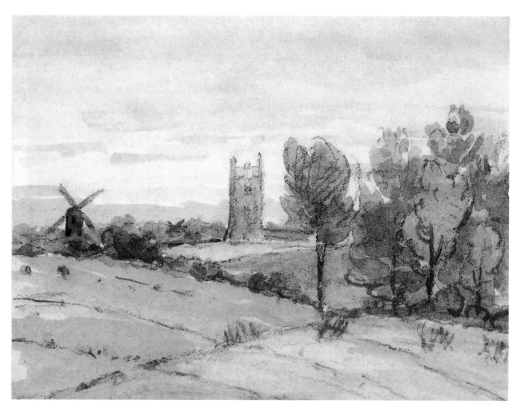

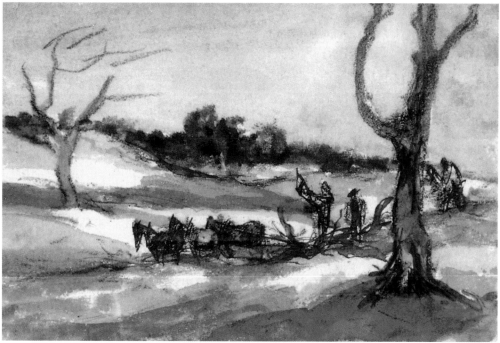

CHAPTER 9
WITH FATE CONSPIRE

Feeling that I was losing Tom to his ambitions was a sadness in my life, but when Nanna died I was distraught. As so often in those days it was dearest Mr Barton to whom I turned for words of comfort. He had the language of consolation, the balmy sentences of true faith. His unwavering confidence in life, his trust in the rewards of goodness, all assured me that Nanna would be at rest. Eventually I turned my attention to the root of my truly selfish grief: that I had lost a great friend and ally. Mr Barton said that I should be thankful for the many years we had shared together.

Charles Lamb an acquaintance of Mr Barton, once said:

> 'When the spirit is sore fretted, even tired to sickness of the janglings and nonsense and the noises of the world, what a balm and a solace it is to go and seat yourself for a quiet half an hour upon some undisputed corner of a bench, among the gentle Quakers.'

Is that why I always ran to him to find peace and a steadying word? From the first time we met, when I was but a child, I was drawn to his peace and his love. He showed me how to find that deep still place at the centre of my being and that place became my salvation; without that oasis of calm I would not have been able to bear the disappointments of this life. Knowing that he had borne his own disappointments so stoically, how could I complain? Papa had told me the story of his sad life, yet I knew that he never shirked his duties. Watching him I learned that sometimes hard work was its own reward. Oh dear, this all sounds very worthy and pious and I do not mean it to be. All I mean to say is that his example was my inspiration and for that I was always grateful.

Mr Barton had indeed had a sad life, studded with loss and hardship, and yet he was one of the happiest souls, always able to find the good in any situation. His mother had died when he was born and then his father died when he was seven. He was sent to live with his grandparents and then later he went to the Quaker school in Ipswich. He came to Woodbridge to begin a business as a coal and coke merchant and married Lucy, the niece of his former master. The following year his beloved wife died in childbirth, just as his mother had before. He always called her his 'angel wife', as she lived always in his heart. The baby girl was named Lucy too, and was sent to relatives to be raised, while Bernard, heartbroken, gave up his business and left Woodbridge to become a tutor in Liverpool. But he could not stay away for long and returned to work at the bank of Dykes and Samuel Alexander in Woodbridge, there to remain for forty years, becoming something of an institution in the town. Everyone was pleased to see him at his place in the bank; he always had ready a kindly smile or an enquiry after the health of a member of the family. He was very popular with all ranks of society and was frequently invited to join people

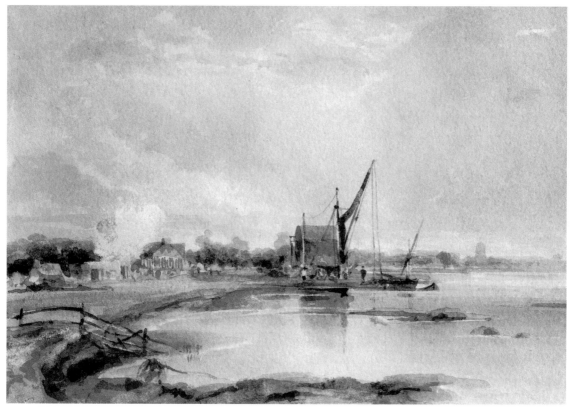

116. Lime Kiln at Melton Dock, River Deben. *By Thomas Churchyard. Watercolour. 5½ x 7½ in.*
Private Collection.

for dinner or a soirée, where his good spirits and frankness of nature always added to the general enjoyment.

He wore plain Quaker clothes and always spoke in the modest language of his religion, leading such a regular life that there was a saying that the housewives knew it was time to put the potatoes on to boil when they saw him go home to lunch in his cottage. He often ate his dinner at Brook House, the Quaker school, as his cottage was so small there was no kitchen. When she was old enough, his daughter Lucy came to join him in his little home, where she cared for him with great love and devotion.

He gained some fame from his poetry; Mr Barton was a prolific poet and known throughout the world as the Quaker poet of Woodbridge. He first published anonymously a collection called *Metrical Effusions* in 1812, printed by a local bookseller. He sent copies to those people he admired and asked their opinion about his talent. He dreamed of being able to leave the bank and devote his life to poetry, but although he was always fondly read and praised, everyone agreed that he should not take such a step. He even asked Lord Byron, who advised that he should continue to write but not to trust his luck to publishing. He asked Charles Lamb who replied:

117. Bernard Barton's Cottage.
Photograph. Private Collection.

'Throw yourself on the world without any rational plan of support beyond what the chance employ of booksellers would afford you! Throw yourself rather, my dear Sir, from the steep Tarpian rock, slap dash headlong upon iron spikes.'

Six years later he published again a collection of poems about goodness. This time he had twenty-four subscribers to help fund the venture, including William Wordsworth, Robert Southey and the local solicitor James Pulham. Four more books followed in the next few years, and Mr Barton became a familiar name to many who enjoyed his pious, gentle verse. He corresponded widely with the people he admired, writing streams of letters to Walter Scott, Lamb, Byron, and Mrs Opie; he wrote to anyone who would reply. His letters were written as though an extension of recent conversations, and were valued by many for their innocence and simplicity, but some people were annoyed by the sheer numbers of them, which could become a chore.

I can clearly recall the first time I met Mr Barton, soon after we had settled at The Beeches. It was a Saturday afternoon when a carrier's cart, on its way out to Bawdsey, stopped and down climbed a little gentleman in plain grey clothes, with spectacles balanced on his nose. He said a few words to the carrier, waved a cheery thanks and then turned away with a worried expression on his face. He hesitated, looked again at the houses ranged behind the great beech trees and bit his lip. Maybe he was unsure of the address? Then he took a deep breath and with a little scurry, chose a gate and a front door and knocked. He had chosen ours and I was pleased because he had looked so worried and I thought perhaps we could help him. In fact he had guessed correctly since he was looking for our Papa.

'Excuse me; I wonder if it might be at all possible to speak to Mr Churchyard?'

'Oi'm afraid he's not at hoom, Sir,' replied our maid, Winnie, and I thought how sad he looked, as though this were the greatest setback imaginable.

'Will he be very long away, do you know?' he asked her, with a timid frown. Tom and I

were watching from the window, and we were frustrated by Winnie's slowness in reply. So we tumbled over one another to get to the door and we said in chorus, 'We know where he is, shall we take you there?'

Our reward was his smile. How he beamed with pleasure. His eyes twinkled and his face shone.

'Oh please do that, it would be so very kind of you.' Then, with a sudden frown, 'Will it be all right with your Mamma?'

'Tom, run and tell Mamma where we are going,' I commanded.

I did not want to leave this delightful man, who had been transformed from worried little old gentleman to a sprightly fellow with the news that his quarry might be found. Tom was back in a flash and we set off down the road towards the river, where we knew Papa had intended to go. He was planning to paint a watercolour of the lime kiln there, when the tide was at full flood, so that the painting would have the full clear reflection in the calm waters.

'Is it far?' our friend enquired, looking nervous about walking too many miles. 'I have the locomotion of a cabbage,' he chuckled.

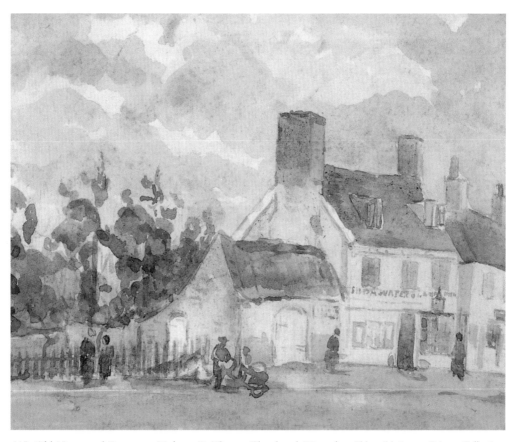

118. Old Horse and Groom at Melton. *By Thomas Churchyard. Watercolour 3½ x 4½ in.* *Private Collection.*

119. An Angler on the River near Ufford Bridge. *By Thomas Churchyard. Pen and Ink. 3¼ x 4½ in.* *Private Collection.*

'No, not too far, he should be just along the river-wall a way.'

Without warning he stopped in his tracks and out shot his thin white hand. 'What a rude man I must seem, you are both so kind to me and I haven't introduced myself to you.' Then with a little bow, 'Mr Barton, your servant, Miss,' and he shook my hand vigorously.

Then he turned and bowed to Tom, who solemnly bowed back.

'And may I have the pleasure of knowing to whom I am indebted?'

'This is Tom, he is my brother, he's two years older than me; I'm Ellen, I'm eight ...' I had to stop for breath.

He laughed and clapped me on the shoulder. Then on we walked again.

'I, too, have a daughter, her name is Lucy but she is grown up now; she is twenty-six.'

'Where does she live?' I wondered.

'She lives with me in a little nutshell of a cottage; she keeps me tidy and keeps me smiling.'

'I live with my Papa, too,' I said, 'and I make him smile.'

Mr Barton laughed again and said that he was sure that I did. Then we turned along through the salty sea grass on the wall, towards the spot where we could see Papa sitting on his little canvas stool deeply involved with his paints. When we came level with him we stood quietly for a moment while Papa finished a very wet sweep of his brush, blueing across the sky, catching the very shape of the heavens above us and trapping it on the paper

120. River Deben at Wilford Hollow. *By Thomas Churchyard. Oil on Panel. 12 x 17 in.* *Private Collection.*

below. Then he propped the painting on the easel and springing up he grabbed Mr Barton by the shoulders, shaking his hand and laughing all at the same time.

'Well met, my friend,' he said. 'I had just finished this and was going on up the river-wall away, to do some more sketches.'

Tom and I were surprised. We had imagined that Mr Barton was a client, needing Papa for business, but it seemed that they were friends. This was an even greater pleasure. As we retraced our steps we listened to their chat about mutual acquaintances, friends and heroes. From talking of Papa's painting their conversation turned naturally to the works of Mr John Constable, whom Mr Barton also admired.

'One year when the influenza epidemic was bad in London, Mr Constable brought his children earlier than usual to stay in East Bergholt. He loves them to spend their summers in that place, where he had been as a child. He says he loves his girls when they are beautifully bronzed by the Suffolk summer.' Papa waited while Mr Barton caught up a little. 'Anyway, apparently one day he was travelling back to London on the Shannon Coach to the Blue Boar Inn and there were two strangers inside with him. As the coach passed through the valley about Dedham, Constable remarked that it was beautiful. One

of the strangers replied proudly,

'Yes Sir, this is Constable's Country'.

'John nearly choked with surprise but, fearing that the man might spoil the compliment with his next sentence, he thought it best to admit his identity.'

Papa and Mr Barton laughed at this tale but I knew that Papa had dreamed of such fame for himself. Mr B spoke in turn of some of his own heroes. He corresponded often with many of the great poets and authors of the day. He aspired to their fraternity just as Papa dreamed of Gainsborough and Constable. So they found they were brothers in their disappointment.

After that first meeting Mr B was often at our house, for then he loved to walk out a little way into the countryside, and sometimes I was able to go with Papa to town where I would see Mr B and Lucy in their sweet little cottage. He would love to read us poems, all about the beauty of the world and the weakness of man.

It was Mr Barton, I remember, who had first mentioned the name of a Mr FitzGerald to us. Papa had indeed met Edward FitzGerald on odd occasions over the years but came at last to be friends through Mr B. The budding poet had heard that Mr FitzGerald knew many famous people in the world of the arts and politics. He knew that his parents were very wealthy and owned many large properties; that he spent his time moving between his lodgings in Charlotte Street, London, his father's estate at Naseby, which included the famous battlefield, his aunt's home in Paris and family estates in Ireland. But when Mr B heard that he loved his own little home best and had been known to say that he would always 'run back to Suffolk', then Mr B felt sure that he would like him.

One day Mr B had discovered that Mr FitzGerald knew William Bodham Donne, as they had been at school together in Bury St Edmunds. Then the news arrived that he was coming to visit. Mr B had for some time been very keen to be introduced to Mr Donne. He corresponded with many famous people but rarely had the chance to meet them, since he could not afford to travel far or often. So Mr B had contrived to be introduced to Fitz, who instantly recognised in him a genuine and honest soul. Fitz read some of Mr B's poems and found that he could love them for their air of simplicity and gentle quietness, although he could also tell that unfortunately they were not always good and sometimes were perfectly unreadable. But the best of Mr B's poetry reflected the man; he was tolerant of those around him and free with his acquaintance. All Mr B desired was that men were honest, so he was always slow to suspect dishonesty; that they were agreeable, and as he was easily pleased he usually found the best in all men. Of course, he found both of these qualities in abundance in my dear Papa, so they remained friends without falter. He also found them in Fitz, who looked for the same qualities of tolerance and kindness in his own friends. So eventually these three very different men found comradeship together, their different ages and situations no barrier to friendship.

Soon after Mr B had met Fitz it happened that Fitz took to calling at the poet's little house to sit and talk in the evening, it being conveniently placed in the town. When he was in Suffolk Fitz took pains to see his new friend as often as he could. He knew that the Bartons had very little money and so he took care always to bring contributions to the refreshments. The Bartons had no kitchen, but they were fond of making things like toasted cheese for supper. Fitz assured them that cheese on toast was his favourite meal,

121. Gravel Pit at Plumstead Common. *By Thomas Churchyard. Watercolour. 4¼ x 7½ in.* *Private Collection.*

to ensure that they did not try to offer more. Once he amused us all by writing from London to say that they should, 'lay in Double Gloucester' as he was coming home soon; another time he signed a note 'Philocasteotostus', lover of toasted cheese.

Their talk was full of poetry and plays, novels and histories. They discussed Thomas Carlyle, William Makepeace Thackeray, James Spedding and Alfred, Lord Tennyson, all friends of Fitz's from his days at Cambridge, or they talked of Homer, Goethe, Byron or Scott. Mr B was desperate to know every detail that Fitz could tell of these heroes. Together they read the *Tales of the Hall* by the Aldeburgh poet George Crabbe, who had died only a few years earlier. Coincidentally, his son the Revd George Crabbe was the unconventional Vicar of Bredfield, a humorous and lively new neighbour of Fitz's. So he promptly introduced them and enjoyed their pleasure in each other. At one time Mr B thought that Fitz had had a soft spot for Revd Crabbe's daughter, but she married and that was that. But they were all great friends and Fitz helped Revd Crabbe to publish his *Life and Works of George Crabbe*, to commemorate his father's life.

During their evening chats Fitz had noticed the paintings that adorned Mr B's walls. He realised that they were an anomaly in this little house, worth much more than Mr B could afford to pay. Then he learned that they had been supplied by my Papa. Over the months Papa had come to sell paintings to Mr B at very low prices, on the condition that he should be the one to re-purchase them when the time came for a change and finances

122. Horse Grazing. *By Thomas Churchyard. Watercolour. 5¼ x 7¼ in. (Photograph courtesy of David Messum Fine Art Ltd)* *Private Collection.*

allowed. This enabled Mr B to have beautiful works of art, in which he could feel he owned a stake, yet he did not have to spend much of his limited wealth. So art became another great topic for their suppers, and Fitz could tell of the marvellous Old Masters that he had seen in London and Paris. Then it had seemed obvious that Papa should also be invited to supper to meet Fitz. It was soon clear that Papa's ability to discern the provenance and quality of paintings was superior to both of his friends. They teased Papa about his seriousness for picture dealing and there grew a warm-hearted rivalry between Papa and Fitz, which amused Mr B.

Mr B realised that he could never compete with them, and with his usual humility he recalled the proverb which says that when two men ride the same horse, one needs must ride behind. He was happy to take that back seat and just enjoy the talk and the paintings. Fitz soon realised, too, that he needed to 'ride behind' when it came to knowledge of paintings. He and Mr B could discuss the pros and cons of works but they always referred to Papa for a final judgement. Fitz owned some Constable paintings, which were in his rooms in Charlotte Street. He often tried to persuade Papa to go to see them. In the end Fitz brought the paintings home to show Mr B and to receive approval from Papa. Because Fitz had the money to buy what he liked, Papa was rather afraid that the price of a painting would rocket if he, Papa, was known to be interested. I believe this was the cause of Papa's secrecy, which Fitz sometimes complained of to Mr B. And Fitz's tastes were known to change: he preferred Old Masters originally, becoming interested in works by Constables and Old Crome because of Papa's enthusiasm.

Fitz once told his old school friend Tennyson that he had learned 'to respect the man

who tries to paint up the freshness of earth and sky.' He could as easily have been speaking of Papa or of Constable.

So the three men became close friends and although Fitz ranged far and wide, Papa travelled about Suffolk and Mr B merely journeyed up and down the Thoroughfare, their paths often crossed to catch up with each other's news. Sometimes Revd Crabbe joined the party at Fitz's house and then the four would eat and drink and talk of everything under the sun, always laughing at the vanities of mankind and the more gentle gossip from the world of letters.

'I have read in the paper that East Anglia is peopled with "a lawless population of paupers, disbanded smugglers and poachers",' said Crabbe one day.

'And I thank heaven for it,' replied Papa, 'or I should make no living at all!'

'I read that Mr Dickens has offended the whole of Ipswich by slandering the Great White Horse,' said Fitz. 'The famous Mr Pickwick's adventures with a lady in yellow curlpapers are the talk of the town.'

Papa went to London to purchase a painting by Constable called *Higham Village*, from Constable's old friend and biographer C.R. Leslie. Then, when Papa brought it to show Mr B, he saw that he fell in love with it, so much so that he wanted to buy it from Papa for himself. After a long 'higgle' he managed to buy it with some cash and a swap. He was over the moon with 'his' sweet village painting. He talked of little else for weeks. Papa organised an excursion to Dedham Vale to take Mr B to 'his' village for real. Taking their lunch, they had the loan of Fitz's brother's carriage and drove through Ipswich to the scene of so many of the paintings Papa adored. Mr B was in seventh heaven as they walked along the river bank after seeing Higham until they reached Willy Lott's cottage, where Papa set up his easel to paint from life what he had copied so often before from canvas. Some workmen from the Constable lands came across to speak, and said, 'This looks like the business'.

The workmen remembered the days when Mr John was always to be found in some corner of the land. Mr B was so happy; he lived for weeks on the memory of that excursion. He was so easily pleased by the small fame that came his way — when the first *Suffolk Directory* was published and he was entered with 'poet' after his name, how proud he was. He wrote to the Queen to ask if he could dedicate his next collection of verse to her and was granted her permission. What an honour for our kindly Quaker poet. Papa contributed his drawing of *Gainsborough's Lane* for the frontispiece, and another, *Scene on the Deben*, for a vignette on the title page.

Fitz was always going to and fro; he did not seem to know how to settle. When he was at his little cottage, we saw him often for a few autumn months as he passed up and down from Mr B's and called in to see us too. He complained during the winter that the cottage was like a hut, with walls as thin as a sixpence and windows that wouldn't shut. But in the summer it was an idyll. It had been built by the wife of the previous owner of Boulge Hall. She and her husband stopped speaking to each other and, when it was too much to bear, she escaped to the cottage. It was said that he only spoke to his dog and she only spoke to her cat. Papa said that truth was certainly stranger than fiction.

As time went on, Papa, Mr B, Fitz and Revd Crabbe took in turns to host dinner for each other. On one such jolly occasion Fitz had declared that they were the 'chief wits of Woodbridge' and should always meet together for good talk, good food, good liquor and

123. Extensive Landscape across a Valley. *By Thomas Churchyard. Oil on Card. 8¼ x 13 in.* *Private Collection.*

a furious smoke. The title stuck and was oft repeated in gentle self-mockery. They were a strange group of friends: rich and poor, young and old. Revd Crabbe was rather eccentric and great fun; Fitz said he had a young heart in his old body. Fitz was sometimes called the Boulge Hermit, as he only spoke to those he wished to, and offended many others. Sometimes his behaviour was very strange. Papa could return home and tell of an evening when Fitz was munching on apples or turnips and drinking milk, having decided to be vegetarian. Other times there would be lavish food: mutton, wild duck, pickles, port and porter. The menu was always a surprise to his guests, and the chaos of his rooms was an equal wonder. Papa winced at the sight of large pictures standing piled against the walls, and the books that lay open around the tables and floor.

Mr B was always called on when he was host to supply toasted cheese, as all the friends swore that no one cooked it quite like Miss Barton. But when it was Papa's turn to entertain the jolly company, I was always determined to put on a good fare. The table had its two leaves added to make lots of space. The decanters were filled and the cellaret was stocked up. Although they all kindly thanked Mamma for her hospitality, I knew that they knew I had planned it and supervised its execution. They were the jolliest evenings and, although the men were eventually left to smoke and drink port alone, I still felt a part of it all. I can see

them now smoking and talking, Papa's foot resting on the painted fender, the fire ablaze. I hear Fitz telling Mr B of a lady he admired, saying that she could 'sing and play, talk and be silent in harmonious order'. I prayed to attain such a balance and such praise. I might have been jealous, but I knew she was a married lady and living in the wilds of Bawdsey.

Poor Mr Barton I believe ate more at these dinners than during the rest of his week together. His friends were always offering him their hospitality. He couldn't return it with the same lavishness, but his company was a blessing in itself. He once wrote to the Prime Minister, Robert Peel, and, amazing us all, boldly criticised his handling of a number of issues. Then out of the blue, Lord Northampton invited Mr B to London, to a soirée. Mr B accepted, but then immediately wrote to Robert Peel to ask if he was going there, too, as then they could meet! Fitz and Papa were amazed at Mr B's audacity, but were even more amazed when Mr Peel invited Mr B to join him for dinner at Whitehall. What a brave man was our quiet Quaker. He wrote the details of every moment of that big adventure so that we should know everything. Other guests that evening included Dr Buckland, the geologist; Mr Stephenson, the engineer; George Airy, astronomer and measurer of the earth's circumference; Professor Owen, naturalist; Sir Charles

124. Convivial Gathering at Woodbridge. *By Thomas Churchyard. Watercolour. 5 x 6½ in.*
(Courtesy of Ipswich Borough Council Museum and Galleries.)

143

125. *Woodland Scene. By Thomas Churchyard. Watercolour. 8¼ x 11½ in.* *Private Collection.*

Wheatstone, renowned physicist and inventor; Michael Faraday, physicist and chemist; Charles Eastlake the artist; and Henry Hallam the historian. What illustrious company for Mr Barton, the poet. Later he was awarded a Poet's Pension by Queen Victoria; we were very proud.

Fitz was much less reverent about the great men he knew. He told us with glee how Carlyle had groaned in embarrassment when Fitz had polka'd down the street to the tune of an organ-grinder. He accused Carlyle of only having one great idea, which had grown like a tape-worm in him until it consumed him. He often found him very grumpy and bad-tempered; 'he smokes indignantly!' Fitz declared.

He summed up his London friends very amusingly and usually caused us to laugh a great deal. He declared that William Harrison Ainsworth was a snob but that Tennyson wasn't. Tennyson had recently agreed to be godfather to one of Dickens's children. The Count d'Orsay was to be the other godfather. This meant that the poor child was to be called Alfred d'Orsay Tennyson Dickens, proving beyond a shadow of a doubt, said Fitz, that Dickens was the most awful snob of all.

Oh how my mind wanders around those far-off days. It was all so exciting to the ears of a young maid who had hardly been outside her family home. How I loved to sit and listen to them chatting and joking. How I loved them all. It seemed that it would go on forever in the comfortable worn groove that we had settled in. But of course nothing stays the same forever and we all grew older, with Mr B growing poorly with the advancing years and little Ellen growing up, no longer a child. Heigh ho!

Now I must do something constructive today or I will not be happy. Another walk at least and then on my way home I must do a little shopping I think. My supplies have been diminished by young Ernie's appetite for cakes. Maybe a stroll down the street to Melton and then some marketing?

126. A Sandy Bank in a Wood, 'Melton'. *By Thomas Churchyard. Watercolour. 5 x 3¼ in.*
Private Collection.

CHAPTER 10
ONE THING IS CERTAIN

Walking past The Beeches, our home for over ten years, I get a jolt of silly possessiveness. How strange that so many decades later I still feel that it is ours. We were rather hard up at first, while Papa tried to re-establish himself. Luckily this did not take too long, for his old clients remembered him well, but he did have to battle with some people's opinions that he should never have abandoned his young family and his career in the first place. And he had to contend with the numerous other attorneys who seemed to pervade the area. Some had made great fortunes, by fair means and by foul. It seemed to me that foul must have often been the case, since Papa did not ever make a fortune and he was the best lawyer there ever was. Opposite our home stood Melton Hall, which was a large and constant reminder of what could be achieved by accepting the right clients. Old Mr Pulham, whose office wasn't far from Papa's, was very grand; many years earlier he had even commissioned Constable to paint a portrait of his wife. His family were good friends of the Constables and their children were friends, too.

So Papa started again from scratch. At first he had to use a make-shift office along the road that ran down to the quays, next door to the coal and corn merchant. He did not mind, but there were few lawyers whose dignity could have withstood this coming down in the town. He had been affectionately called the Poacher's Lawyer before, and had been sorely missed by the ordinary folk of the area. They were quick to go to him again. Although there wasn't much money in their work, at least it was never ending. They did not mind slipping into his little office when they were in town to ask for advice or representation. Unhappily Papa realised that he wouldn't be able to earn enough from their business alone, and to feed his growing family he needed to attract some customers with money.

He settled back into his life here and into his career as a 'lawyer who paints'. If he still regretted the failure of his dream to be a 'painter who knew the law' he did not show it to us. He began again to collect together works of art by those artists he most admired. The gradual improvement in his finances was charted by the paintings that came and went from our walls. He had sold many of his treasured paintings before going to London and now he sought again the Constables and Cromes, George Frosts and Gainsboroughs, which were to be found scattered around the countryside.

Papa's great great-uncle Isaac had a stepson called John Smart, who had become a very well-respected teacher of drawing in both London and Ipswich. Papa looked him up when he was in Ipswich at the Sessions, when Mr Smart was in his eighties and getting

127. *The Quay at Woodbridge. By Thomas Churchyard. Oil on Panel. 6½ x 5½ in.* *Private Collection.*

128. Pin Mill, River Orwell. *By George Frost. Pencil. 9 x 12½ in.*　　　　　　*Private Collection.*

very frail. Papa was overjoyed that he had gone, because Mr Smart had given him a folder full of drawings by George Frost. He told Papa how, together with Frost, he had sketched along the banks of the Orwell in those places where Gainsborough had sketched before them. Papa admired Frost's work immensely, but mostly I had the feeling that he was almost jealous of the man whom he felt was the bridge, the link between Gainsborough and Constable.

Frost had come to Ipswich as a young boy just before Gainsborough had left for Bath, at a time when Gainsborough's reputations both as artist and philanderer were at their height here, and his sudden departure ensured that Ipswich gossips talked about him for a long time afterwards. From his position at the Blue Coach office, the company that ran coaches between London and Ipswich, young Frost talked to anyone and everyone; he became a great fount of knowledge as well as an admired artist himself. It was also from the same coach office that he met the young Constable and became something of an inspiration to him. Papa believed that, as with John Smart, Frost had gone out together with Constable, to the leafy lanes and grassy banks along the Orwell, following in the steps of Gainsborough, and there they had copied his subjects. They copied his paintings and drawings too, as Mr Frost owned many.

Old Isaac Johnson, the Woodbridge surveyor and prolific artist, died, and our own dear Ben Moulton succeeded him on Mrs Johnson's recommendation. Ben bought all of Isaac's records and his surveying instruments, and Papa bought hundreds of his sketches from all around the county. Like Papa, Isaac had travelled far and wide in Suffolk and he always returned home with bags full of sketches of churches or gateways, trees and lanes.

Around this same time, when I was only about ten or eleven, Papa came home from his office very upset. He had read in a copy of the *Morning Herald* a report of Constable's death. It was a great shock to him. There had been no mention of ill health; he was young still, at least he seemed so. His family were certainly young and I think that Papa had felt a strong kinship with him.

'This report doesn't tell us much,' he complained, 'and he wasn't a "Miller"! His father owned mills, which is not the same thing at all! And it says he came from "near Woodbridge". I suppose to those fools in London East Bergholt *is* near Woodbridge. At least they got the name of the county right!'

Papa talked of little else for some days; he desperately wanted to know what had happened to his hero. He asked everyone he thought may have heard news; everyone who was newly arrived from London or was planning to go there. He went to see Revd Daniel Constable Whalley, John's nephew, who had been curate at St Mary's until recent years. He had no news to add, but promised to let Papa know as soon as he heard more.

129. The back of Gobbit's House, Woodbridge. *By Thomas Churchyard. Watercolour. 3¾ x 4¼ in.*
Private Collection.

Then a week after the report had appeared, Papa came home from work greatly excited once again. During the afternoon young John Constable, the artist's eldest son, and Golding, the artist's eldest brother, had come to the office to speak to Papa themselves. This was better than Papa could have hoped. Young John had been there at his father's side and so he told the story first hand. The poor boy had been so greatly affected by the sudden event that he had been unable to attend the funeral. Then his uncles had brought him home to East Bergholt, to grieve with his Suffolk family. Apparently, Mr Constable had been working all day on a painting of Arundel Mill and Castle. He then popped out on some small errand of charity. On his return he had a little supper of bread and cheese, before taking a book to bed to read; it was Southey's *Life of Cowper*. After a while he called his housekeeper, Mrs Roberts, whom young John called 'Bob', as he felt that he was thirsty and would like some figs. As there were none, he had some plums instead. He then fell asleep for a while. When he awoke, shortly, he had very painful heartburn. Young John wanted to call the doctor but his father asked for a dose of rhubarb and magnesia. After this he felt worse, giddy and exhausted; he was sick, felt better for a while, and then the heartburn returned. So he drank large amounts of hot water, which did not help. He stood up, sat on the edge of the bed, sat on a chair, returned to the bed and then twisted over and never spoke more.

Papa recounted the visit in detail to us all at supper (and many times after) and he showed us an account that he had written as a record of the conversation. Mr Constable was buried at St John's Church in Hampstead, with his beloved wife Maria. His tombstone says:

'*Eheu! Quam tenui e filo pendet. Quidquid in vita maxime arridet!*' 'Alas! How whatever is most pleasing in life hangs from a slender thread!'

'Will his children be all right?' I had asked Papa.

There were seven children, now orphans, and at that time we were seven too; the parallel seemed important to my young mind. I, struck with fear at the thought that a father could die and leave his young family without warning, worried and fretted, watching Papa's every move, anxious about any sign of ill health, until Papa could bear the strain no more.

'Ellen, you do not have to worry about me so. I am very well and have no intention of leaving you. I am a mere forty years old and as fit as a fiddle.'

He quietly took me aside, drew me on to his lap and gave me a great warm hug, although I was rather too big and no longer fitted at his side in the chair.

'I have heard that Mr Constable's friend Mr Leslie is organising the estate to try to protect the children, so that they will have enough to live on. There is to be an auction of many 'Studies from Nature' to raise money. I will go to London and see if I can afford to buy one of them, to help the fund. And the National Gallery is getting up a subscription to buy a painting called *The Cornfield* for three hundred guineas! The children have many relations and will be safe and sound.'

After a few weeks my morbid feeling dispersed and I thought no more about death. Well, at least I stopped thinking about it as a monster looming up to snatch Mamma or Papa from our midst, and I put it to the back of my mind as something that did not really affect me.

I think that I became grown-up that year. I began to lose my childish view of life because an inkling of our mortality had lodged in my brain. So that I would not pester

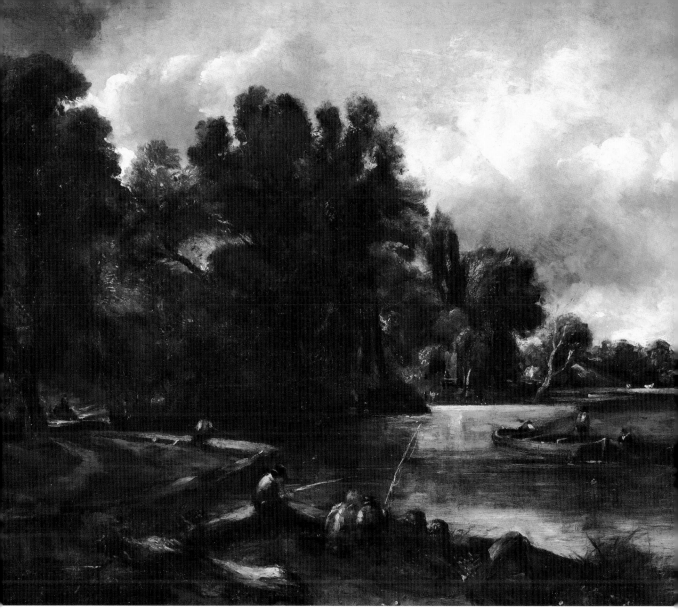

130. Boys Fishing by a River (after JC Stratford Mill). *By Thomas Churchyard. Oil on Canvas. 23 x 30 in.*
Private Collection.

Papa too much, I turned to Mr Barton with my worries. He kindly answered me and
showed me how we must be able to contemplate the death of those we love and our own
death. Death is certain and so it is silly to resist the thought of it. He had lost his own
dearly loved wife when she gave birth to Lucy. Birth and death go hand in hand. We are
born and we will die.

It was not long after this we lost our darling baby brother, and for the first time felt the
grief that comes with a life cut tragically short. Losing grandparents is hard, especially if
they have been an important part of your life, but even as a child I knew that it was as it

131. An Explosive Sky. *By Thomas Churchyard. Pen and Wash. 4½ x 7¼ in. (Photograph courtesy of David Messum Fine Art Ltd)* *Private Collection.*

should be. Nothing prepared us for the death of the baby; our family had been so lucky until that time.

The following January, to cheer us up in the depths of winter, we gave a party for Papa's forty-first birthday; we had been so sad that Papa and Mamma decided that we needed to start the New Year in a positive way. Although we often had visitors we hadn't often had a celebration, so gradually excitement grew in all of us. Papa made many friends through his work, and as soon as the party was decided on we started to receive anonymous gifts of pheasant, partridge, duck and venison. Mamma couldn't decide what we should cook for the feast, so I had asked Nanna what she thought we could do with the presents that we had received. She helped me to plan a menu of delicious pies and roasts.

We decided on a jugged hare, which could be prepared earlier and kept warm, and served with some red-currant jelly that Nanna had in her cupboard. We would make a game pie using pheasant and partridge in the big green pie dish with the blackbird pie funnel, to cause some amusement. But the main dish would be roast haunch of venison, with gravy made from port wine. For dessert we would have bread and butter pudding, which was Papa's favourite; it would cook in the oven after the venison was served. It sounded like an awful lot of food but, as Nanna said, we would be able to make hash and fricassee with the leftovers for some time to follow. In the hope that Fitz would be able to join us, I planned to make a little dish of poached eggs with cream, as I knew that he

preferred not to eat meat. His partiality for cheese on toast I thought I would leave to Miss Barton to supply; I was sure that a man could only eat just so much cheese on toast, whatever he said.

On the big day, we managed quite well to get everything cooked in the order we intended, although it was very cold outside and it took an immense amount of wood and coal to keep the range stoked up to temperature. Tom's share of the effort was to keep bringing in the fuel. Emma, our cook Violet and I did all of the preparation and cooking. Laura and the little ones were in charge of supervising the table decoration and the rooms. They had been cutting out pictures from periodicals and colouring them to make them pretty. Then they strung them together to decorate the mantelpiece and the sideboard. Laura cut out and decorated some card placenames so that we could arrange the guests into a happy order. Mamma went back and forth from the dining-room to the kitchen all day long, asking if everything was going to plan, although I doubt she knew what the plan was.

Mr Barton arrived early with Lucy to see if they could help. He was very excited because he had composed a poem for Papa's birthday and wanted to discuss the best time to read it. He read it three times to me while I was trying to decorate the game pie with pastry leaves and egg yolk. Then I heard him read it to Tom who was blocked in the doorway with an armful of logs. We steered him to Mamma, saying that she should decide the best time. Five minutes later we heard the poem orated again. We knew that Papa would be very honoured by it as it was actually extremely good and very complimentary. Dearest Mr B, he did so love Papa.

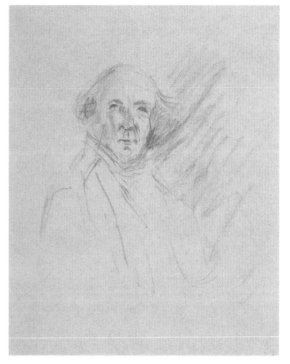

In the evening Papa's friends arrived: the Moultons, the Everitts, Mr Meadows and more. Some couldn't stay, but popped in to raise a glass and to wish Papa a happy birthday. Some did not want to leave and raised many glasses during the evening. I had really hoped to see Mr FitzGerald but he had been detained in Ireland at his uncle's house. I had been waiting for a chance to show him how magnificent my young kitten was now that he was fully grown.

After the dessert had been cleared away, the Stilton cheese was placed in the centre of the table and the port decanter was brought in. Papa was seated at the head of the room, beaming. He was in his element and thought that nothing remained to complete his happiness. Then Mr B stood and produced his ode with a great flourish. He wasn't good at public speaking, but he was determined to read his gift to Papa

132. Self Portrait. *By Thomas Churchyard. Chalk. 7 x 6½ in. (Courtesy of Ipswich Borough Council Museum and Galleries.)*

himself. Silence fell and Mr B cleared his throat. He began:

'On the birth of a King,
Or a Queen, let Laureates sing;
And to recompense their lay,
Quaff their sack, or pouch their pay;
In such odes I see no fun;
Here's to Tom - at forty one!'

Everyone clapped and raised their glasses, Mr B took a sip and grinned, and then he continued,

'If a Poet's wish could tell,
Doubt not I would wish thee well;
Yet what could best wish of mine
Give — but is already thine?
Wife and bairns, surpassed by none —
These are thine at forty one!'

At this Mr B waved his arm at all of us and beamed even more brightly, sipped again and drew breath for verse three, and went on to praise Papa's ample table, friendly fireside, his wonderful paintings, by his own hand and those of great masters and so on. By this time we all had tears welling in our eyes at the sentiments that were so accurate and so lovingly told. Papa was unable to speak for controlling himself; his eyes were blazing with tears, reflecting the lights of the candles and the fire. Now the tears were not to be denied and we were all smiling and sniffing and wiping our cheeks.

Ending with a long, low bow, Mr B positively floated with happiness at the thunderous applause that followed. We all had to clap and cheer both the subject of the poem and the poet, in an attempt to fight back the tears. I thought that it was the very best poem that Mr B had written, and was amazed at how perfect it sounded that evening at the party when earlier, in the kitchen, I hadn't been able to hear it at all. Papa declared that it was one of the most precious presents that he had ever received. He was very flattered and honoured. The party ended on such a high note that we seemed very dull when the last people had donned their coats and begun their journey home. The Bartons were given a lift with the Moultons and I heard Mr B saying that he would have to write to Fitz about the whole evening, as soon as he got in. He was afraid that he might forget some small detail and he did not wish to omit anything. The original copy of the poem was one of Papa's keepsakes and is now one of mine, still in my box with the little red ribbon tied delicately around it, next to my own poem.

News of the evening spread about the town and our village, and we heard such exaggerated reports of the mountains of food and the quantities of drink consumed that we wondered if it was the same party. Stories grew and elaborated as they passed along, like Chinese whispers; often it was hard to know if they had any basis in fact at all. Nanna was told a story of her son's wit and when she asked Papa if it was correct he only smiled,

which of course did not help her to decide. It was said in the town that Papa's gun dog, Victor, had gone into Mr Barritt's confectionery shop, had knocked to the floor some sausage rolls and then proceeded to eat them up. Mr Barritt was a friend of Papa's and a Quaker friend of Mr Barton's, too. He waited until a few days later when Papa was passing his shop and then he came to his shop door.

'My friend,' he began, 'if a man's dog came into my shop and consumed a quantity of sausage rolls, what remedy at law would I have in such a case?'

'Oh,' Papa replied, without hesitation, 'you can recover your losses against the owner of the dog.'

'Then you owe me 18 pence, for it was thy dog Victor!'

As quick as a flash Papa replied, 'Quite right, if it was Victor then I owe you 18 pence; and I charge you six and eight pence for the legal advice, so you owe me five and tuppence!'

Papa had stayed at The Beeches to be near to his mother, but as the family had grown in number and size we had become very cramped. As the house staff had increased too, the

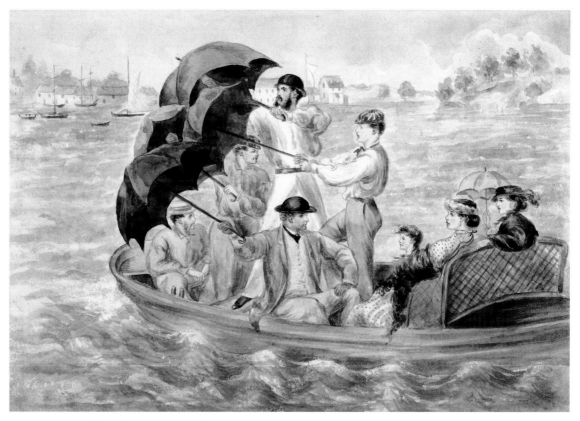

133. A Brilliant Idea. *By Harriet Churchyard. Cartoon. 5½ x 8 in.* *Private Collection.*

house had become a place to leave at every opportunity to find room to think and breathe. After Nanna was gone we had moved from Melton to Woodbridge, from the village street to the centre of the town, to a house and office together. Marsden House was a large and elegant red-brick building. There were five bays and three stories, with beautiful windows and an imposing front door. It had been Papa's office for some years, his partner living there in part of the house. It was important to try to attract some moneyed clients, the sort who could actually pay their bills. Papa's fame had grown along with his family. Now we felt we were at the hub of things and, best of all, only a few paces from dear Mr B's little cottage.

Papa's partner Mr Meadows had amicably parted from the business and so Papa worked on his own. He was such an eccentric in many ways that I began to see how hard it must have been for anyone to work with him. He resisted the ordinary, monotonous work of a solicitor. He only wanted to do the interesting work and then go out sketching. He employed two clerks in the office, perched on stools, rather pimply youths who couldn't concentrate at all if any of the Churchyard girls were within sight or sound. Luckily I think that they were a little afraid of this Miss Churchyard, and I was saved the sight of their blushes, but they were very silly about Emma and Laura, and we had many occasions to laugh at their expense. At work Papa sat in his old armchair at a mahogany writing table, surrounded by his law books; at play he was to be found in his studio painting or sketching. Miss Ann Bird, our governess, came to Marsden House with us and continued to teach the younger girls; She had become a real part of the family and Mamma depended on her to order their day.

As it happened it was a good time to move to the office, as Papa was becoming very busy. There had been much unrest in the country among the farm labourers. They had been protesting about low wages and the high cost of living. Many families were destitute and were driven to crime to feed their families. They were like bandits, struggling to ambush the game without getting caught by the enemy. The big landowners closed off rights of way and preserved game for their sport, and the warrens of rabbits and hares caused damage to smallholders' crops and destroyed their hedges. Locally poachers became heroes, as the smugglers had before them. Such resentment grew up that it exploded from time to time in massive destruction and intimidation.

Theft was rife: of wood, corn, livestock as well as game, anything that could be eaten or sold. Then trespass and malicious damage followed when the ground-swell of feeling was too strong to be subdued. Arson, the burning of ricks and barns, sometimes the animals inside them too, was both protest and revenge against the landowners who did not seem to listen. The less determined used threatening tactics to intimidate, hoping that they would get the same results but without the same risks.

At the Lent Assize in Bury St Edmunds, Papa was acting for a William Wagley, also fondly known as the Debach Boy. He was just ten years old and he was accused of arson. The farmer's wife who was the main witness against him got muddled and told varying versions of her story. The case was dismissed.

The newspapers were full of the trials for arson and threatening letters. 'A whole county is on fire', said *The Times*.

At the summer Assize Papa was acting for James Friend of Tunstall. He had written a

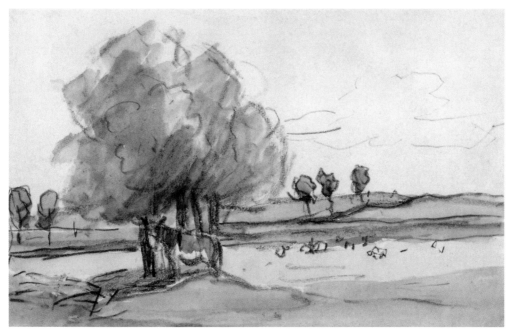

134. A Donkey Resting Beneath a Tree. *By Thomas Churchyard. Watercolour/Chalk. 3¼ x 6 in.*

Private Collection.

letter threatening to burn down William Cockrell's premises and his stock, writing, 'Ve are starven, we wol not stan this no longer'. There was little that Papa could do to help him, since the accused had borrowed the writing materials from a neighbour and had left behind the half a sheet that he hadn't used. He was found guilty: fifteen years' transportation to Botany Bay, a hell on earth in those days.

How these characters still inhabit my head all these years later. How they suffered.

Eventually something was gained from all of this destruction, as the public began to notice the complaints of the labourers. Charities sprang up, as did new schemes to help the displaced and disillusioned, schemes for allotments in every village and for emigration to the new world and the chance of a fresh start. Some jobs were saved and the fall in wages was stemmed, for a while.

But in the meanwhile Papa was busy with the defence of the poachers and the arsonists. He was a thorn in the side of the landowners, especially the often absent owners of the big estates, who were very litigious. They might arrive once a year in their coach and four, heraldic designs announcing the pedigree of the passengers. They would host a large shooting party and then drive away again, leaving their land agent to deal with the estate until the next year's sport.

Papa understood the Game Laws better than any man. He could drive any number of holes through the prosecution's cases by spotting errors. The laws were so complex that they were open to endless confusion. A culprit could be fined, imprisoned or transported, but which of these depended on a host of minor details. Was the offence committed by

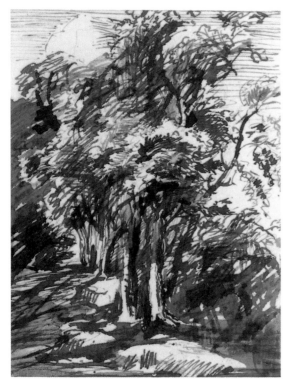

135. Trees beside a lane, Aldeburgh. *By Thomas Churchyard. Pen and Ink. 4¼ x 3¼ in.*

Private Collection.

day or by night, on a weekday or a Sunday, on open land or enclosed, public road or footpath? Did the accused give his name or did he refuse, did he offer violence on arrest or go peacefully? A gamekeeper wasn't allowed to detain a man on the high road; a policeman wasn't allowed to enter a field to make an arrest. If these poachers were local heroes then Papa was a superhero to them. He did not always win but if he did not, he always managed to reduce the charge to the minimum. The cases were never-ending: Charles Goult, shepherd boy from Hollesley, charged with having set a snare to take game on land over which Captain Capper Brooke of Ufford Place had sporting rights — found guilty; a labourer accused of taking 44lbs of straw worth 8d. — innocent; John Manners, charged with being on enclosed land in search of game; Newson of Bawdsey, accused of unlawfully taking one rabbit on night of 4 November; William Garnham, gamekeeper to Sir Philip Broke, accused a man of trespass on Rushmere Heath in search of game; Bawdsey Union Friendly Society charged a member who lived in Felixstowe for false claim; Lambert, a groom, accused of stealing copper bolts from his master Mr Garret of Snape Maltings; a village woman for stealing 6d. worth of wheat by gleaning while the sheaves were still in the field; for the inhabitants of Tuddenham against a rate levied for road repairs; disputes about the ownership of a dog, a hive of bees, sheep, etc; Thomas Mortimer, maltster of Tuddenham, against defrauding the Revenue in a Malt Tax case.

His friends took a great interest in Papa's work. Mr B was always sure that the poor fellows had suffered enough and was pleased if Papa won. Fitz, whose parents themselves were substantial landowners, said that he was very pleased he wasn't the oldest son. He wouldn't have liked to have had to deal with land agents and gamekeepers. Young Tom wasn't so sure on which side of the fence he stood. He argued with Papa about the men he defended.

'Every man has the right to a defence, it is my duty to do the very best I can to put their case.'

'But they are guilty; nearly all of them are guilty!'

'Not until they've been tried and found guilty; until then they are presumed innocent.'

'But you know as well as I ...'

'I know that my job is to defend the accused. You will have a responsibility as a farmer

136. *Study of Sheep Grazing. By Thomas Churchyard. Pencil. 1½ x 4½ in.* *Private Collection.*

to pay decent wages and to look after your men.'

There was a lot of bitterness and argument between neighbours and friends. The arson attacks went on for over a year.

Papa was famous for his defence of the poor; maybe it was his own ancestry that gave him sympathy for the country dweller rather than the landowner. Sometimes he earned very little from this work, as he wouldn't charge people what he knew they couldn't pay; sometimes he even waived his fees completely. He was more interested in the rights of the case and especially if it was a fine point of law, but he also liked to take on interesting cases that could test his skills. One of the reasons that Papa was often short of money was because he was very prone to taking work for no payment. He found that he could not turn his back on a case that he thought had merit just because the client was poor. So of course all of the poor clients turned to him with their problems. There were very few solicitors who would work for little or nothing. One example was the case of John Stannard v. Joseph Cullingford, sued for 2s. damages done to four faggots standing in a drift way! The faggots had stood there for a long while and Joseph Cullingford thought that if he snipped eight or ten inches off the tops he could make some pegs for his verbena. He was caught in the act and the owner had asked him when he was coming back to get the rest. Cullingford said that if he wanted to he could send the faggots to him and he would pay for them, but instead of the faggots he was sent a writ. Papa cross-examined and he showed that the faggots were only worth 5d. each so the claim for 2s. for the missing few tops was more than the whole value. The judge was very surprised at this and said:

'This action is brought as a matter of principle I suppose.'

At which Papa stood and said:

'I appear to defend as a matter of principle too, for if such trumpery actions are to be brought, our newly established County Courts will be a nuisance'.

The judge agreed with Papa and he showed his feelings by granting 1d. judgement and no costs. The plaintive Mr Cullingford then told the court that Papa had undertaken the case without payment. There was great applause.

But working for little or no reward wasn't going to help us pay our bills. Papa had lived most of his life with great expectations that never actually came to anything, at least not when they could do any good. It was this and other factors that seemed to cause our finances to ebb and flow. Once again Papa found that he was rather short of money and he needed quite a large mortgage with the bank; they insisted that he lodged with them a life insurance policy for £1000 as security for the overdraft. He was very serious and downhearted as he completed the documents, using his seal with the image of a three-masted schooner tossed in a storm and the words 'such is life'; he hated to be in this sort of position. My brother Tom was farming in Ufford at the time, still hoping for an inheritance that would allow him to farm for himself. He was more and more downhearted too, and I believe that Papa felt bad that Tom's hopes were so far from coming true. He knew just how it felt to want something badly and yet not to have any chance of it. He hadn't approved of Tom wanting to farm but he had come to respect Tom's decision when he kept at it and tried so hard to make it work. They both hated the way that it made them feel to be waiting for the deaths of aged relatives to free them from their situations. Eventually young Tom couldn't keep going, and so he decided to travel to America to see something of the world and to learn something new about farming. He would return as soon as he heard that he might have some land to work.

Harriet and Kate were still away at school in Bury St Edmunds, but they were the last daughters for whom Papa needed to pay. He couldn't bear to not treat us all the same, and once he had conceived the plan to send us off there he had to find the money to send us all. I wish that he had never started, but at the time he felt that money was available. By the time he had reached Kate and Harriet he had suffered many years of expense. Then there was the question of Charley and what to do with him. He needed a lot of direction and education because he was so wilful. Papa wanted to plan a career for him but Charley wouldn't say what he was prepared to study, so the time went by without any decision being taken.

Then a funny little event came popping into my mind. Emma and I were walking along the Thoroughfare from the haberdashers, chatting about the ribbon we had bought to trim up our bonnets. Out from the tobacconists stepped a short, dark-haired young man, so close in front of us that we had to stop in our tracks.

'Good day, ladies,' he said in a soft Scots accent, 'my name is McGhee, Donald McGhee and I believe that I have the honour of addressing Miss Churchyard, and would it be Miss Emma?' Then he bowed with a great flourish and smiled a rather sickening smile.

'You are correct,' I replied, but hadn't known what to do next.

It wasn't really done to speak to strangers, but he made it very hard to walk on. My horrid vanity overruled my sense and I was flattered to be seen speaking to this smart and attractive stranger.

'I very much hope to be seeing you again soon,' he drawled and then with a wink he walked off in the other direction.

Emma and I were amazed. We went on in silence for a while and then nearly collapsed in giggles.

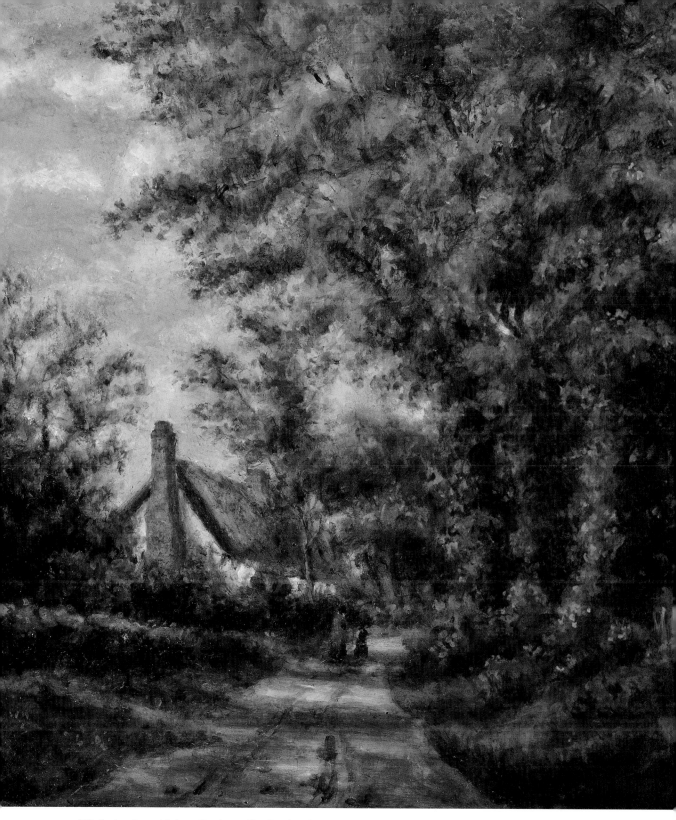

137. Spring Lane, Melton. *By Anna Churchyard. Oil on Board 7¼ x 7½ in.* *Private Collection.*

138. Kingston Farm, Storm Clouds. *By Thomas Churchyard. Pen and Ink. 5 x 3¼ in.* *Private Collection.*

'He winked, I swear he winked!' she stammered through the giggles.

We did meet him again quite soon after this. He appeared at the door of the house, asking to see Papa. As he was shown into the office he caught my eye as I passed through the hall and again I was saluted with a wink and a cheery, 'Hello, Hen!'

Forcing my mouth to contain my mirth until I was safely in the drawing-room, I flung myself on the sofa and laughed until my sides ached. Mamma was quite amazed and she insisted that I told what had caused my hilarity. I don't think that she could see exactly why I was so amused. Emma shared the joke and she contrived to cross and re-cross the hall in the hope of seeing the Scot on his way out. But he left in a great hurry and did not look back.

Later we tried to wheedle out of Papa who the visitor was. He did not seem to want to speak of him, but eventually he told us that he was the new land agent for the Thellusons at

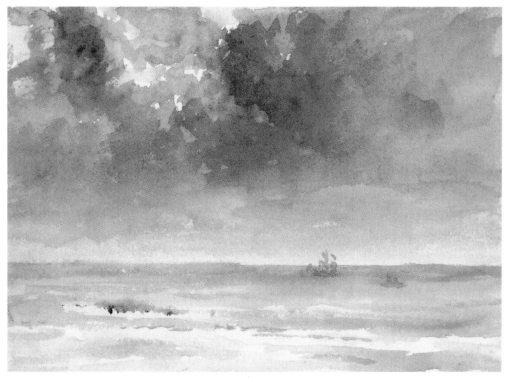

139. Study of Cloud and Sea, with Sailing Vessel. *By Thomas Churchyard. Watercolour. 3¼ x 5¼ in.*

Private Collection.

Rendlesham and had come to ask Papa to refuse to defend a case that was due to come to court. Needless to say Papa had refused him. I was very sorry that he had upset Papa this way. He had offered money and money was the very thing that would least persuade Papa to any course of action.

Years went by without the money situation appearing to improve and eventually the bank pressed for repayment of their loan. Ben Moulton had to come to make an inventory of all we possessed to satisfy the bank that they were covered for the money. Then the following year they pressed Papa to sell his life policy, which only raised £165 at auction, bought by the bank itself. Papa was declared insolvent and our family were required to move out of Marsden House, back to Melton once more. Knowing the trials of such troubles, Fitz, whose own father had gone bankrupt, often took Papa out and about with him to try to cheer him up a little. They went out to Hollesley Bay and Papa painted on the beach while Fitz sailed on the sea.

These awful years brought sadness to everyone. At the age of thirty the one dream of my life died when I heard that Fitz and Lucy had married. Hope wasn't rekindled with the news, within the year, that they had separated. At around that time Papa and Fitz went to Aldeburgh together, and there was an enormous storm that neither of them ever forgot. I think that it was like the storms in their lives. Fitz had only just survived the heavy

140. *Rural Scene 14–20 Sept 1856. By Thomas Churchyard. Black Chalk. 2½ x 4½ in.*
Private Collection.

weather of his marriage and its break-up. He appreciated Papa's support more than he could say. They were both criticised by the polite society of the town for the way they lived their lives, but they were the sort of men who held up their heads and carried on. It helped a lot, however, to have the unquestioning support of true friendship.

Quite soon we were able to move back to Woodbridge, this time to Hamblin House, which was just across the road from Marsden House. In a way this was good; we were not far from our friends and favourite places, but we also had to look out at the life we had led before. Later that year Papa had a very celebrated and successful case that actually paid some money, and this helped the community to forget the troubles of the insolvency. He prosecuted Dr Rigaud, the Headmaster of Ipswich School, who had severely and undeservedly flogged a boy of fourteen. He had hit him at least twenty times on various parts of the body for what he called 'blackguardly behaviour' in the Arboretum: running down a bank, jumping over flower beds and throwing stones at a notice board. The boy was selected for punishment because he was the oldest boy there and, worse still, the previous winter he had been seen throwing snowballs! Dr Rigaud left the school and then the country, accepting a colonial bishopric in the West Indies.

When Uncle Isaac finally died the news was sent to young Tom and he returned as soon as he could, hoping to be able to begin farming at Byng Hall. But by the time the estate was sorted out it became quite clear that there was nothing for Papa to inherit and therefore nothing for Tom to farm. Papa found it too terrible to have to disappoint his son and also to find that his last chance of having any money to leave to his daughters was all up. Now that he knew there would be no money for us Papa set out to protect some of his possessions against repossession. He divided up his paintings into seven lots for his daughters and together he and I placed them into guard books, each containing

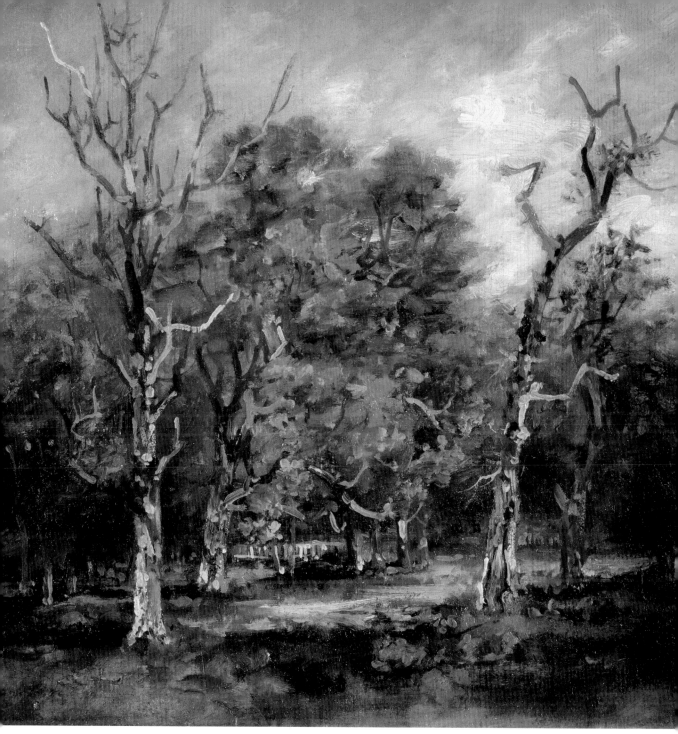

141. Study of Trees in the Park at Campsea Ashe. *By Thomas Churchyard. Oil on Panel. 9 x 9 in.*
Private Collection.

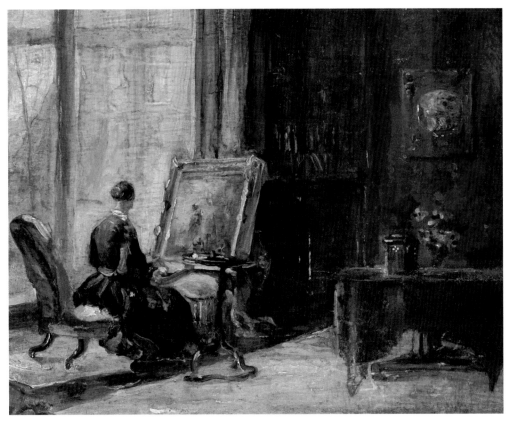

142. Interior Scene, Laura Churchyard at her Easel. *By Thomas Churchyard. Oil. 5 x 10½ in. Private Collection.*

watercolours and drawings. These were officially given to each daughter in turn so that they were their possession and not Papa's. Then we went through the oil paintings and wrote on the back of each one the name of the daughter to whom it was given.

Some easing of the financial situation came when Lord Rendlesham paid Papa a retainer to act as his prosecuting solicitor in all poaching cases. It was his way of beating the system that hitherto Papa was able to use against him. Papa hated to have to accept the offer but his position was impossible and he needed to earn whatever money he could.

Although Papa felt he had to accept Lord Rendlesham's retainer, he still took on small cases as long as they were not against that estate. A poor recently widowed woman with two small children and another on the way was sued by her father-in-law for the return of furniture that he said was his and not his son's. The judge was appalled at the case and asked who would take up the case for the woman? Papa said that he would gladly and would be pleased to act gratuitously for her. He had to be sure to balance his kind acts with fee-paying rights of way cases and such like.

Life carried on with its ups and downs, Papa growing older and a little sadder I think, but never returning from a walk without one or two sketches in his pocket. Once he was

even struck by lightning, rather a shock to us all in many ways. He had been out shooting at Campsea Ash and it began to rain; he went for shelter to a farmhouse belonging to Mr Henry Tillett, a friend. There he was invited to stay for luncheon to wait out the storm, but during the meal lightning struck the house. It came down the chimney and across the floor, hitting Papa's gun where it stood, loaded. It threw Papa from one end of the room to the other.

Looking at a photograph of him, taken by a friend with a keen interest in photography, I sigh. It shows Papa standing outside our house posed in front of an easel. It was an image that we saw frequently. Another photograph shows Papa and Laura together; she spent a lot of time painting with Papa at home and out in the fields. Her painting was very good and very similar in style to Papa's; she was a dedicated pupil. Papa still collected works of art whenever he had the opportunity, although money was scarce. It was impossible to pass up some chances, such as when he managed to buy a version of *Willy Lot's Cottage* from 1816 by Constable from the sale of Leslie's collection; it was a beautiful little oil sketch just eight by ten inches.

I know in the back of my mind that these musings are circling around the one thing that I want to think of and yet in the same moment am always afraid to dwell upon. Everything I recall leads to it in some way, every place I visit I see him, everything I see draws me to the pain of love. Fitz was always there: with Papa, with Mr B, in Woodbridge, by the sea and in my heart. I tell little Ernie innocent tales of my youth but I cannot tell him of what I feel inside. I cannot speak of Fitz with my sisters or my brother; there is no one to whom I can confide.

CHAPTER 11
TURN DOWN AN EMPTY GLASS

After some few days of absence, at last I heard the tentative knock of young Ernie. As usual he called at tea time and eagerly enquired if there were any chores to do. I set him to work splitting some kindling, just enough to be sure that he felt he had earned a reward. Then, when the pile was high enough, I called him in to have some tea. I had replenished my cake tins and had freshly baked bread ready for his delight.

'Have you been busy, Ernie? I haven't seen you for a while.'

'I've been on holiday!' he declared proudly.

'Really, my word. Where have you been? I was only recently thinking of holidays by the seaside when I was a girl.'

143. Man Fishing by Willow Trees. *By Thomas Churchyard. Watercolour/Pencil. 6 x 9¼ in.* *Private Collection.*

144. The Artist's Spaniel in a Yard. *By Thomas Churchyard. Watercolour. 3¼ x 4¼ in.*
Private Collection.

'I've been to Wickham Market to stay with my cousins there. I go for a visit every year.'

'Do you enjoy going to see your cousins?'

'Yes I do,' he affirmed, 'they live in the countryside and it is so different from Woodbridge. There are no shops nearby, hardly anyone passes their house and they have a dog!'

Clearly this was the best bit of all in Ernie's mind.

'Do you like the dog? What sort of dog is it?'

'I love him. He's called Tugger and I'm allowed to walk him on my own. He is old now and so he doesn't tug any more. He's a brown dog.'

I smiled to myself, trying to hide my amusement from Ernie; he looked so serious.

'I have some cousins. I used to go to stay with them sometimes. They lived in Cheltenham, but this was when I was a young lady. When I was a girl I only saw them once or twice because they lived abroad for many years.

'I can remember the first party I ever went to was when I was just eleven. Aunt Mary, Mamma's sister, was married from our house to Mr Henry Clarke. There was a big gathering of Churchyards, Hailes and Clarkes. We were still living at The Beeches and I can remember the great excitement of such an event. New frocks were made and mountains of food supplied, the house tidied and decorated up with flowers and ribbons. We were so happy to be in the middle of such fun. Cousins appeared and we were able at last to put faces to the names we knew so well. Aunts and Uncles petted us and said exactly the same thing: at last they knew us properly.'

145. Pickle on a Blanket. *By Thomas Churchyard. Watercolour. 2¼ x 3¾ in.* *Private Collection.*

Over our tea I told Ernie tales about the dogs we used to have. Papa always had spaniels and Labradors as gun dogs; he liked to go out shooting, often on his own but also with his friends, particularly Ben Moulton. When my sisters and I were a little older we were allowed to have dogs of our own. Ours were little pet dogs; pugs and terriers who followed us around wherever we wandered, amusing us with their antics. I tried to keep on this subject that interested Ernie so much; he longed for a dog of his own it seemed.

There are stories that are too dreadful to tell young Ernie, stories that are beyond imagination. My own painful memories should pale into insignificance next to them, except my pain is my own and therefore has a special place in my heart. As well as my wasted love for Edward FitzGerald, there is the awful history of my beloved brother. How can I begin to imagine the suffering of my dear Tom? His history was so impossible to imagine that my sisters refused to ever mention him again, not cruelly I can see that, but to protect themselves from the images that would come along with any words spoken. It was the only time that I was glad Mamma was muddled and forgetful; I think that she had forgotten Tom and his family when they had left us. She only ever spoke of him as a boy in the fields, wondering if he would be home soon. In this way his sorrows did not ever register with Mamma and we could spare her some of the pain. I would have liked to have talked to someone, but slowly all of my trusted confidants have left me alone with my thoughts.

Tom's plans never went as he had intended; it's always a problem when one waits for the death of a relative to achieve one's dreams. The waiting becomes too hard to bear, but it's too awful to hope for the death of anyone to make the waiting stop.

After he had left the Classical Academy, Tom did farm about forty acres in Ufford for a while but it was not his land, the land that he longed for, the land with which he felt a kinship. So when he was twenty-six he decided to pass the time waiting for his inheritance

gaining experience of farming and of the world. He sailed off to America, to travel and to see how the farms were run in the New World. American grain was undercutting Suffolk production and Tom knew there was much to learn. He was away for six long years and I missed him so very much. It seemed so far away; it was so far away. Letters took a long time to reach us, and we knew that our letters to him never quite held the news he longed for. Papa too had expectations that had come to nothing; those years when Tom was abroad were the years of Papa's insolvency.

A message one year was sent to tell Tom that he had inherited £250 from Great Aunt Hannah, but it was the following year that the letter was despatched telling of the death at last of Great Uncle Isaac at Byng Hall, starting Tom on his journey home. Home, it turned out, to more disappointment and frustration. Isaac's farm was too heavily mortgaged to be salvaged, and it had to be sold. Papa tried to sort out the immense task of unravelling Isaac's affairs: the loans, the mortgages, the bequests. It was a highly delicate job, as it involved the extended family all over our part of Suffolk. Eventually, in desperation, Papa handed the job to Ben Moulton to sort out for him, believing that an outsider could be seen to be impartial. Everyone knew that Papa and Tom had expectations, but it was clear everyone was to be disappointed. By the time Tom arrived home from America he was able to take Brooks and Lynns Farms on lease, and that was the extent of his inheritance.

Then Tom shocked the family once more. He married Elizabeth Bardwell, ten years his junior and known to the world at large as a servant at Byng Hall. What the world did not

146. View of village across a meadow. *By Thomas Churchyard. Watercolour. 4¼ x 7½ in.* *Private Collection.*

know, well at least most of it did not know, was that she was our cousin. Elizabeth was the illegitimate daughter of Great Uncle Isaac; her mother Leah had worked for Isaac as a maid. Leah had later married and her husband had brought Elizabeth up. When Elizabeth had been old enough she had gone to work for John Woods at the nursery just down the road from us. But she had later gone back to Byng Hall, supposedly as a servant but rather to look after her father. So the town gossiped about Thomas Churchyard's son marrying a servant, but Tom knew her history and knew that she would be worse off than any of us when her father's estate was found to be worthless. So he gave her a name, the name she had every right to in the first place, and gave her a home and his love. It seems that they had been in love for years and she, too, had been waiting for her day in the sun. So many expectations, so much disappointment.

None of our family went to Tom's wedding, which was a very quiet affair for many reasons. There was certainly no money for a celebration and no appetite for one either. While I am sure Papa would have applauded Tom's honourable motives, I know that he realised this move would only serve to bring Tom lower financially and socially. But Elizabeth was the perfect wife for Tom, and they were happy together in every sense. She

147. A lane to Wilford Lodge, Melton. *By Thomas Churchyard. Watercolour. 5¼ x 8 in.* *Private Collection.*

understood about the role of a farmer's wife; she had seen it from first hand and knew just how much work was expected of the women on a farm. In a farming family where the farm office was in the house, and the labourers lived in and around the house, too, the wife was key to the success of the venture. Elizabeth knew how to entertain the farming associates and the representatives who called to do business at all times of the day. The kitchen was open to the labourers, the dairy was under her supervision, and if Tom was called away she was in charge. Her home was furnished with heavy old furniture, which had come down the generations within the family. No chances for her to have anything new or to be able to improve the farmhouse as luckier women were able to do. Elizabeth did not care; she was in love with Tom: her lover, her farmer, her saviour. That at least had brought them both some joy in the midst of their disappointments.

The first year after their marriage nearly brought them to their knees financially when the summer burned the crops to a crisp during the most immense heat and drought for many years. Surely things could only get better. Then the following year Tom and Elizabeth had their first child, known to the family as Very Young Tom. At last there was a new generation for the Churchyard family. I was thirty-four by the time this new Tom arrived and there was no sign at all of me or any of my sisters ever marrying. Maybe Charley would also oblige later, but for now it was wonderful to know that the family continued.

The next year Tom's second son was born, Charles, named for Mamma's little baby who had died at the age of one, as much as for brother Charley who had lived. By now however it was becoming quite clear that there was no money left from Isaac's will, nothing for Papa and therefore nothing for Tom and Elizabeth either; it was a complete disaster. The farms that they leased were advertised for sale to pay the mortgages and the debts.

Tom and Elizabeth stayed just while she carried and gave birth to their first daughter, named Laura. But as soon as they were old enough and well enough to travel, Tom began making plans to emigrate with his whole family to Canada. Papa, saddened that he hadn't been able to help Tom in the end, did his best to help now. He supplied Tom with a long list of tools and supplies that they wanted to take with them, hoping to get a good start farming in the west of Canada. So it was that in April 1863 Tom and his family embarked at Liverpool as steerage passengers aboard the crack mail steamship *Anglo-Saxon* of the Allen line, bound for Quebec, thence by train to the west.

The *Anglo-Saxon* was a speedy ship and a popular one too; having done this run for seven years she knew her job. She was one of the last steam-ships to also carry sail. There was a crew of 86, 48 cabin passengers and 312 steerage passengers. The journey was to cost Tom eight guineas each for him and Elizabeth, then half price for the three children. They had to provide their own bedding, cooking supplies and food for the journey. They were sad to go, but travelled with hope that a new life was possible for them at last.

At the end of the Atlantic crossing the ship was due to meet up with the mail boat off the south-east point of Newfoundland, to hand over mails and despatches. This was a common routine and a regular part of the voyage, but on the morning of 27 April the *Anglo Saxon* found herself three miles off-course in a dense fog. She ran aground, wedging her bows in a fissure between two great twin rocks at Clam Cove. Swinging to port on impact she damaged her stern on a submerged rock. Then the long waves rolling in from

148. Ships at Sea. *By Thomas Churchyard. Oil on Panel. 7 x 13 in.* *Private Collection.*

the Atlantic Ocean swung her around until she lay right along the face of the low cliffs. At first there seemed little panic; the ship carried six boats, although two of the three on the starboard side couldn't be launched. The crew set about organising the rescue and all seemed quite calm as they proceeded. Some of the crew were dropped from the jib-boom that was hanging over the rocks; they fixed a hawser and rigged a basket to carry passengers ashore. This worked very smoothly and within a few minutes 130 of the passengers had been carried ashore. But the continual rolling of the waves pounded the ship against the rocks; suddenly the masts were shaken from their steps and crashed down with all of their heavy rigging, yards and booms on the people who remained on the deck. Just at that moment the middle starboard boat had been filled with women and young children. Elizabeth and her three children could see safety within their reach, but the crew were about to pull away for the shore when the falling rigging crashed down on top of them. The boat was upset and all were lost into the waves. Before long the ship broke up and many more were killed, although some managed to cling to the wreckage. My beloved Tom was one of just ten found next morning by the paddle-wheeler *Dauntless*. Two hundred and thirty seven lives were lost that dreadful day, two hundred and nine survived. Tom lived but wished that he hadn't when he learned that everything he loved was now gone for good.

The survivors were taken on board the ice-breaker *Bloodhound*; they landed at Quebec and most went on later, as originally planned, by train to Montreal. They received a warm welcome by the local community, who rallied round to provide clothing, food, shelter and supplies. A relief fund was set up to assist these poor unfortunates who had lost everything they owned that day. A week later a train was chartered for them by the Allen line to take

them west. Back at Clam Cove the authorities found that the local community had recovered over a hundred bodies and these they had reverently buried on the bank at Clam Cove, set with a rough stone at the head and the foot of each grave.

News of Tom's tragedy reached us soon enough. Bad news has a way of moving very much more quickly than good. The *Ipswich Journal* reported the wreck, and many knew that it was the ship that Tom had taken. Later there was an enquiry into the causes of the wreck and Papa discovered more details and more heartbreaking information. The Allen line had already had five ships sunk in the previous seven years; the company's orders to keep express time to get the mail and the news delivered as fast as possible seemed to be the overriding aim. Early testimony by survivors stated that the ship was travelling at top speed, in fog and off-course. At the inquiry the stories had changed to say that it was half-speed or even less, but that was hard to believe as the ship struck immediately after the cry of 'Breakers' was heard.

I've been told that the drama was soon retold in a Newfoundland folk-song to keep the memory of that awful tragedy alive. Poor Tom had lost his hopes, his home and his family and now he wandered like a ghost, never knowing how to settle or what he should do. We heard news of him from time to time, but it was always hard to write back, never being sure where he would be. After six or seven years we learned that he had made his way to New Zealand. There he died last year, alone, still in self-imposed exile, aged seventy-one, described simply as 'a shepherd on the Canterbury Plains'. My darling brother, our farmer's boy, who shared my first years with such love and affection, whose life fell apart at every turn, alone and friendless on the far side of the world.

149. A Brig at Sea. *By Thomas Churchyard. Pen and Ink. 2½ x 3 in.*
Private Collection.

CHAPTER 12
THIS SORRY SCHEME

Imust be getting maudlin; all I seem to be able to think about is death. Maybe I'm getting like Fitz, who felt that the countryside around here was like a graveyard, as all of his valued friends died and were buried. His life was changed more than he could have imagined by the death of Mr Barton. So was my life, too, in a way, as it finally put an end to my dreams that Fitz would ever come to love me, except as a friend of course, which I know he always did. Mr B began to feel unwell; his age slowly started to tell, although he was always in good humour. I suppose that I was in my early twenties at the time, and I often went around to his cottage to sit with him and chat, especially if he was alone. Lucy often went away to visit relatives and friends; he encouraged her to have a life of her own.

His Quaker employers were very keen on freeing the slaves in the West Indies, but he joked that they were rather blind to the slavery of their clerk in Woodbridge. At last they relented a little and allowed him to finish work at 4 o'clock, no longer requiring him to return after his tea. Then bad fortune struck and Mr B found himself with money troubles anew. He had a nest egg of £1000, which produced him an income of £50, but he entrusted its investment to a relative who lost it all on a bad speculation. He shrugged his shoulders sadly and made even more economies, but the worst part of this disaster was that it was the only money that would have gone to Lucy on his death.

All of this saddened him and weakened him, too. The next year Fitz arranged for a friend

150. Sunset over Farm Buildings. *By Emma Churchyard. Watercolour. 2½ x 3¾ in.*
Private Collection.

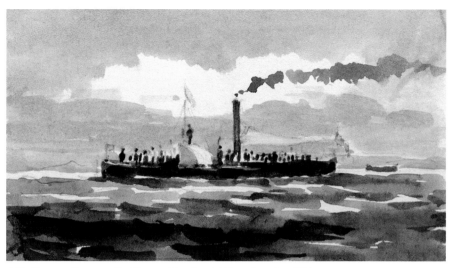

151. Pleasure Steamer. *By Thomas Churchyard. Watercolour. 3 x 5¼ in.*
Private Collection. (Photograph Courtesy of David Messum Fine Art Ltd.)

of his, Samuel Laurence, to come to paint a portrait of Mr Barton, knowing that this would cheer him up. Although he protested that he needed no portrait, he was very pleased underneath it all. In writing directions for Laurence, somehow he summed up our life in 1847:

> 'A steamboat will bring you to Ipswich for five shillings (a very pretty sail) from the Customs House to Ipswich, the Orwell Steamer; going twice a week, and heard of directly in the fishy latitudes of London Bridge. Or a railroad brings you for the same sum; if you travel third class, which I sometimes do in fine weather. I should recommend that; the time being so short, so certain; and no eating and drinking by the way, as you must be in a steamer. At Ipswich I pick you up with the washer woman's pony and take you to Woodbridge. There sits Barton with the tea already laid out; and Miss about to manage the urn; plain agreeable people. At Woodbridge too is my little friend Churchyard with whom we shall sup off toasted cheese and porter. Then last but not least, the sweet retirement of Boulge: where the graces and muses etc. I write thus much because my friends seem anxious; my friend, I mean Miss Barton: for Barton pretends that he dreads having his portrait done; which is 'my eye' so come and do it. He is a generous, worthy, simply-hearted fellow: worth ten thousand better wits. Then you shall see all the faded tapestry of country town life: London jokes worn threadbare; third rate accomplishments infinitely prized; scandal removed from Dukes and Duchesses to the parson, the Banker, the Commissioner of Excise and the attorney.'

While Laurence worked, Fitz sat with them and entertained them by reading from *Pickwick*

152. Quakers' Meeting House, Woodbridge.
Photograph. Private Collection.

Papers. Then, when the portrait was completed, Fitz managed to pay a large part of the price himself by pretending that there had been a mistake in quoting the fee. The picture hung in pride of place over the mantelpiece in Mr B's little sitting-room.

Nothing could stop the decline in Mr B's health and he became more feeble with each day. When his breathing became laboured Dr Jones admitted that it was surely heart disease and no remedy would stop its progress. So it was that in the cold dark days of February 1849 we lost another dear friend. He was buried in the old Quaker burial ground in Turn Lane and Fitz wrote an epitaph for him praising his gentleness and wisdom:

> 'Lay him gently in the ground,
> The good, the genial and the wise;
> While spring blows forward in the skies
> To breathe new verdure o'er the mound
> Where the kindly poet lies.
> Farewell, though spirit kind and true;
> Old friend, forever more Adieu.'

There was no money left for Lucy when her father died, so she had to sell off his paintings and his collection of snuff boxes. Then, deciding that his poems were his greatest asset, Fitz helped her to edit a selection of her father's letters and poems. He wrote a memoir to open the work and Papa did three engravings to illustrate the poems. Nine hundred subscribers ordered copies of this final collection of the gentle poet's works including every nobleman in the area, and many more from all parts of the kingdom; politicians and pillars of the church; whole Quaker families of Alexanders, Peckovers, Rowntrees, Gurneys; as well as his many faithful correspondents — Dickens, Kingslake, Thackeray, Wordsworth — and of

course his dearest friends: Fitz ordered ten copies, Revd Crabbe twelve and Papa six. One special copy was illustrated with watercolour paintings by Papa and us girls.

Nothing was ever quite the same again after Mr B died. He had been a benign centre, the calm around which the world seemed to revolve, and without him we all seemed older somehow and life seemed rather more of a chore.

But worse was still to come from my point of view. Thrown even more together than before while working on the collection, poor Fitz somehow managed to get engaged to marry Lucy Barton.

I realise that I sound peevish and bitter, but honestly everyone was horrified since it was clear that Fitz was not really the marrying sort. Yet in the beginning when the news finally got out, everyone seemed prepared to think that maybe they were wrong and it would prove to be the ideal solution to both of their situations. I nearly died with shock when Lucy told me.

'Oh Ellen, I have to speak to you,' she had whispered. 'I have such a secret and I am bursting to tell it. I know that I can trust you to keep it for me.'

I don't know why I hadn't guessed, it was clear that she had set her hat at Fitz for years, in fact I couldn't remember a time when I hadn't known that she admired him. As the years had passed and I had grown older I had trusted that he was safe from her charms, but I had not counted on his perfect correctness.

'Ellen, Edward has asked me to marry him!' She beamed at me so happily and triumphantly. She knew of my love as well as I knew of hers, although she had always discounted my chances: I was too young after all.

'Why is it a secret?' I asked rather nastily, forgetting in my shock to congratulate her.

'When will it be?' My heart was numb with horror; surely this could not be true.

'He says that we cannot marry while his father's financial difficulties are unresolved. He is trying to help some of the creditors who have lost money and so he is unsure of his own situation. He is so sensible. I don't mind waiting though; it is enough to know that he has asked me.' Her grin was too awful to behold.

I thought it strange that he should ask her but then declare that they must wait indefinitely. Surely it wasn't what he wanted? If it was a secret then I couldn't ask him about it. Although knowing Lucy it wouldn't be a secret for long.

Lucy Barton was the only object of jealousy and hatred that I ever had. The jealousy lasted throughout my childhood but the hatred was to flare up and then die with her marriage. After that was over I stopped hating, but I never quite forgave her for the pain and the misery she caused, not to me but to Edward. Lucy Barton was justly admired by everyone who knew her, admired for her gentleness and for her loyal care of her father, for her piety and intelligence. She was not admired for her looks. She was tall and big-boned, so heavily featured that she always looked almost masculine. The children of Woodbridge followed her calling out *step-a-yard* as she strode in a determined fashion along the street. Her voice was deep and drawling and very unattractive.

I can't deny that she was kind, generous and that I have no genuine reason to have come to hate her, but that is what hate is like.

As soon as she was old enough to be released by the relatives who had brought her up after the death of her mother, she came to look after her father, acting as his housekeeper

153. A Windmill at Melton. *By Thomas Churchyard. Watercolour. 6 x 4 in.* *Private Collection.*

and guardian. He had already begun publishing his poetry collections and writing to his many correspondents; thus Lucy came to know and be known by many of Mr B's friends. She began a Commonplace book when she was sixteen and Charles Lamb wrote the first entry in it; later she persuaded Fitz to add an entry. Lucy was twenty-eight when we first met; she was very kind and attentive to me, a mere child.

Around the same time Fitz had become a close friend to Mr B and was coming to know Papa too. As I sat beside Papa on visits to Mr B's little cottage I heard tell of other worlds and other lives. Lucy seemed to be a part of these strange worlds; she knew the ladies and the gentlemen, she attended soirees and paid visits to the grand houses in the area. Gossips had joined Edward FitzGerald's name to that of one of the Revd Crabbe's daughters but it seemed to come to nothing, except that it seemed to have started a glimmer of a thought in Lucy Barton's mind. She often spoke her thoughts aloud to me, as though at my age I wouldn't care nor have an opinion myself. I believe she thought that she was teaching me about the world, as an older sister might. She was so pleased whenever she could report that Fitz had called in to spend an evening with them. I thought that he went to see Mr B, but she always assumed that he was just as keen on her company. He was too genteel to not speak to her, too polite to not include her in their chat; after all in that little cottage one could not get away from her. He praised her toasted cheese and she made it a great drama to produce some for him whether he wished for it or not.

She taught me to follow her example: setting a slice of bread on the footman by the fire, carefully facing the coals till it toasted on one side and then the other, then placing the slice of cheese on the top and standing it to melt. She could manage to keep this up for hours, just doing one more so that she could sit on a stool at the feet of the men, firelight playing on her face. When I was old enough to help to produce food for Papa's evenings I made quite sure that I never gave them cheese on toast. There was no way that I could bring myself to compete over such a thing. I wonder if my bitterness at Lucy and her toasted cheese was what drove me to learn to cook. One of my greatest thrills was the recognition I received from Mr B in his poem, complimenting my cooking skills. Thinking of it now, it seems very silly and it was hardly fair to compete in such a way with a woman who had no kitchen.

Fitz praised Mr B's poetry and so Lucy declared her intention to write a book. Miss Barton's 'Bible History' was created and she begged Fitz to write a little preface for her. Lucy converted from the Quakers to the Anglican Church to free herself from some of the more strict constraints that her father followed. She was always simply dressed when he was alive and was careful not to give him any cause for pain, but she wanted more from life, more from society. Maybe the family who had brought her up were more worldly than her father; maybe she found his way of life rather a shock. She wanted the life that Fitz's family led and she gladly accepted any chance to stay with them. Why did she not see that Fitz hated that world and in fact envied the gentle calm of the Quakers?

Every time Fitz mentioned her in his letters to Mr B, she made sure that the letter was read out loud to us, she wanted everyone to hear the 'kind remembrances', but what did they mean except to show Fitz's politeness? Did he write of her eyes? Did he say of her:

'She hasn't those eyes for nothing – rather mischievous eyes, if I remember?'

as he had written of me. What are 'kind remembrances' compared to that? And what if

154. A Cottage at Playford. *By Thomas Churchyard. Watercolour. 3¾ x 4¾ in. Private Collection.*

he wrote asking for cheese toast, calling it nectar and ambrosia? Was he not being kind to Mr B and mindful of his limited resources? If he stayed the night in the cottage to catch the early coach or the train he ensured that it was when Lucy was away, too correct and discreet to put them in a difficult position.

Fitz was also fond of Miss Elizabeth Charlesworth and joked about her being a special favourite of his, never realising that Lucy had her own eyes on him. Lucy ensured that she was oft invited to Playford to the Charlesworths', a part of the literary set. She wanted to always be there, always a reminder. It was at Playford that Fitz met Edward Cowell, a young and talented man destined to play an important role in Fitz's life. And it was at Playford that Cowell proposed to Elizabeth Charlesworth, a woman much older than him, and there that she accepted him. Fitz was surprised and joked about his broken heart, but his preference was not so strong. Maybe he was a little jealous that two of his friends should unite in a closer bond, excluding him. Lucy, though, took heart; she was a little older than Fitz and this proved that such a union could happen. Lucy was a great friend of Elizabeth and Elizabeth encouraged her dreams, sure that a sensible, down-to-earth wife such as Lucy would be good for the dreamy Edward FitzGerald, who never seemed to know where his place in the world was to be.

With Elizabeth's encouragement Lucy began to be more open about her feelings and Mr B realised that she was becoming infatuated with his friend. But Mr B understood Fitz much better than Lucy did, and he realised that it was unlikely that Fitz would ever feel the same.

155. Landscape with Trees and River at Ufford. *By Thomas Churchyard. Watercolour. 10 x 15 in. Private Collection.*

He was too kind to tell Lucy not to be so silly and trusted to fate to sort out the problem, hopefully without causing her too much pain. I looked on with dismay, no longer the little child, now a young woman and with quite as unrealistic a dream of love as Lucy's ever was.

She leaped on every little thing to try to advance her case; everyone could see it except Fitz, who did not realise for one moment that anyone thought of him romantically. Fitz thanked Lucy for her kindness to Mrs Faiers, his housekeeper. He asked her to play a hymn at Boulge Church in his place; he had promised to do it but forgotten. Lucy did it and received more thanks. She sewed him a purse for his birthday and sent it to him at his sister's house at Geldestone. Fitz was rather embarrassed to receive it; he hated his birthday and he hated personal gestures of such a kind. Mr Barton knew that it was inappropriate and pretended that it was from him to help smooth the difficulty. Then Fitz bought gifts for Mr B and Lucy from London, regretting that he hadn't been more generous in his thanks. But that led Lucy to more intimacy and she began to ask him to do errands for her in London, buying coffee and such delicacies.

As her father's health got worse and worse, her devotions became more intense. Maybe the terrible thought of finding herself alone was adding to her error. That last Christmas when Mr B was very weak indeed, Fitz shared their turkey with them and was as attentive

as a dear friend should be. Then the following February Mr Barton died quietly, safe in the knowledge of a life well spent. His only sorrow was that Lucy was to be left in very reduced circumstances. Fitz remained nearby in Suffolk so that he could do all he could to help her sort out her affairs; he had promised as much to Mr B. Lucy insisted on paying off all of her father's debts, with the money raised from the publication of her late father's works and Fitz admired this resolve, praising her bravery, and her friends began to understand that he was in fact fond of her. He did not realise what it looked like to the outside world.

Then the worst day of my life occurred, as Lucy told me in the strictest confidence that she was betrothed to Edward FitzGerald. Heaven knows how it happened, and it was clear that it would be the worst disaster if it were to come to pass. Later some people said that Mr B had arranged the marriage as he lay on his death bed, but I do not believe that was so. I'm quite sure that Mr B knew that Fitz's inclinations were not that way and he would never have tried to tie him against his nature. Mr B knew Lucy's infatuation but had probably hoped that it would slowly wither and die. I believe that Fitz found himself in an impossible situation and his natural sensitivity forbade his letting her down in the eyes of society. He wanted to help for the sake of his old friend as much as from the kindness and generosity that he showed to all who needed it. He knew that he couldn't offer money; it would be offensive to Lucy and to her friends. I believe that she could have let him off the hook, that she should have freed him, but she did not. Lucy was sure that he would come to love her, sure that she could make him happy.

Fitz's father was bankrupt and his affairs were in disarray. Fitz used this as an excuse to put off the evil day when he would have to wed Lucy Barton. She went to live in Norfolk with the Gurney family at Keswick Hall. Hudson Gurney had been a friend of her father's; there she lived as companion to his grand-nieces and as a family friend. She stayed there for seven long years, waiting for Fitz to come to claim her as his bride. I know that he tried at least once during that time to give her the chance to free him but she did not take it. He wrote to her via Mrs Jones, the doctor's wife, and suggested that he felt they were not suited to each other; Lucy replied that she had no such fears. There was no escape. Her friend and his, Elizabeth Cowell, kept Lucy informed about his movements during this long, long engagement. Was she the agent who had pressed Lucy's case in the first place? Was it her great idea to get him neatly sorted out to her own satisfaction? Was it Elizabeth who forced the issue in the end as soon as she knew she was leaving for India, to be sure that he did not renege in the end?

Whoever or whatever the cause, Fitz found himself finally having to marry Lucy Barton in 1856; they were forty-eight and forty-nine years old respectively. His mother had died and this finally solved his money troubles that had dogged the intervening years, but he no longer had a reason for more delay. The date and the place were settled and he finally told his friends who had been kept in the dark until now. Lucy chose Chichester since it was near her wealthy relatives, despite Fitz begging her that there should be no fuss or ceremony. He did not want bridesmaids and wedding breakfasts, but Lucy and her family wanted everything; the customary ritual! Whatever they managed to arrange for the breakfast and for the bride, they still couldn't stop him from arriving in his old slouch hat and his everyday clothes. Someone recorded that he looked like a victim being led to his

156. Norwich Cathedral from the North West. *By Thomas Churchyard. Watercolour. 4¼ x 7½ in.*
(Ipswich Borough Council Museum and Galleries.)

doom; he walked by Lucy's side as one walking in his sleep, mute and with head bowed.

'It was also reported that he only spoke once during the repast:
being offered some white blancmange he waved it away with a
gesture of disgust, uttering half audibly 'Ugh! Congealed Bridesmaid.'

Poor dear Fitz, how he must have suffered. How I hated to hear of this debacle. How I hated Lucy Barton for being so cruel and so silly.

They went to Brighton for their honeymoon, another place he had always hated. He did not want to give up his bachelor habits: he wanted to smoke, to be alone, to wear his old clothes and go unshaved; Lucy wanted to improve him, to smarten him and tame him. He wanted to be silent and Lucy was outspoken and prim. He wanted to stay indoors and study; Lucy wanted to enjoy the social amenities, she had learned to be a lady during the years in Norfolk and she thought that was what he wanted. She tried to live up to his family, while he had always tried to get away from that way of life. Of course Lucy did love him, she adored him, but she would destroy him by her love. The harder she tried, the worse it was; horrendously she began to dress as a young woman in the way his mother had, so ludicrously, forgetting the simple plainness of the Quakers, which he always preferred.

It was all so painful to them both and by the time that they realised it was never going to work Lucy's health was suffering as well as his. She went off to friends to lick her wounds and Fitz went to his old lodgings to lick his. They had one last attempt to try again in rooms

157. Field and Distant House. *By Thomas Churchyard. Watercolour. 3¼ x 4¼ in.*
Private Collection.

overlooking Regent's Park, lodgings kept by Marietta Nursey, the daughter of Perry Nursey of Bealings. Marietta was an old friend of Fitz and as yet had never met Lucy; she was to become his confidante in this almighty muddle. She was the one person to whom Fitz poured out his pain and spite; he had needed a vent for his distress and couldn't speak to anyone in Woodbridge, realising that he could not complain about Lucy to those who knew her and knew his history with her. He felt that he was in the wrong and should never have let it get that far, but he had no idea of how to get out of it. Before it was all over he had become quite drunk in front of Pollock and his wife, sulked in front of Donne and shocked his sister, Mrs Wilkinson, who had befriended Lucy many years before. Everyone who met them as a couple were shocked by the bitterness and pain they met. Lucy grew enormous, and Fitz couldn't refrain from showing his disgust. He called her names to his friends: the 'Contemporary', the 'Elder', or just 'She'. He behaved in a most ungentlemanly way for the first time in his life; the situation was so far beyond the limits with which he could cope.

At last Lucy realised that she irritated him merely by being in the same room, although she never really understood why. She never understood him at all. Lucy retained her love for him and always dreamed of reconciliation. They finally separated in August 1857, less than a year after the dreadful deed of marriage was done. While Fitz's friends, who knew his kind heart and generous ways, realised that he had reacted so vehemently because he had been trapped in an impossible situation, many others never understood and never forgave him. Dr and Mrs Jones in Woodbridge had been great friends of Lucy and her father and they felt that they had a duty to shun Fitz. Even though Lucy did not wish for that sort of revenge, people quickly took sides; many people in Woodbridge found him

hard to accept anyway and this was the perfect excuse to snub him once and for all.

In later years Lucy came to understand at least something of Fitz's nature and of his preference for the company of vital young men. She wrote:

> '...touching his boyhood, the deduction may be ventured, not without a shade of certainty, that if among his school-fellows flourished any embryo Apollo he would have temporarily constituted the youth his heart's idol.'

What she did not say was that this extended throughout his lifetime: he always had to have an idol to worship, and as each one fell from their pedestal, another was found in due course.

As soon as Lucy accepted the situation was impossible he was able to be generous and settled on her £300 per annum for her life, with the only proviso that she shouldn't live in Woodbridge and that she should leave him alone. Lucy in her blindness to his now physical disgust at her presence would come to visit friends in the town, not seeing such an act as breaking her promise, and he would recoil at the sight of her walking along the pavement. Later when the feelings had lessened a little he was able to admit that he was to blame for the failure of the marriage, but it remained the most awful period of his life.

Lucy still yearned to have someone to care for and she spent some time as nurse to the Brownes at Goldington, then in Kent and Brighton.

If only she had not insisted on that marriage.

158. Cherry Tree Inn, 'Entrance to Woodbridge'. *By Thomas Churchyard. Watercolour. 7½ x 11½ in.*
Private Collection.

CHAPTER 13
THE HEART'S DESIRE

Fitz was a grave man, never really light hearted or very happy with himself, but he was always witty and amusing. He enjoyed losing himself in the company of intelligent and genuine people. Writing to his friends he had often enough daydreamed of the sort of woman he could imagine living with; he even met and admired a number of women he thought could fit the bill. But somehow he realised that a happy marriage was not going to happen and that it was better to remain good friends, not to try that ultimate experiment. He had plenty of opportunity to meet young ladies through his many sisters and from his social circle, dutifully attending suitable gatherings, like the regular meetings of a local literary circle at Playford, the home of Mrs Biddell. When he saw that his friends were marrying and settling down, but realised that sort of life would never suit him, he wrote,

> 'If I were conscious of being steadfast and good-humoured enough I
> would marry tomorrow, but a humorist is best by himself.'

Fitz always had friends and for the most part his friends remained close throughout his life. Many of his contemporaries from school and university were regular correspondents for years. Later he began to collect a diverse ragbag of friends from every place and every conceivable station in life. In his youth he had befriended a young man called William Browne at Tenby, where they met by chance whilst on holiday. This episode became for Fitz one of his most enchanted memories, and he never forgot the images of that place nor the feelings that he experienced at that time. Family and friends thought Browne wasn't really Fitz's sort of person, not a scholar nor an artist; he was a ridin', huntin', fishin' sort of chap and excelled only in those areas that usually meant nothing to Fitz.

Many years later at one of those Playford soirées Fitz met Edward Cowell. He was to become one of the most influential friends in Fitz's life; he was intellectual and stimulating, but most importantly he was keen to encourage Fitz to improve himself. Within a few weeks they were corresponding and deeply involved in discussions about language and languages. Fitz was inspired to learn more and began to devote his time and effort to studying Spanish and then Persian.

Although Fitz's mother was one of the wealthiest commoners in the country, his father's resources were not so great; after much bad planning and bad management he managed to lose even that which he had. He seemed to have a knack for selecting dishonest managers and agents who leeched his funds away, resulting in bankruptcy. Fitz's mother tried to keep out of the financial disaster that played itself out in Manchester, ensuring that her wealth was not tainted by it. But as the troubles grew and worsened Fitz felt that he needed to help and he turned to his old friend, 'Le Petit Churchyard', for some guidance through the legal minefield in which his father languished. Fitz lost some of his income,

159. Grundisburgh Bridge. *By Thomas Churchyard. Watercolour. 7 x 11 in.* *Private Collection.*

which he did not mind greatly, but he wanted to help relieve the troubles of some of his father's creditors, especially those who were more vulnerable. He was ashamed that his family could be the cause of great hardship to those who had trusted them. He realised however that he could only do so much, therefore he elected to help a few deserving people by paying off what they were owed, rather than giving everyone a tiny percentage of their debt. It was the best he could do himself, but it caused him a deal of concern and stress. He hated trading with the London lawyers and often wrote to Papa from there, checking on fine points of law.

It was during this stressful time, made so much worse by the death of his beloved old friend Bernard Barton and then Fitz's dreadful secret engagement to Lucy Barton, that he began to write and translate much more. Finally succumbing to his friend's encouragements to have some of his work printed, he began the search for a publisher. Although always published in modest print-runs for his friends' eyes only, he produced some of his early prose pieces and then his translations. He gave me a copy of *Polonius* which he had written up by hand and also a copy of *Euphranor A Dialogue on Youth*. Under the influence of Edward Cowell, Fitz had brushed up on his Spanish and freely translated

160. Figure on Path by an Oak Tree. *By Thomas Churchyard. Watercolour. 4¾ x 3¼ in.*
Private Collection.

six dramas of Pedro Calderón de la Barca; these he published and at last risked the opinion of the world, only to be cut to the quick by the criticism. He admitted that he had taken license with the translation to make it of interest to the modern reader, but he was condemned for this and he hated it. He also now began to translate from the Persian some quatrains and verses that took his interest. He translated *Salaam and Absal* and looked to Cowell, his young teacher and friend, for approval.

Maybe the many hours of study took their toll, for this was when he began to speak of failing eyesight, a common problem but a cruel one for someone who lived by books. Within a few years he began to employ readers to come and help him in the evenings; reading by an oil lamp or a candle seemed to make matters worse so he

161. Tree by a river. By Laura Churchyard. Watercolour. 3¾ x 4¾ in. Private Collection.

needed the use of younger eyes as the light failed. The first one was Alfred Smith, son of his friend Job; later boys were sons of farmers, a cabinet maker, a butcher, a taxidermist and a book binder. But Fitz kept himself busy in a vain attempt to forget about his marital dilemma.

The following year his father died after an illness of just three weeks. Once more his world was turned upside down. His brother John moved into Boulge Hall with his family and Fitz felt that he must move out of his little cottage. Fitz and his brother loved each other but couldn't really manage to live together. John was an impassioned preacher of Evangelism and was eternally trying to save everyone from the fires of Hell. Fitz often said that John was the maddest of the family because he did not know it.

Unsure where to go and where to settle, possibly afraid to buy a house of his own in case that necessitated the consummation of the marriage arrangement, he moved his things to Farlingay Hall, Job Smith's farmhouse just a little nearer to Woodbridge. The whole household consisted of Job, in Fitz's words 'a taciturn, cautious, honest, active man'; his wife, 'a capital housewife' and their son 'a strapping lad' who could have carried Fitz on his shoulders to Ipswich, he liked to joke. There was a maidservant who, 'as she curtsies of a morning, lets fall the teapot etc'.

From his new base Fitz could still visit his old friends, my Papa and old Revd Crabbe at Bredfield, and he was also better placed for the coach or the train. He kept up his correspondence and many interests; he arranged for the famous actress and author Fanny Kemble, sister of his old schoolfriend J.M. Kemble, to come to Woodbridge Theatre and

162. Jolly Sailor, Orford. *By Thomas Churchyard. Watercolour. 3¼ x 4¼ in.*
Private Collection.

perform. She surprised everyone by staging an abridged version of *Richard III* — it was simply the next piece in her repertoire, which she always stuck to without fail.

For some years Fitz had been writing to Thomas Carlyle, since Carlyle began writing his book about Oliver Cromwell and Fitz had told him that his family owned the battlefield at Naseby. After many invitations to visit Suffolk, finally Carlyle agreed and came to stay at Farlingay. He thoroughly enjoyed his visit and marvelled at the peace and quiet, except for the night when the cows had begun mooing and couldn't be stopped! Fitz took him out in a pony and trap to Orford and Dunwich and Aldeburgh. He gave Carlyle some of Papa's paintings to take home to remind him of his visit, and three weeks later he wrote to Carlyle that he had once again,

> 'Driven with the little artist lawyer (who did the sketches I gave you)
> to Hollesley Bay (on the sea) and while he painted on the shore I
> got a boat and had a great splash of sailing.'

Then Fitz's mother died and all of his money difficulties were over. He would have enough and more for the rest of his life. But now his hand was forced and he had to marry Lucy Barton. Fitz sounded as though he was announcing a funeral when he told friends:
'I am going to be married – don't congratulate me.'

And on another occasion he called his marriage, 'a very doubtful experiment'. Young George Crabbe, son of the Revd George and grandson of the poet, said that he would never forget Fitz's miserable tones when he mentioned the looming nuptials. His old friend Browne knew that Fitz was not cut out for marriage and, begging him to do

anything but marry her, he wrote: 'Give her whatever you like, except your hand. Make her an allowance.'

Fitz wrote back: 'I would cheerfully do so, but then people would talk.'

Browne replied: 'That from you! You who do not care a straw what anybody says about anything!'

And Fitz explained the problem: 'Nor should I care, but Miss Barton would care a very great deal. It would be cruel.'

It was destined to be cruel to both of them anyway. If only she had had the understanding and the foresight to release him from the vow. But she was encouraged forwards by her friends and he was unable to see a way out.

After the ill-fated wedding he tried to bury himself in translating the quatrains of Omar Khayyám from a manuscript in the Bodleian Library that Cowell had copied out and sent to him, in an effort to encourage him to use his mind to overcome his unhappiness. Cowell and his wife had sailed off to India and Fitz was quite sure they would never meet again. As a parting gift he gave Cowell the oil painting of his cottage at Boulge, made by Papa the day I fell in love. He wanted them to take it to India as a reminder of the good old days of innocence and peace. Fitz wrote to the Cowells pouring out his distress:

> 'I believe there are new Channels fretted in my cheeks with
> unmanly tears since then, 'remembering the days that are no more'
> in which you two are so mixed up.'

It was the most awful time for Fitz; he was very low. He missed the Cowells; their close friendship that had survived their marriage was now stretched to breaking point by their departure for India. He was devastated by his own marriage — he did not know how to keep faith with himself and yet get out of this appalling situation. By August 1857 Fitz and Lucy had separated for good. After the settlement he calmed down a bit, realising that he had done nothing to adapt to married life.

He found that he couldn't return to Farlingay Hall as Mrs Smith had gone out of her mind, so for three years he had no base at all. He wandered distractedly between his sister's house at Geldestone, William Browne's house at Goldington, London and Lowestoft. He turned to the water for amusement and found that it suited him well. He bought a little vessel to sail on the Deben and the Orwell and he became intrigued by the fishermen and pilots, studying their ways and their words with great interest. He felt free from care when he took to the water, free from the past and the present troubles, he wrote to friends:

> 'The country about here is the cemetery of my oldest friends; and
> the petty race of squires who here succeeded only use the earth for an
> investment … So I get to the water, where my friends are not
> buried nor pathways stopt up; but all is as the poets say, as
> creation's dawn beheld. I am happiest going in my little boat round
> the coast to Aldbro' with some bottled porter and some bread and
> cheese and some rough soul who works the boat and chews his
> tobacco in peace.'

163. A Lane in Dunwich. *By Thomas Churchyard. Watercolour.*
4½ x 3½ in. *Private Collection.*

Revd Crabbe died in the autumn and Fitz was plunged once more into grieving for an old and faithful friend he wrote to Professor Cowell:

> You may imagine it was melancholy enough for me to revisit the
> house when he who had made it so warm for me so often, lay cold
> in his coffin, unable to entertain me any more! His little old dark
> study (which I called the cobblery) smelt of its old smoke; and the
> last Cheroot he had tried lay three quarters smoked in its little china
> ash pan. This I have taken as a relic, as also a little silver nutmeg
> grater which used to give the finishing touch to many a glass of
> good hot stuff and also had belonged to the Poet Crabbe.

They had often quarrelled but they always made up again, with the help of their friends. Fitz had been like a member of Crabbe's family and had often stayed in their house. He had been fond of one of Crabbe's daughters and remained friends with them until his

164. Path with Closed Gate and Stream. *By Thomas Churchyard. Oil on Panel. 7 x 5½ in. Private Collection.*

165. Fort Green, Aldeburgh. *By Thomas Churchyard. Watercolour. 7¾ x 11½ in.* *Private Collection.*

death. He was also very close to young George Crabbe and travelled with him during a couple of summers, and often staying with his family in his later years.

Then death intruded once more the following year, when Fitz's friend William Browne suffered a hunting accident. He took a long while to die and Fitz could hardly bear to visit him on his death bed. He did go and did speak once more to Browne but it was too awful to him, to see his young vital friend broken and wasted.

More and more often Fitz took to the water and found himself distraction among the fishermen and seafarers of the coast. He made particular friends with James Fisher and his sons Ted and Walter at Aldeburgh, after he had bought them a pipe and a beer one night. He saw a lot of Walter, often sailing out with him, and Walter even came to Woodbridge to visit Fitz. Once when sailing they were asked by a pilot to take him out to a ship, and Fitz was paid a dole of 6s.8d. for the trip, which he kept afterwards in a box on the mantelpiece,

'I'm proud of the first money I ever earned.'

Fitz published his translation of the *Rubáiyát of Omar Khayyám* for his friends to read. Khayyám's free-thinking religious scepticism appealed to Fitz's way of thinking, but Edward Cowell thoroughly disapproved and regretted ever sending the verses to Fitz. They fell out over Fitz's interpretation of the verses: Cowell thought that the words were directly

166. A Cottage in a Wooded Landscape, Ford and Bridge. *By Thomas Churchyard. Watercolour. 7¾ x 5¼ in.*
Private Collection.

167. St Margaret's Church, Lowestoft. *By Thomas Churchyard.*
Watercolour. 3¼ x 4¼ in. *Private Collection.*
(Photograph Courtesy of David Messum Fine Art Ltd.)

about God, but Fitz thought the text should be taken at face value. Fitz, like Omar, deliberately obscured the sex of the 'beloved'. Something in this translation made East and West seem somehow in sympathy, which was unheard of at this time. Many Victorians came to be shocked by the work, but opinion was changing and faith beginning to shift on its foundations; it was the same time as the publication of Charles Darwin's *On the Origin of Species.* The *Rubáiyát* was serene and cheerful, an elegy on all faiths, resigned and philosophical. It accepted the existence of the Knowing One but stressed the impotence of human destiny. Two hundred and fifty copies were printed by Bernard Quaritch; Fitz kept forty copies for friends and told Quaritch to sell the rest.

For a while, after the death of Mrs Smith at Farlingay Hall, Fitz returned there, but after nursing his wife Mr Smith was not well either. He thought that he needed to sell up and move, no longer able to manage the farm and the house. So, pushed to find another base, Fitz rented two rooms above Sharman Berry's gunsmith shop on Market Hill in Woodbridge. He defied his critics in the town, who still blamed him for his treatment of Lucy, and determined to live in the centre of it. Once more he returned to his old bachelor ways, his preferred state. The two rooms were cramped, uncomfortable and fairly dirty when he arrived, so he set out to decorate them in his own style. He bought some paintings for the walls, including a Gainsborough from Papa, and set out his books and music. He was seen walking around the town and riverside, often remembered for his Inverness cape, double-breasted flower-satin waistcoat, slippers on his feet and a handkerchief tied over his hat. The youngsters in the town called him 'old Dotty' as his eccentricities grew.

He spent a lot of his time on the water sailing, or away in Lowestoft or Aldeburgh, and

168. Harwich, Essex. *By Thomas Churchyard. Watercolour. 1 x 2 in.*
Private Collection.

while he was away he asked his new friend Frederick Spalding to do errands for him and to organise his post and books. Frederick was a young merchant's clerk, the new favourite. Once again Fitz came to be accused of ruining the young man's life when he encouraged Spalding to set up his own business in malting, lending him the money to do it. Then later Fitz tore up the bond for the loan and absolved the debt. But Spalding was not a businessman, and his family blamed Fitz for pushing him on to try too much.

After no recognition for two or three years, suddenly the *Rubáiyát* was 'discovered'. The story goes that Quaritch had found the unsold copies and had reduced them from 1s. to 1d. and put them in the bargain box at the door of his shop. A few copies were bought by Whitley Stokes, a friend of Dante Gabriel Rossetti. Rossetti liked it so much that he went back and bought more copies for Edward Burne-Jones and George Meredith. The work that had been borne out of Fitz's despair and unhappiness, which had caused something of a rift with Cowell, was suddenly the talk of fashionable London society. Meanwhile Fitz was amusing himself writing to *East Anglian Notes and Queries* in the *Ipswich Journal*, 'The Vocabulary of the Sea Board'.

He bought another boat that was more suitable for the sea. Now he sailed the coast from Cromer and Wells down to Kent and the Essex ports. But he admitted that he only sat on board while his captain did the work:

> 'You may think I have become very nautical by all this: haul away at
> the ropes, swear, dance hornpipes etc. But it is not so: I simply sit
> in Boat or Vessel as in a moving chair, dispensing a little grog and
> shag to those who do the work.'

He still moaned about the local gentry enclosing the land; he still fought back in his own little ways:

> 'But we are split up into the prettiest possibly squirearchy, who want
> to make the utmost of their little territory: cut down trees, level all
> the old violet banks and stop up all the footways they can. The old
> pleasant way from Hasketon to Bredfield is now a desert. I was

169. Isle of Wight. *By Thomas Churchyard. Watercolour. 4½ x 10½ in. (Photograph courtesy of David Messum Fine Art Ltd)* *Private Collection.*

walking it yesterday and had the pleasure of breaking down and
through some bushes and hurdles put to block up a fallen stile.'

He fought other little battles too, using his influence with old friends. He wrote to Stephen Spring Rice at Trinity House, the Authority responsible for lighthouses and navigation, to ask for a new buoy at the mouth of the Deben and it was done. So Fitz joked about 'his' buoy and said that it had gained him the only kudos he had ever had in Woodbridge.

Then he bought another new boat, '*Scandal*', named, he said, for the staple industry of Woodbridge, since the gossips had never stopped talking about him: about his marriage, about his strange friendships and his odd ways. '*Scandal*'s tender was called '*Whisper*'. His new skipper was Tom Newson, who held his head permanently on one side like a magpie looking into a pot. Now the passages were further afield: up the Thames, over to France, Holland and the Isle of Wight.

More deaths depleted Fitz's store of close friends, plunging him into depression each time bad news arrived. His favourite sister, Eleanor Kerrich, died in 1863, just after Fitz had imagined that he had seen her as through a window. It was the only time he had a strange experience like that but it seemed to him to be a real one. He was too upset at her death to go to the funeral and never liked to go to her house after she was gone. Later that year news came of Thackeray's death. They had been friends since their student days and had always felt a great love for one another. Thackeray had answered when asked who was his most beloved friend, 'Why dear old Fitz to be sure…' The following year Fitz's sister Isabella died. Slowly his siblings were disappearing and with them his connections to his family and his childhood. The family had always been strange in many ways, but as

children they had found some comfort in each other's company when they felt most ignored by their mother.

Although he remained in the rooms above the gunsmith's shop Fitz bought himself an old farmhouse with six acres, called Grange Farm on the outskirts of Woodbridge. He called it a 'rotten affair' and set about getting builders in to improve the accommodation. He couldn't really imagine living there on his own, but felt that he should own some sort of property. He called it various things, usually Little Grange, belittling it in his usual manner. It had once been two small cottages that had grown over the years, with three cramped bedrooms above a kitchen, a scullery and a sitting-room. Fitz's builders added one large and airy room on each floor and a lavatory; outside he had constructed a handsome garden terrace. As the years went by and the battles with the builders over the work and then their bill were completed, Fitz began to plant the garden with trees and flowers, a duck pond, and also bought extra land to preserve his view of the river. He kept in touch with his old servants Mr and Mrs Faiers; they even came to dine with him and he reported that Mrs Faiers complained about the modern world,

> 'How the gals dress'd out nowadays – how they went about "pomped up"
> with roundabouts that made them like beer barrels.'

In 1865 Fitz set out for one of his longer cruises, this time to Calais. He anchored at the mouth of the Deben ready to get away on the tide, and slept on board. Then he had a really famous sail from Felixstowe Ferry — getting out of it at 7 am and being off Broadstairs … as the clock struck 12.

170. Beach Scene with Shipping. *By Anna Churchyard. Watercolour. 3 x 5 in.* *Private Collection.*

While he enjoyed his sail Papa died of heart failure. Since the death of Mr Barton, Fitz and Papa had become even closer friends, Papa wasn't one of Fitz's protégés; he was admired for his talent as an artist and collector and for his skill in his career. Fitz had few friends who were quite independent of him, or that he could admire, so once again he felt this loss deeply. When he came home he was keen to help us where he could, knowing that we, like Lucy before us, were in dire straits. Mamma was very ill and unable to help at all, but my sisters refused to speak to Fitz, believing that he was to blame for Papa's money problems. Poor Fitz was always there to blame, because people knew that money meant nothing to him, yet it was always the greatest problem to us. Fitz had already noticed that Papa showed the same symptoms as Mr Barton had done, and so wasn't entirely surprised. He headed the list for a subscription to help us over the first loss and to give us time to work out how we would manage. The following year Mamma died too, she had no taste for life without Papa to coax and encourage her. Then the rift between Fitz and my sisters became complete. He had always been my dear friend and I knew that he considered me a cut above my sisters. But he had been heard to say of Papa:

> 'He hasn't a penny, yet here are his daughters, all at home, kept like
> white mice!'

Of course his words were quickly conveyed to our door. Papa had known what Fitz thought but that never changed his idea of how to live his own life. Fitz's complaint was that we were trained for nothing, that it was folly to spoil daughters in that way, letting us stay at home and amuse ourselves with faddling occupations. But he had never included me in his criticism, I knew that full well. He thought me an accomplished artist in my own way, and said that my work had an insight that my sisters' did not have. He also saw that I was able to run the household. Fitz was most condemning of Charley; when he wrote to tell Marietta Nursey of Mamma's death he said,

> '…the daughters go on as before: doing all for their house, but I
> don't think preparing for other work. The worst is Charley the
> youngest son, who having been brought up idle, is not only idle but
> dissipated and will wring all their money out of them.'

Lucy often came to visit friends in Woodbridge, clearly not thinking that visits were a breach of her promise not to live there. She remained close friends with Dr and Mrs Jones, and as a consequence they did not speak to Fitz for a long while because of his treatment of her. The year Mamma died Lucy came to Woodbridge four times, once startling Fitz by rushing across the road to shake his hand. He had managed to put the worst of the marriage behind him and always wished to be polite, but he couldn't hide his abhorrence.

A new friendship grew up with a young fisherman from Lowestoft, Joseph 'Posh' Fletcher; Fitz described him in his usual poetic way,

> '… a man of the finest Saxon type – blue eyes, a nose less than
> Roman, more than Greek and strictly auburn hair that any woman
> might sigh to possess.'

171. Figures embarking at a Jetty. *By Thomas Churchyard. Pen and Ink. 3¾ x 5¼ in.*
Private Collection.

After a while Fitz played his usual trick of helping Posh to buy a boat of his own. First they bought one called *Porpoise* from Southwold, but she was no good, so then he had one built. It was a lugger, called *Meum and Teum* (Mine and thine), or more often *Mum and Tum* by the Longshoremen. To Fitz it started as an amusement, to play at being a herring merchant; they were to be partners, but soon it became nothing but worry and trouble to him. Once again he ended up by doing Posh no service at all. But he adored the water and the men who went on the water; he found some escape and some comfort — 'As we lay all day on the mud where samphires grow!'

In 1868 a second edition of the *Rubáiyát* was published by popular demand. A.C. Benson described Fitz at sixty:

'A tall dreamy-looking man, blue eyed, with large sensitive lips, and a melancholy air; as though he guarded his own secret; strong and active from much exercise, yet irresolute in his movements; with straggly grey hair and slovenly in dress, wearing an ancient, battered, black banded, shiny edged, tall hat, round which he would in windy weather tie a handkerchief to keep it in place; his clothes of baggy blue cloth as though he were a sea farer, his trousers short and his shoes low, exhibiting a length of white or grey stockings. With an unstarched white shirt front, high, crimpled, stand-up collars, a big black silk tie in a careless bow; in cold weather trailing a green and black or plaid shawl; in hot weather even walking barefoot with his boots slung to a stick. He never carried an umbrella except in the heaviest rain.'

172. Jessop's Quay, Woodbridge. *By Thomas Churchyard. Watercolour. 7 x 11 in.* *Private Collection.*

His routine during these sailing years was quite set. He started sailing in June and continued for as long as the weather would allow, maybe as late as November, before he had *Scandal* laid-up for the winter. While she was in the water she was to be ready to sail whenever he required her. He would just turn up without warning, arrive on board and settle down on deck with a book, usually in Greek or Latin, and a smoke. There he would sit and stare across the river and chat to Posh or his skipper Tom Newson, or just spend the day reading. He hated to go below and avoided it at all costs. Posh and Fitz often fell out and there was a lot of unhappiness and stress throughout their partnership. Fitz wanted Posh to stop drinking so much, but Posh couldn't bear Fitz to command his life. Fitz began to fear for the lives of his men and every time they were out at sea he was worried that one of them should drown and he should feel responsible. He began to buy all of the latest safety equipment but the sailors were not ready for it and did not want to be different to their peers. Posh accused him of mollycoddling them, buying life jackets and respirators to wear in the dust of the net room. 'Lor! I should be ashamed to be seed a wearin' on it!'

Eventually for both their sakes the partnership was split and Posh was left to go his own way, but not before Fitz had had a photographic portrait done of him, and also had commissioned Samuel Laurence to paint a portrait, which Fitz hung beside greater heroes on his wall.

173. Coastal Scene with Tall House. *By Thomas Churchyard. Watercolour. 3½ x 4½ in.* *Private Collection.*

Gradually his eyes were growing worse and he took to wearing wire-rimmed spectacles with small lenses of different colours, ranging from pale green to deep blue. He felt that straining his eyes to read by the oil lamp on board ship was making them worse; at home he still employed boys to read to him in the evenings. They were paid for their work but also fed on plum cake and entertained with games of piquet. Eventually he decided that he should give up *Scandal* and going to sea; he sold her, but he kept the smaller *Waveney* and her skipper, Ablett Passiful, to sail on the river:

> 'I content myself with sailing on the river Deben, looking at the crops
> as they grow green, yellow, russet and are finally carried away in
> the red and blue wagons with the sorrel horse.'

After he had finished battling with the builders at Little Grange over the cost of the improvements, he decided to add another two rooms, putting off the day when he would be expected to move from his two rooms into his house. A third edition of the *Rubáiyát* was published and talk was rife about the identity of the author. Great interest had sprung up in America, and there Fanny Kemble's daughter believed that she had guessed the identity of the author; quickly it became an open secret, whispered everywhere. In 1873 Fitz received a letter, which had been written ten years earlier by John Ruskin to the author of the *Rubáiyát of Omar Khayyám*. It said how great he thought the translation was, and begged for more of Omar Khayyám to be prepared for publication. The letter had

174. View of Woodbridge from the Docks. *By Thomas Churchyard. Chalk. 3¼ x 5½ in.* (*Photograph courtesy of David Messum Fine Art Ltd*) *Private Collection.*

come via Charles Eliot Norton, Professor of Fine Art at Harvard University; he had sent it to Thomas Carlyle, who in turn sent it on to Fitz.

Frederick Tennyson, brother of Alfred, came to visit Fitz in Woodbridge for a few days; they had corresponded throughout the decades since they were students but Fitz had lost hope of ever meeting him again. Frederick had lived abroad and Fitz couldn't bring himself to travel to see him.

At last he found he was forced to move house. Sharman Berry's wife had died and he had married again; he was a little man and his new wife was a buxom widow. She fancied herself as very genteel and she did not like the idea of having a lodger, so she bullied Sharman into telling Fitz that he must go. At last Fitz moved to Little Grange, where he was looked after by John and Mary Anne Howe. There he settled with his doves, his pond, the Quarterdeck walk and the little summerhouse. He entertained his nieces and nephews and later came to invite friends to stay like Charles Keene, the *Punch* illustrator.

At this time he visited Cade of Ipswich to have a photographic portrait done of himself, saying that his nieces wanted it. There were three views taken but he only selected two: one he called the *Statesman* and one the *Philosopher*. He was quite pleased with them in the end and sent copies to his friends and family. Once settled in his new home I often called to see him and we would sit in his garden and chat about the old days. He told me that he had sent to a friend an oil sketch by Papa, a 'moonlight'; it brought back memories of their long friendship. Every spring he would remember Papa when he saw the aconites appear:

'My friend Churchyard (in his elegant way) used to call them "New Year's Gifts".'

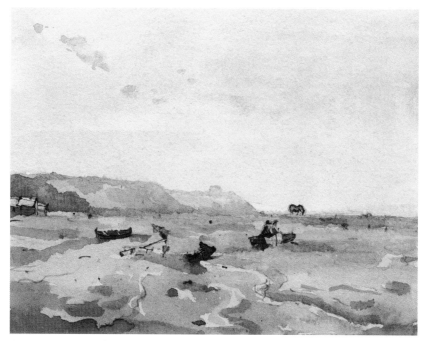

175. Extensive Beach, probably in Lowestoft area. *By Thomas Churchyard. Watercolour. 3¼ x 4¼ in. (Photograph courtesy of David Messum Fine Art Ltd)* *Private Collection.*

Age slowed him a bit and restricted his world to narrower boundaries, but he still visited the coast at Lowestoft, Dunwich or Aldeburgh; he still sailed down the river when the weather allowed, but he began to feel old and mortal.

His favourite brother Peter died with Edward's name on his lips.

Out of the blue Fitz had a visit from Alfred, Lord Tennyson, another friend who he had written to over many decades but never expected to see again. He wouldn't let him stay at Little Grange, saying that it wasn't grand enough, but instead he put him and his son up at the Bull Hotel. They spent the days in his garden or out on little excursions, and the years since they had met seemed to slip away. Later Tennyson reworked *Tiresias* and dedicated it to Fitz. It began:

> 'Old Fitz, who from your suburb Grange,
> where once I tarried for a while,
> glance at the wheeling orb of change,
> and greet it with a kindly smile…'

Sadly Fitz never saw this poem.

The world was changing and Fitz hated it; he hated the fact that he was so alone, so many friends had gone. The river was silting up and the port was declining, barges appeared to transport the cargoes, but this changed the whole atmosphere of the river. At Kyson was

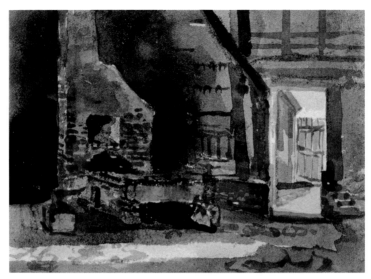

176. Blacksmith's shop, Woodbridge. *By Thomas Churchyard. Watercolour. 3½ x 4¼ in. (Photograph courtesy of David Messum Fine Art Ltd) Private Collection.*

a section of the river called Troublesome Reach, which was the worst sticking point for the larger ships. It was dredged out by order of John Loder the Woodbridge bookseller, with money raised for him by the town. He had been tried for libel by a local schoolmaster, after accusing him of buying personal items in an order for school supplies. John Loder had lost his case, but everyone in Woodbridge believed in his integrity. Fitz started a collection to pay his fine for him; £250 was raised but he refused to take it. Instead he used it for the dredging of Loder's Cut, which would be of benefit to everyone. He said that the fact that the town supported him, was enough.

Fitz needed company and I often called when I knew that he was alone, sitting and chatting about old friends. He wrote to Anna Biddell:

> 'It wants half an hour of my single pipe-time: I have been four hours
> on the river: then after Tea came dear old Doughty for nearly two
> hours: then Ellen Churchyard for half an hour: then to water my
> garden: and still it is but 8.30pm, too dark to read out of doors.'

His brother John died and then his sister Lusia, leaving only him and his sister Jane, who lived in Italy. They had never really been close, but when she came to stay with him briefly he found that they at last had more in common and got on a lot better than when they were young. She, too, had disapproved of his marriage and separation at the time; Lucy Barton had been rather closer to her than many. But after so many years these differences were worn thin. Even Dr Jones was happy to speak to Fitz now; to be fair Lucy had never wanted anyone to take up her case against him.

Fitz felt sure that he knew when he would die, knowing that his family rarely lived

much beyond seventy. He said that he welcomed the tell-tale signs of heart disease as it meant that he would have a quick death. When he came to die he did not want to have 'a lot of women messing about him'.

Six weeks before he died he packed up a tin box with copies of all of his works and sent it to Aldis Wright at Trinity College, Cambridge. He took a last trip to London for the day and also a visit to Geldestone Hall, which he had not visited since his sister's death. In April 1883 he wrote a new will to be sure that all was arranged as he would wish, and in June he died at the home of his friend George Crabbe the Third. Crabbe wrote to Aldis Wright:

> 'I grieve to have to tell you that your dear friend Edward FitzGerald died here this morning. He came last evening to pay his annual visit with my sisters, but did not seem in his usual spirits and did not eat anything. At ten he said that he would go to bed. I went up with him. At a quarter to eight I tapped at his door to ask how he was and getting no answer went in and found him as if sleeping peacefully but quite dead.'

He was brought back home and buried at the foot of the tower of Boulge Church as he had requested, not wishing to join his family inside the mausoleum. His funeral was attended by Edward Cowell, Aldis Wright, Crabbe and a number of friends from Woodbridge, plus two or three old farmers who remembered him well. Lucy did not go to the service although she was in Woodbridge at the time. Of course it wasn't usual for women to follow the coffin, it was a task for the menfolk.

I felt as though my life was now freed from the straps of love that had bound it for so long. It sounds strange, I should think: my love did not die with Fitz, but the pointlessness of that love died. Yet I missed him like we miss the sunlight in winter. I knew that he was ready to go to his long rest, and could not wish him back. On his headstone he had asked to be placed:

> 'It is He that hath made us and not we ourselves.'

177. Three Sailing boats. *By Thomas Churchyard. Pencil. 3¾ x 5½in. (Photograph courtesy of David Messum Fine Art Ltd)* *Private Collection.*

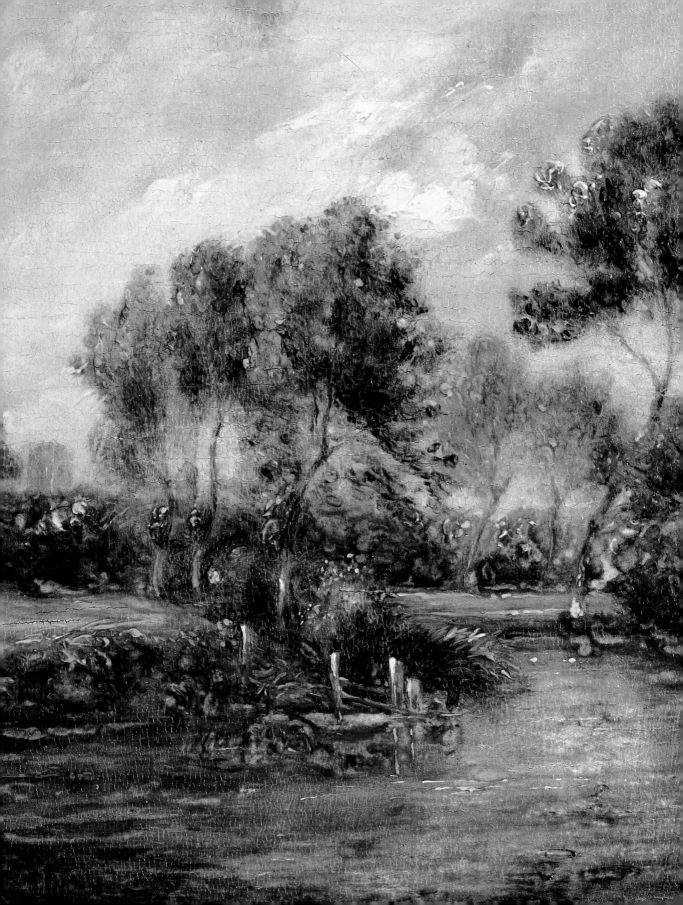

CHAPTER 14
BUT A LITTLE WAY TO FLY

Charley comes and goes each day as I sit and think of my life. He huffs and puffs his indignations, but says little, unless I force a conversation on him. I believe that he has been doing quite a lot of painting at the nursery, but what will come of it I cannot guess.

Then one morning he is sweetness and light and I really should have realised that it was a bad sign.

'Ellen, please may I look through Papa's oil paintings? I just want to remind myself of his work and his style. I know there are a lot on the walls but I want to remind myself of those I haven't seen for a while.'

I was pleased at his words but mistrusting of his motives. He would certainly gain something if he studied Papa's work, but could I really trust him? Still we must try to be trusting, I suppose; we must start from that position and risk being proved wrong.

'Of course you may look at them. If you help me to move the crates into the light we could go through them together.'

'Oh no, I wouldn't want to disturb you. You are always so busy: cooking, shopping and walking about. I'll do it and then I'll pop everything back as I find it.' He smiled rather sickeningly, not a regular sight.

'It is no bother and I would like to see the pictures which are packed away, for old time's sake. There were one or two which I had thought to show to young Ernie next time he comes.'

The smile freezing on his face, he looked almost angry, but knew that he had no choice. So together we went into my parlour and began to unpack some of the oil paintings there. It was such a delight to see old friends once again and of course each image sparked old memories of people and places. How strange it is that one's childhood becomes so clear in one's mind when viewed from such a distance. Charley clearly did not wish to reminisce and rather trampled on my thoughts as he just grabbed the pictures and held them up to the light to study for a while and then to lay down once more. I soon found that I did not enjoy doing this task with him and wandered back to my kitchen with an excuse about checking the temperature of the oven. After all what harm could he do? I would rather go through them on my own, or better still with Ernie. Each painting could fuel a host of stories I felt sure.

After an hour or so I heard Charley call out to me and then slam the front door, as he set off for the pub no doubt. I looked in the parlour and true to his word he had packed the paintings neatly back in the crates that protected them, and even pushed them back against the wall.

178. View near Grundisburgh Church. *By Thomas Churchyard. Oil on Panel. 6½ x 5½ in.* *Private Collection.*

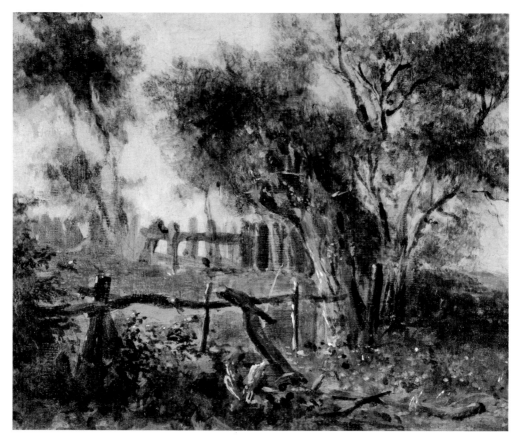

179. Country landscape. *By Thomas Churchyard. Oil on Panel. 5¼ x 6½ in.* *Private Collection.*

My day passed as usual: I walked to Kingston Meadows and strolled along the river-wall for a while enjoying the sunshine and collecting some wild flowers. I had a yen to paint a study of the flowers, to see if I could still see clearly enough for detailed work. My eyesight was not as it had once been; maybe I would have to get Ernie to read to me, as Fitz had with his young lads. With a small posy of flowers I headed homewards for tea, thinking of the oil paintings and wondering if my little friend would be coming to chat with me for a while.

Ernie came and helped me to water my sweet peas and the few vegetables that I managed to grow in my little garden. It had been rather dry for a while and I wanted to be sure they got a good start. After the chores came the cakes and tea, so we made ourselves comfortable near the kitchen range.

'Do you go to the National School?' I asked.

180. Stork's Bill. *By Emma Churchyard. Watercolour. 5½ x 3 in.*
Private Collection.

'Yes I do,' Ernie replied keenly. He liked school very much and I knew that it mattered to him.

'Did you know that it was once our theatre? My friend Ben Moulton bought it in 1833 along with a business partner and they kept it going for thirty years before it was closed and then turned into the school.'

'I didn't know that Woodbridge had a theatre, although it is called Theatre Street so I suppose I should have guessed.'

'I think it was built in the beginning to entertain the soldiers who were stationed here in the barracks, at the time of the Napoleonic Wars. Then we became rather fond of it in the town and so it kept going. I can remember Ben loved the theatre more than anyone; he would go to all the half-price performances so that he could afford to go more often. Maybe that was when he decided to buy it himself. Fitz once arranged for the famous actress Mrs Kemple to come to perform here; it was greatly exciting. People gasped at her, she was so much larger than life. Poor Fitz squirmed in his seat but I don't think that she was offended. The usual performances were rather more provincial, I have to say.'

181. An officer escorting two young women. *By Thomas Churchyard.*
Watercolour/Pen and Ink. 3½ x 4½ in. *Private Collection.*

'What was it like to have soldiers in the town?'

'Well actually I don't really remember the days when the barracks were full, but I think that generally it was a good thing for the town as a whole; it meant more business and more resources. But there were always troubles too; the young men were not at all pleased when the town filled up with handsome soldiers in their smart uniforms. Girls are always fond of a neat uniform.'

Ernie looked dubious at this idea. He thought that the boys would have been lured by the uniforms and the weapons, rather than the girls, but I did not explain what I meant. Then it was time for him to take his leave and go home to his mother's chores.

'Next time you come we'll look at some of my father's paintings, which I have in boxes.'

Ben Moulton had been a friend of our family since the first day he arrived in Woodbridge. Papa had helped him to get established in his career and had helped him often, over the years. But Ben had helped us, too, by being discreet and gentle when hard times caused us to have to retreat. He sold our furniture the first time, when Papa went to London for his vain attempt at success and fame. Then decades later it was Ben who came to Marsden House to make the inventory of our possessions for the insolvency order. He was

182. Pinks. *By Ellen Churchyard. Watercolour. 6½ x 4¾ in.*
Private Collection.

discretion itself as he carefully listed everything that was to be found in every room; I accompanied him as he did his job. I tried to comfort him, as he tried to reassure me. It was not his fault that we were in this position, but he hated to have to be the one to itemise our lives this way. Mamma sat in the parlour and treated Ben's arrival as if he were merely visiting Papa, as he so often did. Some of my sisters were away visiting our cousins in Cheltenham, but those who remained at home took themselves out of the house to sketch, unable to bear the humiliation of the inventory being made. I wanted to experience, to face, the pain, not to shirk it. So I helped Ben as much as I could by telling him truthfully about which items could be described as belonging to Papa and which were more feminine possessions, which had been presents to us and which were liable to be sold to pay off the outstanding debts.

Soon after that we had to move from Marsden House for a while, back to Melton. Then, when the financial muddle had been sorted out as far as possible we had returned to Cumberland Street to Hamblin House. Life went on once again, but sadly debts began to mount up as before.

But it was after Papa's death that Ben had to sell his possessions for the final time. Ben had been there to help us when Papa fell suddenly ill and died. He had arranged the

183. Bredfield Street from Haugh Lane. *By Thomas Churchyard. Watercolour. 5 x 4½ in.*
(Ipswich Borough Council Museum and Galleries.)

funeral for us and he led the mourners to the silent, beautiful graveyard at the old church in Melton. Fitz had been away sailing to France when Papa died and did not know about it until after his return. Anyway it was hard for Fitz to help us as he would have wished, since my sisters quite hated him and refused to speak to or notice him at all. They blamed Fitz for Papa's debts, convinced that Fitz had led him to a higher lifestyle and into wasting money on buying works of art that he couldn't afford. They now refused to speak to Fitz ever again, even pretending that he was not there if they chanced to pass in the street. I hated their behaviour and it added to the atmosphere that grew between us; I tried to sort

out how we could live and I felt that my sisters tried to ignore the problem. Fitz was, however, very kind to us and helped John Loder to set up a committee to raise monies to help us. The committee spoke of Papa's goodness and said that

> 'He had left a widow and seven daughters totally unprovided for: his two sons not being in a position to give them the smallest assistance. The fund was to support the widow and to help the advancement in life of the daughters.'

They raised £600 from kind benefactors, many from the legal world and also Ben and dear Fitz, of course. The tradesmen of Woodbridge felt that they had given enough in extending credit for many years, with little expectation of payment.

184. Auction Scene. *By Harriet Churchyard. Watercolour. 4¼ x 5½ in.* *Private Collection.*

My sisters hated the charity, but while they turned their hatred on Fitz they were not so hard on Ben and so he was able to help me to sort out the situation. In theory it was Mamma who was now the head of the family and it was her name in which things were done. But she had no idea of what was required and did not wish to be made to understand. Papa had saved for us the vast majority of his paintings and sketches by the clever plan of giving them to us years before. I had helped him to sort them and divide them, writing our names on the backs to indicate their ownership clearly. Ben once again sorted through our things and allocated the furniture that was fairly to be considered ours, and the rest that needed to be sold to settle Papa's debts.

Ben arranged the auctions; the first one included many wonderful works of art by other artists, to be sold in a marquee in the garden. He said at the start:

> 'I dare say that this collection ought to have been sold by Christie
> and Mason in London; but if a mistake has been made I alone must
> take the responsibility. Gentlemen, every lot is the property of the
> late Mr Churchyard. We have no reserve upon them and not a
> single bidding will be made on my part, to enhance their value
> against you. We have no other market to take them to, therefore
> your price will be ours, let that be whatever it may. Under these
> liberal circumstances I trust with the large and respectable
> company I see around me you will give a fair market price.'

I sat through the sale as I had sat through everything else. I wrote the name of the buyer and the price against every item; it raised £650. There were many local names, people wishing to buy a memento of the famous Mr Churchyard or those who knew that he had good taste and thought the work would be valuable one day. There were many dealers too: Roe of Ipswich, Cox of Pall Mall, Pierce of High Holborn, Lawrence of Wilderness Row, Watson of Piccadilly and Noseda of The Strand, a print seller. We sold four Constables at £120, five Morlands, three Wilsons for £60; watercolours by Crome went for less than £10 each; some Gainsborough drawings, which sold for a couple of guineas the pair; four Cotmans, £15 the lot. There were seven of Papa's oils including a large one of Melton Meadows that only raised £7 15s; the George Frost drawings that Papa had had from a friend and more Crome oils.

The following week was the sale of household effects. Once again Ben presided over the task, sadly seeing the last of the items that he had known as well as us for decades. Once again the populace of Woodbridge and beyond came to buy up pieces of history; some came for love and some for revenge.

Together with the subscription that was raised by Papa's friends and colleagues, Ben helped me to settle the bills and debts as much as was possible, a sad and sometimes humiliating business but it had to be done. During this time when I was so tied up with this business I seemed to become even more estranged from my sisters than ever. We had often had differences, but without Papa there to hold us together those differences became more and more profound. While they hated Fitz, I am afraid I loved him and needed his friendship and love in return. They were hard in their dealings with poor Ben, who was

185. Snow scene in Melton Street. *By A Daughter. Watercolour.* 5¼ x 7½ *in.* *Private Collection.*

trying to do his duty and also to be a friend at the same time, a difficult position to maintain. They were also hard on the townsfolk who justifiably felt that they were due payment for the services and goods that they had supplied. In short they seemed to close ranks against the world. I suppose it was their grief, which was, of course, deep, but I grieved too. I just needed to be practical and busy, it was my way of coping. Mamma was too ill and too tired and I was Miss Churchyard, and I had to act like it.

We had to move, that much was clear, and to lessen the distress to Mamma we moved across the road once more, this time to Penrith House, an elegant Georgian white brick house, but rather cheaper than Hamblin House. We were allowed to keep the feminine possessions that were not considered to be Papa's: the six-octave pianette, a Canterbury music stand, work table, jewel case, Chippendale mirror, tray-top table, cane seated chairs, ivory fans, the Wedgwood, Worcester, Spode and Lowestoft china, and three hundred of Papa's books. Looking at the list I can see that we had spent a lot of money on things other than Papa's Old Master paintings. We tried to arrange the house in a manner that would

186. The Cow Tower, Norwich. *By Thomas Churchyard. Black Chalk. 5½ x 3¼ in.*
(Photograph courtesy of David Messum Fine Art Ltd.)

be soothing to Mamma, arranging around her all the familiar pieces so that she would feel comforted.

Slowly I organised the household; my sisters did not like me doing it, but they either couldn't or wouldn't do it themselves. And all the while poor Mamma faded away, now totally lost without her one true love. She died only a little more than a year after Papa; the Doctor said chronic bronchitis, but she had been fading away from us for a long time. Finally she was at rest and her children were orphans, not trained to any career, nor yet quite educated enough, accepted as gentlewomen but neither fish nor fowl, as Nanna would have said. Without dowries we were of little interest to suitors, nor were we young. We needed to look to our talents and find a way to keep ourselves.

When I had tried to take charge in my own right as the head of the household I soon realised that we couldn't live like that. My sisters would not submit to being organised by me, nor yet would they deal with things themselves. In the end I could see only one answer and so I accepted a position in Norfolk as housekeeper to a large household. Leaving Woodbridge for who could tell how long was an appalling thing to have to do, but I knew that I couldn't live near-by and not feel bad about my position and lack of funds.

Ben wrote to me every week and kept me informed about the 'goings-on' in Penrith House and with news of the town. Fitz wrote to me too. He rarely mentioned my sisters as he knew that he had nothing to say that was good; he disapproved of their behaviour more and more. But he knew that I felt alone and unhappy.

As soon as was possible a solution was found that I think saved my sanity. Ben Moulton offered me the job as housekeeper in his own home. I was soon back in the heart of Woodbridge again, in a comfortable home earning a small living, but for very pleasant work, which was more like living with friends than employment. I lived with the Moultons for fourteen years, at the top of New Street, next to the Bull Hotel, until Ben died in 1885; then I found that he had provided for me in his will, leaving me thirty pounds a year for life. This wonderful gift was the gift of freedom; it allowed me to settle into my own small home and

187. Seckford Almshouses from Fen Meadow, Woodbridge. *By Thomas Churchyard. Watercolour. 7½ x 11½ in.*
Private Collection.

to be my own mistress for the very first time at the ripe old age of fifty-nine.

Dear Ben.

Then the door burst open and Charley fell inwards, clutching a bottle of port in his hand. He hit the floor with a crash and lay there winded. I made no attempt to help him up, knowing that he would be nasty and that it would be best to leave him. When he finally dragged himself in a sitting position he waved the near-empty bottle at me and jeered,

'There, that's what Papa's paintings are worth. I got this at Banyard's for one of those cigar box paintings!' he laughed and coughed convulsingly.

Fury began to rise in my breast. Suddenly I realised that he had intended all along to take one of the paintings when he asked to see them that morning.

'Dear Major Hart offered to buy it from me. But I told him I'd rather swap it for port than deal with him, the snooty so-and-so.'

My heart sank. Everyone in Woodbridge would know about this whole episode and no doubt they would think that I gave Charley the picture in the first place. He would have to go; I cannot live my life like this. There is talk of the Seckford Hospital rules changing to allow unmarried men to retire there. I must do what I can to get them to accept my wastrel brother, before he drives me to a deed I might regret.

EPILOGUE

Ellen Churchyard's story is set in 1897, when she was seventy-one. She lived until 1909, remaining independent thanks to the help of her many friends.

During the later years of her life she was often approached by writers for information about Bernard Barton and Edward FitzGerald. Sometimes she was asked to sell the books, poems and paintings that she had been given during her life. The writer E.V. Lucas continued to keep in touch with her for many years after he had written a memoir of Bernard Barton. He helped her to sell her copy of FitzGerald's *Polonius* and two copies of the *Calderón* dramas, when she was in need of money to supplement her annuity. He took them to Sotheby's auction of books where they were listed with the note:

> 'The forgoing, three lots, were presented by FitzGerald to his friend
> Thomas Churchyard, Lawyer, Woodbridge, and they subsequently
> passed into the hands of his daughter Ellen, also a friend of
> FitzGerald.'

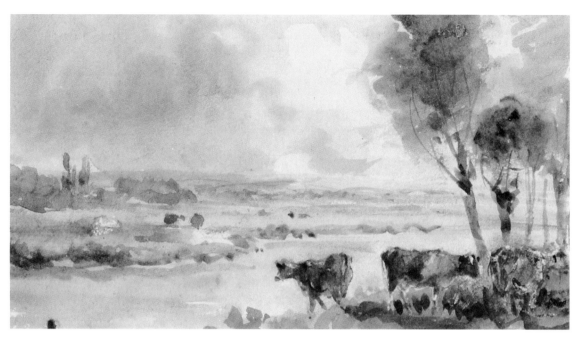

189. Cattle by Marshy River. *By Thomas Churchyard. Watercolour. 3¼ x 5½ in.* *Private Collection.*

Polonius sold for £11.10s. and the *Calderóns* for £14 and £30.10s., all three going to collectors in America. We can be sure Ellen made good use of this windfall, never selling her treasures unless it was entirely necessary. Generally she was wary of even letting people so much as look at the things she owned. The year before Ellen died, Harriet had asked her if she had a '*Readings in Crabbe*,' as the printer John Loder was asking for sight of a copy.

Ellen had replied,

> 'Yes, dear I have a little book in its paper cover of some of Crabbe's poems abridged and described by EFG, there were only a few copies published and distributed among friends. I was one of the lucky friends to have one given to me by himself.'

She hadn't lent it to Loder, suspicious of his intentions, and jealous of her most valued possessions.

188. Townscape with Washing. *By Laura Churchyard. Watercolour. 2¼ x 4¼ in.* *Private Collection.*

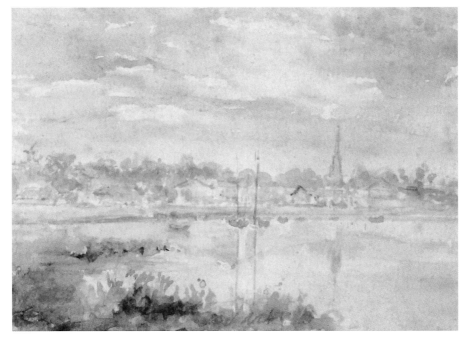

190. View of Woodbridge from the Deben. *By Thomas Churchyard. Watercolour. 3½ x 4½ in.*
Private Collection.

Bessie Churchyard lived on until 1913, when Miss Elsie Redstone was called upon to sort out her possessions and to put them into the attic with those of Laura, Anna and Kate, the White Mice still guarding their privacy to the bitter end.

Harriet Churchyard continued as Seckford Librarian until she was allowed to retire with a small pension in 1926 when she was ninety years old. She continued to live in the house when Elsie Redstone took over as librarian. Harriet died the following year, now the possessor of many thousands of her father's works.

Lucy Barton died in 1898 in Surrey, where she had spent the last years of her life with a relative. She remained very good natured to the end, although her mind had grown confused. She always kept a picture of Fitz by her chair.

The last remaining child of Thomas Churchyard was the infamous Charley. He had lived with Ellen for twenty long and frustrating years, arriving soon after the death of Edward FitzGerald and staying, on and off, until he was finally offered a place at the Seckford Hospital. For many years the rule excluding single men had kept him dependent on Ellen's charity; as soon as it was changed, he applied for and was granted a place. Maybe the trustees took pity on Ellen as they had earlier helped her sisters?

LECTURE HALL,
WOODBRIDGE.

A CATALOGUE

OF THE NUMEROUS

OIL PAINTINGS,

WATER COLOURS,

ART AND OTHER BOOKS,

OLD CHINA AND EARTHENWARE,

ANTIQUE FURNITURE, &c.

Of the late MISS HARRIETT CHURCHYARD,

TO BE SOLD BY AUCTION BY

ARNOTT & EVERETT

ON

MONDAY, April 11th, 1927,

Beginning at **11** o'clock, punctually, in consequence of the
number of Lots.

On View SATURDAY, April 9th from 11 to 1,
and from 2 to 4.30 o'clock by Catalogue only.

Catalogues, price **6d.** *each, may be had of the Auctioneers,*
Woodbridge.

GEORGE BOOTH, PRINTER, WOODBRIDGE.

191. Handbill for the 1927 Auction of all Thomas Churchyard paintings after the death of Harriet Churchyard.

192/193. Album and Guard Book. Photographs.

Less than three months after Harriet's death in 1927, at Charley's command, Arnott and Everett advertised a sale at the Woodbridge Lecture Hall. Thomas Churchyard's paintings were sold together with works by George Frost, George Rowe, maybe even John Constable himself, but certainly with works by all of the sisters. There were 475 lots, which included 980 oils, over 4000 works made up into parcels, folders and boxes, and the thirty-two guard books of various sizes that had been given to the girls, decades before, to save them from the bailiffs, together with numerous albums and scrapbooks of the sister's work, pasted up by themselves, but to add confusion these often included Thomas's work.

Charley wanted to sell it all, as quickly as possible. It was his revenge. But Charley's final disservice to the whole family was to cloud his father's true talents and reputation for many decades. To maximise the proceeds from the sale he bundled up works by his sisters along with Thomas's genuine work. Purchasers naturally judged the folders full of drawings and paintings as very variable in quality. Some seemed so good they were mistaken for Constables, Cotmans or Cromes, but others so weak that they seemed almost amateurish.

We now have a better understanding of the paintings, and can usually differentiate between the works of Thomas and his children. This is sometimes made very difficult as the children were talented artists in their own right, and could often produce very good paintings, as well as copies of their father's work. Many of the albums that sold in 1927 remained intact, and have come to the market with a perfect provenance.

Today Thomas Churchyard's work can be found in many major public and private collections including: the Tate Collection; the British Museum, London; the Victoria & Albert Museum, London; The Ashmolean Museum, Oxford; the FitzWilliam Museum, Cambridge; Norwich Castle Museum and Art Gallery; Christchurch Mansion, Ipswich; and many more across the world.

www.thomaschurchyard.co.uk

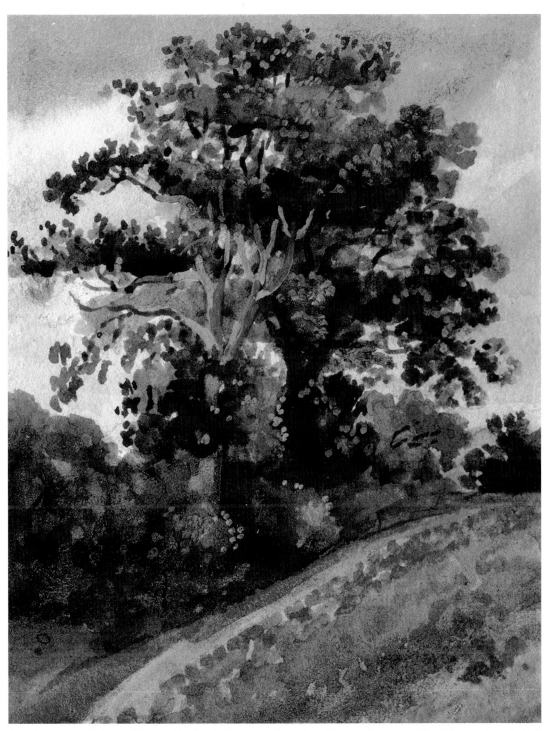

194. Trees on a Hillside. *By Thomas Churchyard. Watercolour. 4¼ x 3¾ in. (Photograph courtesy of David Messum Fine Art Ltd)*
Private Collection.

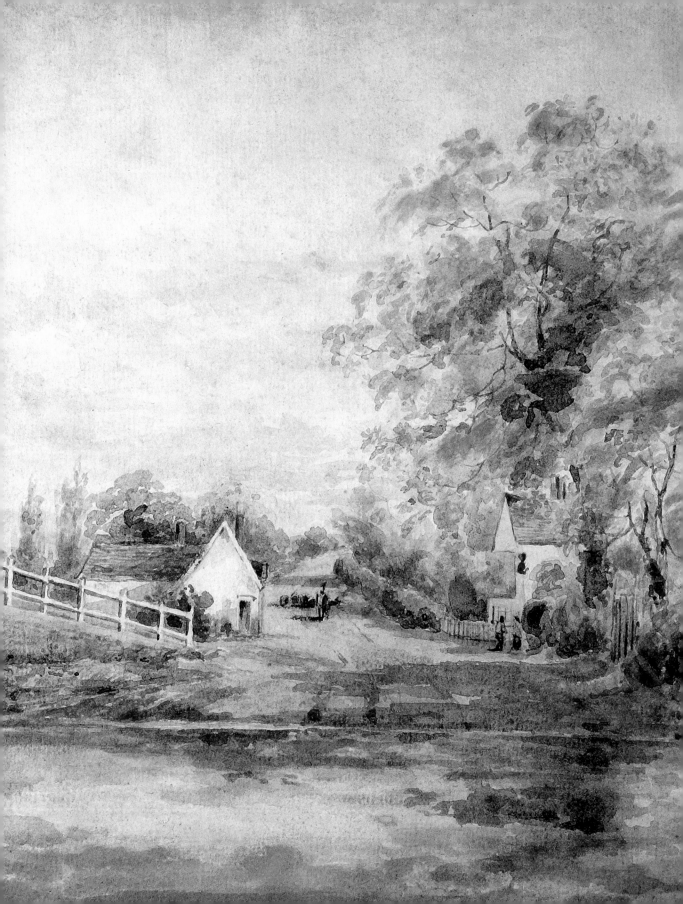

ACKNOWLEDGEMENTS

I would like to thank everyone who has helped me to complete this book: most especially my husband David for very many years of patience, and more recently for the very practical help tracing paintings and taking photographs.

I also owe an enormous debt to Ian Collins for his encouragement and guidance through the maze.

Thanks and acknowledgements must go to Denis Thomas, Wallace Morfey and Robert Blake for their histories, which inspired me from the beginning.

Thanks also to Ipswich Museums for access to the Churchyard Collection at Christchurch Mansion; most particularly to Joan Lyall for her enthusiasm and help with the pictures.

Last but not least, many thanks for the generosity of Churchyard collectors and enthusiasts who have made their pictures available to me: David Messum, Revd and Mrs E. C. Charlesworth, Mr and Mrs J.J. Heath-Caldwell, Mr and Mrs Martin Sylvester, and John Day.

195. Bridge at Martlesham looking towards the Red Lion (detail). *By Thomas Churchyard. Watercolour. 11 x 15½ in. Private Collection.*

BIBLIOGRAPHY

Barcus, James E., ed., ***The Literary Correspondence of Bernard Barton***, Philadelphia 1966

Barton, Bernard, ***Household Verses***, London 1845

Barton, Lucy, ed., ***The Poems and Letters of Bernard Barton***, London 1859

Bennett, Chloe, ***Suffolk Artists 1750-1930***, Woolpit, Suffolk 1991

Blake, Robert, ***The Search for Thomas Churchyard***, Woodbridge 1997

Blake, Robert, ***Thomas Churchyard Bicentenary***, Woodbridge 1998

Bloomfield, Robert, ***The Farmer's Boy***

Cobbold, Revd Richard, ***Margaret Catchpole, A Suffolk Girl***, 1845

Day, Harold, ***East Anglian Painters Vol 1***, Eastbourne 1967

Day, John, ***Thomas Churchyard 'The Oil Paintings'***, Eastbourne 2004

FitzGerald, Edward, translator, ***Rubáiyát of Omar Khayyám***

Martin, Robert Bernard, ***With Friends Possessed, A Life of Edward FitzGerald***, London 1985

Morfey, Wallace, ***Painting the Day***, Woodbridge 1986

Moulton, Ben, ***Pocket Journal***, 1827

Reiss, Stephen, ***Thomas Churchyard***, David Messum Bicentenary Exhibition, London 1998

Simper, Robert, ***Woodbridge and Beyond***, *East Anglian* magazine Ipswich

Terhune, Alfred McKinley and Annabelle Burdick Terhune ed., ***The Letters of Edward FitzGerald Vols 1 – IV***, Princeton, New Jersey 1980

Thomas, Denis, ***Thomas Churchyard of Woodbridge***, Chislehurst, Kent 1966

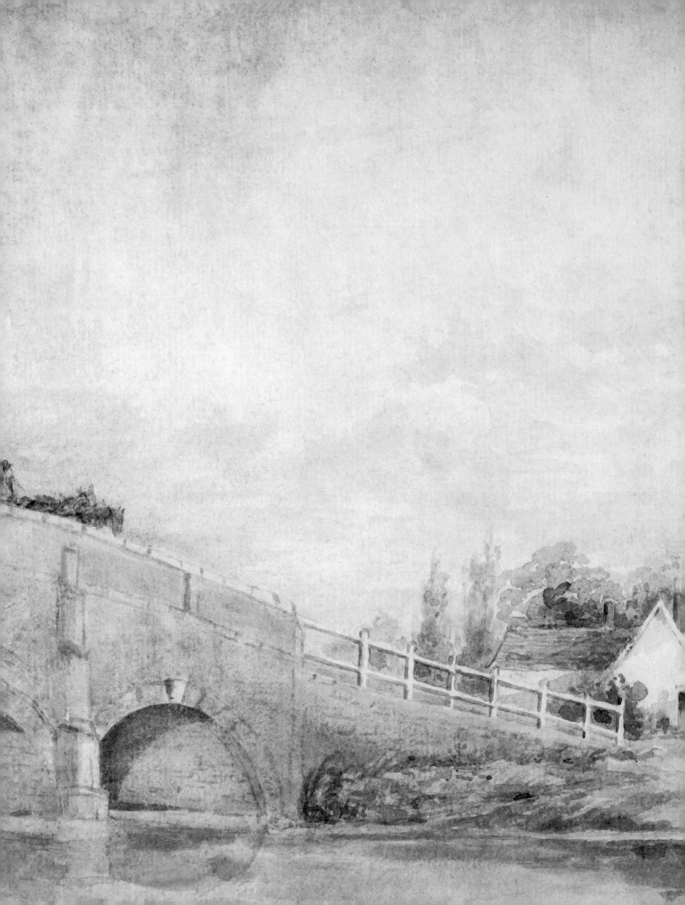